Finest Prospects

The shell of my gallery is finished, which, by three bow-windows, gives me three different, and the finest, prospects in the world

Lord Chesterfield to Solomon Dayrolles,
19 June 1750

English Heritage, the popular name of the Historic Buildings and Monuments Commission for England, looks after over 400 historic buildings and ancient monuments in England, most of which are open to the public.

You can help English Heritage to improve public enjoyment and understanding of its properties by becoming a member. You will gain free admission to all sites and receive a regular Newsletter. For young people, English Heritage has a special organisation called *Keep.*

Details are available at the historic houses or, by post only, from English Heritage, PO Box 43, Ruislip, Middlesex HA4 0XW.

Supported and sponsored by Gateway Foodmarkets Limited.

Finest Prospects
Three Historic Houses: a study in London Topography

Julius Bryant

English ⌗ Heritage

The Iveagh Bequest, Kenwood

Finest Prospects

Published for the exhibition held from
18 September to 31 October 1986

The Iveagh Bequest, Kenwood,
Hampstead Lane, London NW3 7JR

© English Heritage 1986

ISBN 1 85074 131 X

Designed by Two plus Two Design Partnership and
printed by Raithby Lawrence

Cover Richard Wilson *The Thames near Marble Hill,
Twickenham* (cat.44)

Frontispiece George Robertson (detail) *A View of
Kenwood* (cat.86)

Contents

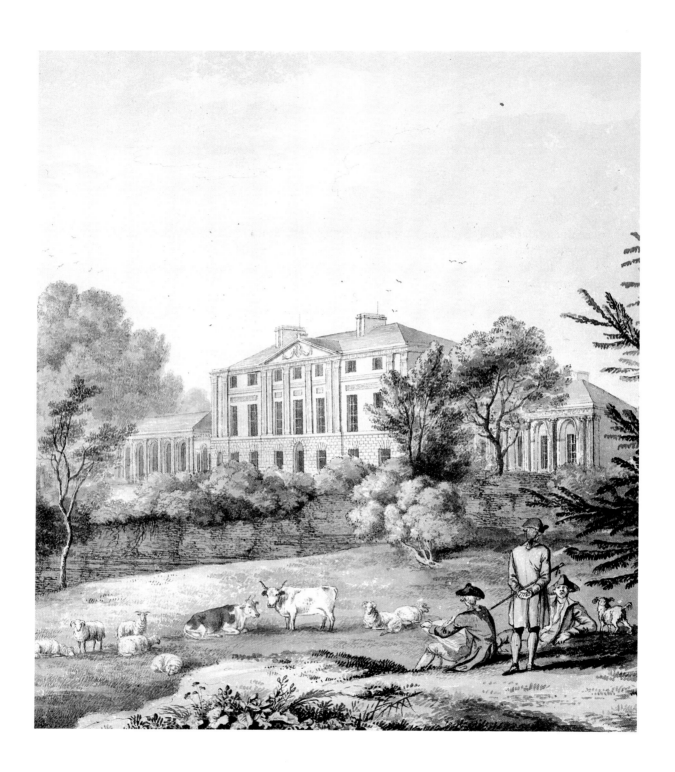

Foreword

This is the first exhibition to be arranged at Kenwood since English Heritage became our new Administrative Trustee on 1st April this year. Although necessarily brought together in a shorter time than usual, it will take its place, I hope, in the series of exhibitions on eighteenth century themes, begun by the LCC over thirty years ago, and continued with such conspicuous success by the GLC.

Finest Prospects takes its title from Lord Chesterfield's description of his new Gallery at Blackheath, and its theme, appropriately enough, from the views to, and from, the three Houses recently transferred to English Heritage: Ranger's House, Blackheath; Marble Hill at Twickenham and the Iveagh Bequest at Kenwood. The 'prospects' from Blackheath, from Richmond Hill and from Hampstead Heath make this exhibition not only a study in London topography, but also a microcosm of English landscape painting. All the great names are here from Wilson to Constable, Turner and Madox Brown, for our three vantage points are among the most popular in English scenery.

Much of the exhibition is drawn from our own collection of prints and drawings, which has been gradually and quietly acquired in recent years, often with visitors' donations. But we are most grateful in addition to those owners, of both public and private collections, who once again have been most generous in their response to our requests. We are particularly indebted to the Earl of Pembroke, who has kindly allowed Colen Campbell's early Palladian design for Marble Hill to be included in the exhibition. Not only has Manchester City Art Gallery lent its magnificent Turner *Thomson's Æolian Harp*, but Birmingham has also enabled us to include Ford Madox Brown's *English Autumn Afternoon* (the house in Hampstead from which it was painted being correctly identified for the first time in this catalogue). Certain crucial paintings, which have appeared before in Kenwood exhibitions, have been borrowed again, and to those owners, who often wish to remain anonymous, we owe a special word of thanks.

Finest Prospects has been researched and compiled by Julius Bryant, Assistant Curator, in a matter of months in order to celebrate our transfer to English Heritage. I trust it will be a pleasurable exhibition, of interest not only to Londoners but to lovers of English architecture and landscape. It reflects the changing fortunes of the 'villa', from its lofty Palladian origins to its popular suburban decline, and the once admired 'prospect' which became the 'beauty spot' of yesterday and today.

John Jacob
Curator, Historic House Museums

Catalogue notes

Unless otherwise stated, all works are on paper and all engravings are line engravings. Artists' titles (P.R.A. etc.) are omitted. Dimensions are given for all works except books, height before width; dimensions for prints are plate size unless otherwise stated. Inscriptions are only given for engravings originally issued before 1850; thereafter printed texts are simply noted as 'caption'. Inscriptions on prints are transcribed as printed, in sequence, line by line, from top to bottom, a slash denoting either the start of a new line or a substantial space on the same line in the original. When the title interrupts the printer's credit, the title is given first (cat. 9, 10). Provenance, exhibitions and literature are only given for original works. Where abbreviated references are made the full details will be found in the Bibliography. Unless otherwise stated, auction references are for London sale rooms. Where ample references exist for exhibitions, only the original and most recent venues are cited. Full reference to exhibitions will normally be found in works listed under 'Literature', where only the most significant publications are given.

Catalogue illustrations appear above or within the entry to which they apply. Not all exhibited works are illustrated. 'Fig' identifies a work not in the exhibition.

Acknowledgements

Finest Prospects is a marriage of two distinct genres, engravings of villas and paintings of extensive landscapes, united through a common theme: the social pastime of viewing such sights, assisted by illustrated travel guides, periodicals and county histories. The case studies of the three villas and their settings that follow are intended as an introduction to a field worthy of several exhibitions.

To John Jacob I am grateful for suggesting the original subject of the exhibition, for editing the initial selection of loans, and for indicating innumerable improvements to the essays. The catalogue entries have benefited from the criticism of my colleague Anne French, who has contributed the entry on Thomas Hofland. Christine Mathez undertook the transport arrangements with Peter Cross, who also cleaned and framed many of the works on display. Gill Nock assembled the illustrations; Georgina Mersh and Claire Harbour typed the bulk of the correspondence and Christine Higgs typed my manuscript with genuine determination. The good humour and dedication of the Kenwood team has been appreciated throughout.

Research for the catalogue has naturally drawn upon the legacy of previous members of the curatorial staff, in particular Jacob Simon. The staff of the various local history libraries and galleries in Twickenham, Richmond, Camden and Greenwich have been welcome neighbours, and I would like to thank Deborah Howard, Patricia Astley Cooper, Brenda Lamb, Malcolm Holmes, Julian Watson, Barbara Ludlow and Veronica Moore. Ralph Hyde of the Guildhall Library and John Phillips of The Greater London Record Office shared their expertise at the outset. Neil Rhind and Frank Kelsall made valuable amendments to the essay on Ranger's House. Debts to the recent publications of local historians are acknowledged in the footnotes. Thanks for help of various kinds are due to Brian Allen, J.H. Appleby, Joan Coburn, Timothy Goodhue, Rodney Harragon, John Harris, Henson International Television, Paul Higham, Michael Jubb, Eliza Lawler, Jonathan Riddell, John Wheeler and others too numerous to mention. Mary Padden designed the catalogue and saw it through the press. I owe both thanks and apologies to my wife, Barbara Bryant, for enabling this catalogue to be written at strange hours and for tramping the outskirts of London with me in search of lost prospects.

Julius Bryant
Assistant Curator

Finest Prospects

An introduction

IN 1750 Philip, 4th Earl of Chesterfield, finished adding a gallery to the side of his house near the top of Greenwich Hill, and wrote to a friend that he considered its three bay windows afforded "three different, and the finest, prospects in the world".[1] This use of the word 'prospect' to describe an extensive landscape viewed from an elevated vantage point is less familiar to us today, when it is more often used in the sense of expectation or exploration. In art history the word is often applied to an early form of topographical landscape painting practised by Netherlandish artists in this country in the late seventeenth century. But in Chesterfield's time 'prospect' carried richer associations, evoking the ideal Italianate landscapes viewed from the rims of sunlit river valleys, as painted by Claude Lorraine in the previous century. The word also referred to a particular type of wide topographical sketch, often employed by military cartographers to record fortifications and harbour installations, and by draughtsmen to record towns for engraving.

From the seventeenth century, the pleasures of visiting high vantage points to enjoy such distant prospects became increasingly popular among fashionable society, and encouraged the building of summer and weekend villas with galleries and gazebos from which to enjoy the views. The desire of the residents to have their houses recorded in their prestigious settings prompted patronage for two particular types of extensive landscape paintings: one from an imaginary aerial, 'bird's eye' position, the other from a natural high point producing an effect that would be described as 'panoramic', to use a word in popular use from 1791. This interest in viewing prospects and houses also stimulated the production of illustrated tour books, particularly from the last quarter of the eighteenth century, in which the reader's gaze was directed from general views to the more particular beauties of adjacent villas by an historical text.

The starting point for this exhibition is engraved views of three eighteenth century villas, all of which are associated with three of the finest prospects in this country: Ranger's House (as Chesterfield's house is now known) stands on the edge of Blackheath, overlooking Greenwich and London to the north; Marble Hill in Twickenham forms the heart of the celebrated rural view west from Richmond Hill, while Kenwood above Hampstead Heath faces south over the City, with a view south-east towards Greenwich. Together they form three high points of a triangle flung across the outer rim of the London basin which lends itself to prospect viewing and, as a result, has held the interest of the public, artists and patrons for many reasons and to varying degrees for centuries. The purpose of this exhibition is to set these three villas in the context of prospect and house viewing in the eighteenth and nineteenth centuries, and to consider the changes in the related paintings and engravings of the houses and their settings that this fashion produced.

Taking this approach, we will discover that prospect painting, far from being confined to the seventeenth and early eighteenth centuries, as is traditionally understood, survived through the development from topography to 'pure' landscape painting, but in a variety of forms, just as prospect viewing continued to appeal, but in different ways. We will also see how the traditional importance of particular prospects

as time-honoured subjects in themselves sets such pictures apart from 'pure' land-scape painting as, like the houses, they originally presented innumerable associa-tions which are easily overlooked today.

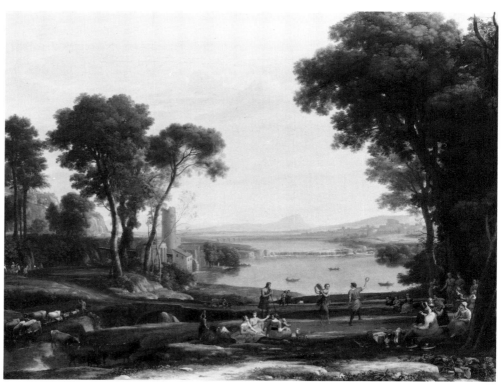

Fig. 1 Claude Lorraine *Landscape: The Marriage of Isaac and Rebekah* 1648, The National Gallery, London.

Accounts of the pleasures of prospect viewing from this period remind us of the variety of appeal it held. Edmund Burke identified "vastness" as one of the charac-teristics of the sublime in his treatise on aesthetic theory, *A Philosophical Enquiry into the Origins of our Ideas of the Sublime and Beautiful* (1757). Burke tried to explain the thrill of crossing the Alps (which had earlier been avoided by travellers), but part of this sensation was nothing new as mankind has always enjoyed climbing to high ground to admire great landscapes. Earlier attempts to articulate and explain this thrill pointed to the almost divine contact with Creation that prospect viewing afforded. The impression such a view could give was not only the infinite diversity of nature, but the harmonious place accorded to man in its midst. A seemingly infinite landscape not only sets man in perspective, but encourages an appropriate scale of thought. According to Addison in *The Spectator* in 1712:

> The Mind of Man naturally hates every thing that looks like Restraint upon it.... On the contrary, a spacious Horizon is an Image of Liberty, where the Eye has Room to range abroad, to expatiate at large in the Immensity of its Views, and to lose it self amidst the Variety of Objects that offer themselves to its Observation. Such wide and undetermined Prospects are pleasing to the Fancy, as the Specula-tions of Eternity or Infinitude are to the Understanding.[2]

London presented an additional, associative appeal for the prospect viewer to con-template, as he beheld not only the nation's capital but, as its major port and business centre, the country's principal source of wealth. Twelve years after the publication

of *The Spectator* essay Daniel Defoe looked north "from the little rising hills about Clapham"[3] towards a City largely rebuilt since the Great Fire of 1666 and responded with appropriate pride:

> behold, to crown all, a fair prospect of the whole city of London itself, the most glorious sight without exception, that the whole world at present can show, or perhaps ever could show since the sacking of Rome in the European and the burning of the Temple of Jerusalem in the Asian part of the world.[4]

One hundred years later, an introduction to a published panorama of London invited its viewers to admire the:

> Thames, the source of all the wealth and grandeur of this Metropolis... an imposing picture of active industry, pleasure, and extended commerce, no where to be equalled in the world.[5]

Writers also remarked on how, seen from afar, the capital appears to lie alongside farmland, presenting a harmonious over-view of urban and rural man working together, with the fruits of his labours reflected in the fine architecture of the City and the cultivated fields surrounding it. As Thomas Noble, for example, wrote from his favourite prospect point:

> Blackheath is the name of the place where I observed the beauties of the Creation and the productions of social ingenuity. Blackheath and its environs are better situated for a wide range of contemplation than any spot. Where will you find prospects more extensive, that at the same time abound with the like grandeur of luxurious cultivation? Behold the magnificence of a mighty city so intimately united with rural cottages of the surrounding labourers of agriculture![6]

The opposite was also true, however, that prospects could appeal for the limited view of man they gave. Barbara Hofland, for example, wrote in 1832 of the view upstream from Richmond Bridge:

> There is a character of beauty and peace, of sylvan splendour, substantial property, aristocratic wealth, and general comfort in this view peculiar to itself, for not a single object interferes to remind us of a painful inequality in the condition of man.[7]

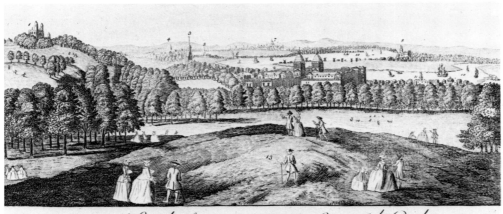

A View of London from One-Tree-Hill *in Greenwich Park.*

Fig. 2 The Gentleman's Magazine *London from One-Tree Hill* 1754, Museum of London

13

This love of prospect viewing also held a 'picturesque' appeal, in reminding the educated spectator of paintings by great seventeenth century artists such as Claude Lorraine, Gaspar Poussin and Salvator Rosa. Claude was the master of painting idealised visions of the countryside around Rome, often showing the Campagna from on high, looking down from an amphitheatre of hills into a wide valley through which a river gently meanders past a classical villa, temple or bridge, and on towards an infinitely receding golden horizon. The popularity of his paintings established prospect points on the itinerary of gentlemen completing their education with a Grand Tour to Italy. In addition to studying the remains of classical architecture and sculpture at close quarters, one had to admire Rome from the Palatine Hill, and the Campo Vaccino (as the Forum was known) from the Capitoline Hill, and then venture further afield to see Tivoli from afar, Horace's villa in the Sabine Hills, and Ariccia set in the Alban Hills, south of Rome. Following in the footsteps of Claude and other revered painters, gentlemen then sought out the classic prospects of Lake Albano and Lake Nemi, before viewing the Bay of Baia and Naples.

Back home, topographical poetry such as John Dyer's *Grongar Hill* (1726) and James Thomson's *The Seasons* (1726-30) encouraged readers to enjoy native prospects on the same terms, by carefully painting their descriptions in words, whether describing the pastoral ideal as presented by Claude, which Thomson evoked in describing the view from Richmond Hill, or the wilder, 'sublime' landscapes painted by Rosa, which travellers sought out in Wales and the Lake District. Thomson, for example, invited his readers to 'trace the matchless vale of Thames', exclaiming:

Heavens! what a goodly prospect spreads around,
Of hills and dales, and woods, and lawns, and spires
And glitt'ring towns, and gilded streams[8]

Where words failed them, some poets claimed their subjects to be equally beyond the brush of the great masters. Towards the end of the century, the fashion for viewing prospects like paintings was further spread by novels in which characters enjoyed such spectacles, and by travel books, most notably the Reverend William Gilpin's *Picturesque Tours* (1782).

The drawing of close comparisons between nature and art made it possible to extend connoisseurship from paintings to real landscapes, keeping Claude, Rosa and other favourite painters in mind as standards of excellence. The architectural theorist Robert Morris, for example, compared real locations as if they were works of art when he observed that whereas Richmond Hill is "advantageous for Prospects of Beauty it has less of Grandeur than Shooter's Hill" at Blackheath. A view of a storm at the latter:

would fill us with Tenderness and Surprize, and even then the Image would have no Tincture of that Horror which would arise in us from the View of a Storm from Dover Cliff. In short, on Richmond Hill the scenes are more still and silent, and a kind of pensive Gaiety is rather the Effect of the Survey than that Vivacity which is diffused through us at the Contemplation and in the Enjoyment of the other.[9]

This distinction was not lost on Lord Chesterfield who used 'prospect' metaphorically to describe the contemporary political scene in 1737:

We have a prospect of the Claud Lorraine kind before us, while Sir Robert [Walpole]'s has all the horrors of Salvator Rosa. If the Prince would play the Rising Sun, he would gild it finely.[10]

Given this love of prospect viewing, it is not surprising that villas were built on high ground around London, particularly along the walls of Greenwich Park at Crooms Hill and Maze Hill, on Richmond Hill and at Highgate and Hampstead. Of course, fine views were not the prime reason for the development of these areas outside the City and Westminster. The presence of royal palaces on the Thames attracted courtiers to live at Greenwich and Richmond. Even after the removal of the court from Greenwich following the Glorious Revolution of 1688, the prosperity of London as a port ensured that the area was favoured by merchants and retired naval men with an eye on their investments in shipping. At Highgate the direct road to London attracted gentlemen with business interests and professional commitments in the City and Westminster to live on the outskirts of the Bishop of London's forest, while Hampstead largely developed in the eighteenth century as a resort with its fresh air, spa, and, indeed, fine prospects.

Houses built at such high points took full advantage of their prestigious settings, with well-lit galleries, gazebos, wide terraces and parterres from which to view fine prospects. Where space permitted, extra height could be gained in the grounds, as on rural estates, by constructing a viewing tower in the form of a 'folly' or by building a 'mount' of earth.

The prospect itself was opened up by laying unbroken lawns in place of formal plantings and by replacing fences with ditches or 'ha-has'. Through the careful planting of trees and construction of ponds the 'pleasure grounds' and distant prospect could be united and then cultivated towards the picturesque ideal. In so doing, nature was encouraged to follow art.

Such landscaping of parkland to heighten the prospect was particularly fashionable for villas as, unlike country houses, they were primarily intended for pleasure. In this villas differ from country houses, as the latter are essentially ancestral seats from which to supervise agricultural estates. For much of the eighteenth century Ranger's House and Kenwood functioned as summer retreats in which to entertain guests or study in seclusion. Although Marble Hill and Kenwood both had a 'home farm' they were not self-sufficient seats with acres of farmland but relied on alternative sources of income.

For the public, viewing such villas, like visiting country houses, was a fashion in itself and a natural addition to any visit to a prospect point. Indeed, in the sixteenth and seventeenth century the word 'prospect' was also used to describe a view of a house, palace or castle by itself. Visitors came to admire the latest styles of architecture and interior decoration, impressive collections of paintings and furniture, modern domestic innovations and, of course, the 'prospect' itself. From the descriptions originally published to accompany engravings of these houses in tour books, county histories and periodicals, and from contemporary diaries and correspondence, it becomes clear that visitors were also greatly interested, as today, in the associations a house carried, the memories it evoked of its various owners, past and present. Archibald Alison underlined this associative approach to the appreciation of landscape and architecture in his *Essays upon the Nature and Principles of Taste* (1790):

Whatever increases this exercise or employment of Imagination, increases also the emotion of Beauty and Sublimity. This is very obviously the effects of all Associations.... The view of the house where one was born, of the school where one was educated.... lead altogether to so long a train of feelings and recollections, that there is hardly any scene, which one beholds with so much rapture. The scenes

which have been distinguished by the residence of any person, whose memory we admire, produce a similar effect.... The scenes themselves may be little beautiful, but the delight with which we recollect the traces of their lives, blends itself insensibly with the emotions which the scenery itself, excites... and converts every thing into beauty which appears to have been connected with them.[11]

The associative response to viewing villas, as with viewing prospects that include the nation's capital, is an added dimension easily overlooked today, by treating paintings and engravings as works of art alone. To close the historical gulf between the original prospect viewers and ourselves even slightly, we must attempt to retrieve lost associations. In engravings of real views they are more accessible today than in any other medium, as the published impressions may be traced to the original sources in which they accompanied descriptive texts; this provides a starting point from which to approach paintings of the same views.

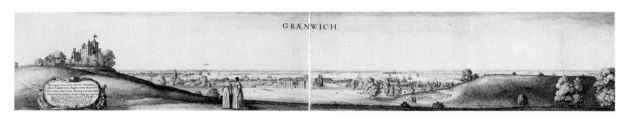

Fig. 3 Wenceslaus Hollar *View of Greenwich* 1637, British Museum

Connoisseurs collected the ideal landscapes of Claude, Poussin and their followers to adorn their homes, but for actual portraits of their houses and estates, shown as part of a fine prospect, they at first turned to an alternative, more topographical tradition, represented by immigrant Dutch and Flemish artists.

The topographical recording of specific prospects probably has its origins in this country in military cartography and antiquarian surveys. Wenceslaus Hollar is the best known early exponent of this genre. In 1636 the Earl of Arundel took Hollar to Prague to record places visited while on a mission to Emperor Ferdinand II and returned with him to England. The first topographical print Hollar produced in this country was a wide view north from the hill above Greenwich, spread across two sheets of paper, which he published in 1637. In 1667 Hollar was appointed 'King's Scenographer and Designer of Prospects' and two years later the British Government sent him to Morocco to make wide coloured drawings of the fortifications and warships moored at Tangier.

Whereas Hollar is not known to have worked in oils, a group of professional Netherlandish painters who arrived in London after the Restoration brought an ability to paint extensive landscapes with great precision. Jan Siberechts, Hendrik Danckerts (cat. 3), Leonard Knyff (cat. 60) and Jan Vorstermans (cat. 4) became the leading landscape painters of the era, painting estates and towns from elevated ground, as used by Hollar, and also from imaginary positions that gave the effect of 'aerial' or 'birds-eye' views, through combining the skills of the map maker and the architectural draughtsman. The grand scale of prospects such as those from Greenwich or Richmond Hill defied literal transcription, forcing these artists to compose the scene in perspective, without apparent loss of accuracy. At this Siberechts proved the most successful, putting the necessities of composition to creative effect, by leading the spectator's eye through the landscape, and relieving the sense of steady concentration on factual detail with an element of human interest in the fore-

ground, in addition to the traditional inclusion of travellers admiring the prospect. Danckerts and Vorstermans are credited with many more views from Greenwich Hill than they painted, but Siberechts's *View from Richmond Hill* (1677, fig. 19) is the earliest known; his elevated view of *The Grove, Highgate* (1696, unlocated) includes one of the earliest painted prospects of London from the north, seen beyond the house and its gardens.

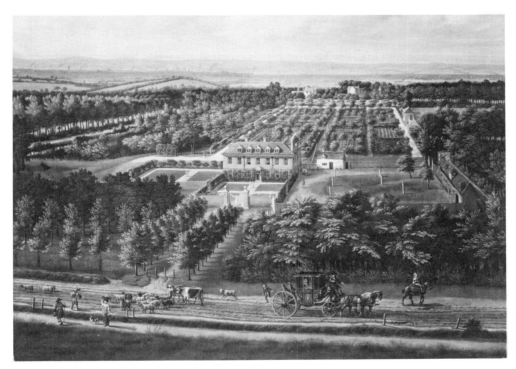

Fig. 4 Jan Siberechts *The Grove, Highgate* 1696, unlocated

Such noble prospects of houses were often kept at the town house or country seat of a gentleman, as a reminder to his guests and himself of his other property. Paintings of royal palaces, displayed as decorative overdoors and overmantels, could also serve as symbols of their owner's allegiance, as did the set of paintings on dining-room panels representing 'the four houses of the King' which Pepys commissioned from Danckerts in 1669.[12]

More considerable than such patronage for oil paintings was the commissioning of engravings to illustrate antiquarian studies, and it is here that the development of the prospect in English art essentially took place. Francis Place (cat. 5), a close friend of Hollar from 1665, produced several wide views of towns and is today regarded as the first English artist to regard landscape drawing as an art form rather than as an adjunct of cartography. A major stimulus came from the foundation of the Society of Antiquaries in 1717, whose members encouraged the visual documentation of surviving abbeys and castles, particularly by Samuel Buck and his brother Nathaniel, from 1721. Urban topography became their speciality, taking up a traditional printing genre dating back to fifteenth century Germany. After receiving subscriptions from city fathers around the country the brothers embarked upon annual tours of England, preparing long prospects of towns to engrave in the winter months. As Ralph Hyde has pointed out[13] civic pride at the town's prosperity, as reflected in fine architecture,

productive farms and shipping, was the essential source of such patronage, reminding us that some of Britain's finest prospects prompted more tangible reactions than fashionable connoisseurship. London was not alone, and significant alternatives among engraved urban prospects include Edinburgh from Calton Hill, Bristol from Brandon Hill, Leeds from Cavalier Hill, and Richmond in Yorkshire. Engravings of favourite rural prospects (such as the Avon from Clifton and the Wye near Chepstow) became more common in the last quarter of the eighteenth century, particularly in books of picturesque tours.

By the middle of the eighteenth century, the painstaking topographical approach of the Netherlandish 'bird's-eye' masters was superceded by artists such as Tillemans (cat. 36) and Wootton (cat. 61,76). The latter in particular sought to assimilate the ideal compositions and atmospheric light of Claude and Gaspar Poussin in house views, while applying the prospect formula to other subjects, such as battle paintings and sporting prospects of race horses on Newmarket Heath. An alternative influence came from the Venetian *vedute* tradition, practiced by Canaletto who arrived in England in 1746. His wide views from a low viewpoint, frequently facilitated by the use of a *camera obscura* were ideally suited to painting not only central London from across the Thames with the terraces of Richmond House and Somerset House in the foreground, but also rural estate prospects, as in his painting from the terrace of Badminton.[14] Far closer to Claude was Richard Wilson (cat. 44-47), who subtley disguised or 'improved' local topography to provide the illusion of a more Mediterranean world preferred by connoisseurs.

Watercolour, the most delicate and precise artistic medium, proved to be the means of reconciling the topographical accuracy and breadth of vision essential to prospect painting in the Dutch and Flemish tradition with the subtle effects of atmosphere and sense of mood admired in Claude. The development of the medium was largely due to the increasing demand for 'souvenir' views of the Grand Tour, and for illustrated antiquarian publications. The two fathers of the native school, Thomas and Paul Sandby (cat. 17,18,21) worked as military draughtsmen, as had Hollar in all but title a century before. Thomas served as Ordnance Draughtsman to the Duke of Cumberland during his military campaigns in Flanders and, like Paul, was employed on the Military Survey in Scotland following the suppression of the Jacobite rebellion in 1746. Their occupation required clear and precise definition of broad open landscapes, not picturesque contrivance. The opportunity was there, however, to develop the simple tonal washes into observed effects of light, and so strengthen the sense of space through aerial, rather than just mathematical, perspective.

In a similar capacity, draughtsmen accompanying gentlemen on their Grand Tours gained first-hand experience of the sources of Claude's poetic sense of mood. J.R. Cozens, for example, built a career out of repeating finished landscape watercolours originally sketched in Switzerland and Italy; with their high viewpoints and distant horizons, these are ideal prospects, full of the atmosphere admired in Claude, without the minutia of local topography. London from Greenwich Hill and the view from Richmond Hill are two of the few native prospects Cozens is known to have painted. To meet the popular demand for watercolours, Joseph Farington (cat. 9,10) and Thomas Hearne (cat. 22) set a new standard in topographical publications, but it was Thomas Girtin who employed the full resources of the medium to convey the true damp atmosphere of native countryside and the capital. Girtin preferred low viewpoints and solid silhouettes to open infinite prospects, but his view of *London from Highgate Hill* (1792, Yale) employs the conventional high foreground to

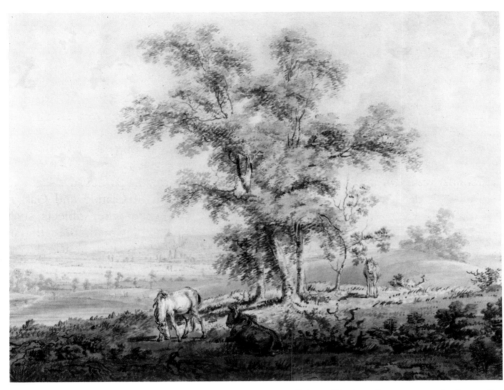

Fig. 5 Thomas Girtin *London from Highgate Hill* 1792, Yale Center for British Art

emphasize the shallow recession of an open plain. Girtin also responded to the fashion for 'artificial' prospect viewing, the visiting of painted panoramas, with his 'Eidometropolis' of 1801. This 360 degree painting, 108 feet long and 18 feet high, represented London from the roof of a house near Blackfriars Bridge; although the original is lost, watercolour studies reveal Girtin's affinities with Buck and Canaletto. The first painted urban panorama, showing Edinburgh from Calton Hill, was exhibited in London in 1789, and drew great admiration from artists.[15]

A very different approach to prospect painting can be found in some of the major works of the Romantic movement. Topography is often thought to hold no appeal to a Romantic painter as the importance of his personal response takes precedence over the details of the outside world. Henry Fuseli, for example, dismissed "as the last branch of uninteresting subjects, that kind of landscape which is entirely occupied with the tame delineation of a given spot" preferring instead the way "Height, depth, solitude strike, terrify, absorb, bewilder."[16] In a similar, if less dramatic light, Samuel Palmer later remarked of a painting he conceived, inspired by Milton's *L'Allegro:*

> The other day I think the true 'vision' came of 'The Prospect'. It is a curious subject, for there seems no medium between a mappy Buckinghamshire treatment and a genial poetic swoon.[17]

Romantic artists preferred to explore the underlying forces of nature in relation to mankind, but this subjective view of nature in fact stimulated a more vital form of prospect painting, as painters climbed to high viewpoints to view distant horizons, to be inspired towards an infinite scale of thought. Indeed, the lone traveller confronting a mountainous prospect, discovering the 'vastness' Burke found characteristic of the sublime, is the archetypal image of Romantic painting.

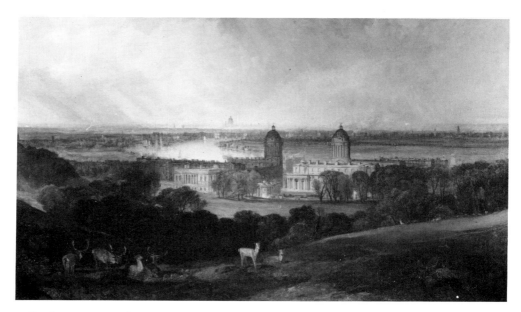

Fig. 6 J.M.W.
Turner *London*
1809, Tate Gallery

Such prospects also set a personal challenge to the Romantic artist, to his ability to capture them on canvas, or by any other means at his disposal. In 1781 the painter De Loutherbourg unveiled his Eidophusikon, a miniature theatre of moving pictures. Besides presenting the Miltonic spectacle of *Satan arraying his Troops on the Fiery Lake with the Raising of the Palace of Pandemonium* this also included an illusionistic *View of London from Greenwich Park* from dawn to dusk. John Martin painted extensive landscapes on Hampstead Heath and Richmond Hill, but also produced vast apocalyptic fantasies exhibited in dark, top-lit rooms, such as *The Great Day of his Wrath* (1852, Tate Gallery) showing Edinburgh tumbling upside down into the abyss, and *The Plains of Heaven* (1853, Tate Gallery). Mezzotints after his visionary prospects, characterized by a painstaking attention to architectural detail set in infinitely receding perspective, made Martin for a short time the best known English painter in Europe.[18]

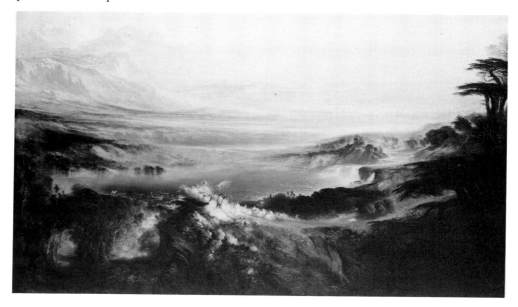

Fig. 7 John Martin
The Plains of Heaven
1853, Tate Gallery

Prospects recur throughout the work of J.M.W. Turner. His outstanding ambition made his oeuvre a confluence of all landscape painting traditions, as he combined the breadth and topographical accuracy of estate painters, military draughtsmen and antiquarian illustrators with the more imaginative ideal of Claude and the 'sublime' drama of the Romantics. He is closest to the eighteenth century fashion for prospect viewing in his paintings *London* (a view from Greenwich Hill; 1809, Tate Gallery), *England: Richmond Hill on the Prince Regent's Birthday* (1809, Tate Gallery) and *Petworth Park* (c. 1828, Tate Gallery). Turner goes beyond other Romantic painters, however, in his greater determination to capture the most fleeting effects of light. His sensitivity reflects his training as an antiquarian watercolourist of the atmospheric school, but his preoccupation with light and shadow as a subject unto itself sets him within a movement which to some artists made prospect compositions seem artificial and thus redundant.

In this way, naturalism, a quasi-scientific pursuit of visual truth, directed painters to analyse changing light, rather than record the known physical world. Oil sketches were the favoured medium, executed out of doors as fresh and direct as watercolours. Turner, for example, took a boat on the Thames near Twickenham from 1805-7 to sketch in oils and nearby three pupils of the watercolourist John Varley were sketching in oil on millboard: John Linnell (cat. 50,112) W.H. Hunt (cat. 51) and William Mulready. Their interest in sketching cottages, fallen fences and trees later took them to Hampstead Heath where an artistic colony grew up around Linnell at Wyldes Farm. As the effects of changing light could be found in the smallest corners of nature, this outlook represented the antithesis of prospect painting, and hence its potential demise. Nevertheless, while many artists preferred to study nature at first hand rather than from afar from prospect points, the three areas that concern this study maintained their importance into the nineteenth century, as artists in pursuit of nature still came to Twickenham, Hampstead Heath and Blackheath to paint in the open air. Consequently the Thames Valley became as important to the development of naturalism in this country as the Fontainebleau Forest was to artists of the Barbizon School in France.

Prospect painting and naturalism were not, in fact, incompatible, as many landscape painters found the more ambitious, time-honoured views irresistible, and painted them afresh. Peter De Wint, for example, a fellow member of Varley's circle, best known for his work as a watercolourist, particularly for publishers (cat. 57,68) turned the celebrated prospect from Greenwich Hill into a sea of sun and foliage in an oil sketch now in the Victoria and Albert Museum. Thomas Hofland, who claimed to be "the first who commenced painting in oil colours out of doors"[19], painted the view towards London across Hyde Vale from Blackheath (cat. 24).

When John Constable painted his first oil sketch of Hampstead Heath in 1819, showing Branch Hill Pond (cat. 110), he recorded a traditional 'prospect', admired from an avenue of trees known as Prospect Walk in the eighteenth century. Some of his earlier views of Suffolk are indebted to the Dutch and Flemish masters, and to Claude, in recording Dedham Vale from an elevated vantage point with the foreground falling away. For Constable and his contemporaries, the seventeenth century masters Rubens, Ruisdael and Philips Koninck presented a vital alternative northern tradition to the prosaic one of the topographers; their paintings of the countryside of Holland and Flanders contained the same sympathy for atmosphere, changed by the weather and seasons, that Constable and his contemporaries sought in their oil sketches, only here it was combined with the grandeur of extensive landscape.

Constable's exhibition paintings remind us that for English artists, unlike the Impressionists later, public ambitions made oil sketches inadequate as an end in themselves; the need to compose such studies into works conceived on a grander scale kept the 'prospect' tradition alive. Light, however, remained the true subject of naturalism, and where topographical elements such as houses were included they provided visual landmarks, precisely placed to enhance the overall composition, rather than subjects of associative interest in their own right.

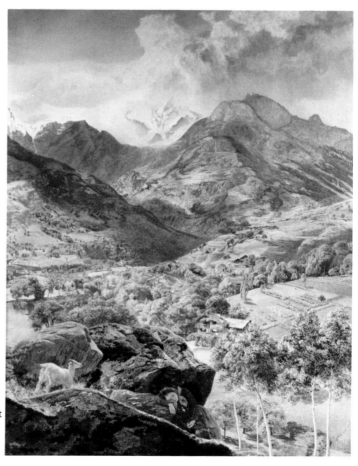

Fig. 8 John Brett
The Val d'Aosta
1858, Sir Frank
Cooper, Bt.

Pre-Raphaelite landscape painters worked with similar ambitions, and could also find inspiration in traditional prospects. For example, Ford Madox Brown's *English Autumn Afternoon* (cat. 119) records a view admired from a 'mount' in Hampstead High Street in the previous century, before the house in which the artist had lodgings was built. Madox Brown even added an imaginary 'prospect point' to create a foreground, complete with a white bench and a young couple admiring the view. The attention to local topography in his panoramic view of Hampstead Heath is so intense that it is almost difficult to recognise the artist's aims as being closer to those of Constable than of Siberechts. Madox Brown's precision may have been motivated by the need to record an endangered prospect, then under threat from the march of London's bricks and mortar. A Pre-Raphaelite follower, John Brett, produced what is probably the most ambitious prospect painting in British art, *The Val d'Aosta* (1858, private collection). At first John Ruskin saw it as the realization of ideals which

had originally inspired the Pre-Raphaelites, for here was a faithful study of an alpine valley in every detail, a comprehensive analysis not only of light, but of local topography, geography and ecology. But ultimately Ruskin echoed Fuseli's attitude (quoted earlier) in realizing the dangers of attempting 'truth to nature' on a grand scale, for 'it is Mirror's work, not Man's'.[20]

Clearly then, prospect painting was not simply a seventeenth century phenomenon, as it is so often presented, of topographical portraits of seats and estates set in expansive landscapes, in contrast to 'pure' landscape painting which emerged in the eighteenth century. Nor is the recurrence through later centuries of British art of extensive views painted from elevated vantage points the result of the influence of the Flemish masters and Claude alone. Prospect painting survived, in modified forms, because it reflects a social activity, prospect viewing, one which appeals in such a variety of ways that landscape painters have always found it a source of employment and inspiration, whatever their particular approach to nature and art. What distinguishes prospect painting from landscape painting in general, apart from compositional characteristics, is the importance of its subjects as specific places, laden with landmarks familiar to thousands in the case of the three points in this exhibition. This forced artists not only to achieve a measure of topographical accuracy, but to evoke the character of the area as the public already knew it.

The problem today is to recognize that character as it originally appeared. To a large extent, the prints at the core of this exhibition, together with the books they came from, provide the key. While reflecting the same changes in artistic approach, their greater commitment to the commercial priorities of the market place makes them a more obvious record of the fashionable tastes of the past. Reading the texts that originally accompanied engravings in periodicals, tour books and county histories, we recognize the strength and emphasis of the public's associative interests in particular prospects, in the people who lived in the villas or visited the area in the past. Such interests could not have been avoided in painting a popular view, and would have been brought to works shown at public exhibitions. In this way, engravings from books complement paintings, in providing some means of appreciating the pictures as they were originally seen, with all the associations different generations found in the 'finest prospects'.

1. Chesterfield to Solomon Dayrolles, 19 June 1750; quoted in Dobrée, IV, p.1559
2. *The Spectator* VI, (No. 412) p.89 (1712); quoted in Manwaring, p.124
3. Defoe, I, Letter II, pp.125-6
4. *ibid.*
5. Quoted in Hyde, p.135
6. Thomas Noble, *Blackheath: a poem in five cantos* (London, 1808) p. viii
7. Barbara Hofland *Richmond and its Surrounding Scenery* (London, 1832) pp. 23-4; quoted in Gascoigne & Ditchburn, p.13
8. James Thomson, *Summer* (1727)
9. Quoted in D.S. MacColl 'Richmond Hill and Marble Hill' *Architectural Review*, X (1901) p.28
10. Quoted in Manwaring, p.55
11. Archibald Alison, *Essays upon the Nature and Principles of Taste* (1790) pp. 15-16
12. Quoted in Harris, 1979, p.42
13. See: Hyde, p.11
14. See: Harris, 1979, p.315
15. William T. Whitley, *Artists and their Friends in England 1700-1799* (London, 1928) II, p.106. See also: Hyde, pp. 128-149
16. J.H. Fuseli, *Lectures on Painting* (London, 1820) p.127
17. Quoted in Raymond Lister, *Samuel Palmer and 'The Ancients'*, exhibition catalogue, Fitzwilliam Museum, Cambridge, 1984 (61)
18. William Feaver *The Art of John Martin* (Oxford, 1975) pp. 6, 198-201. For earlier examples of 'visionary' prospects see the landscape paintings of Joachim Patenier (fl. 1515-1524)
19. Quoted in Gage, p. 40n22
20. Quoted in Allen Staley & Frederick Cummings, *Romantic Art in Britain*, exhibition catalogue, Detroit and Philadelphia, 1968, p.329

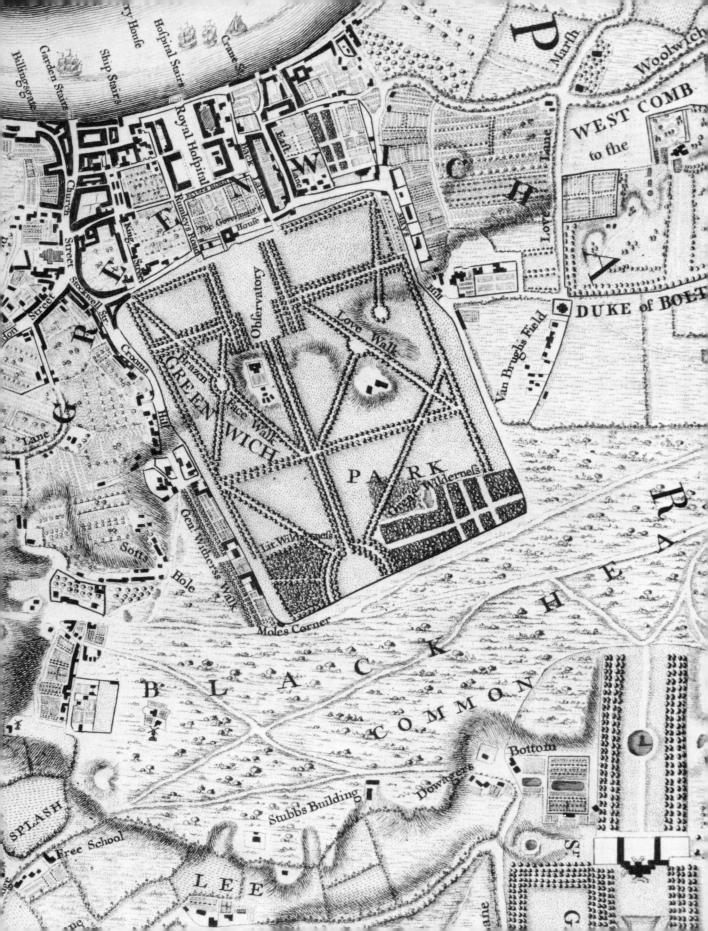

Ranger's House
The 'Babiole' by Greenwich Hill

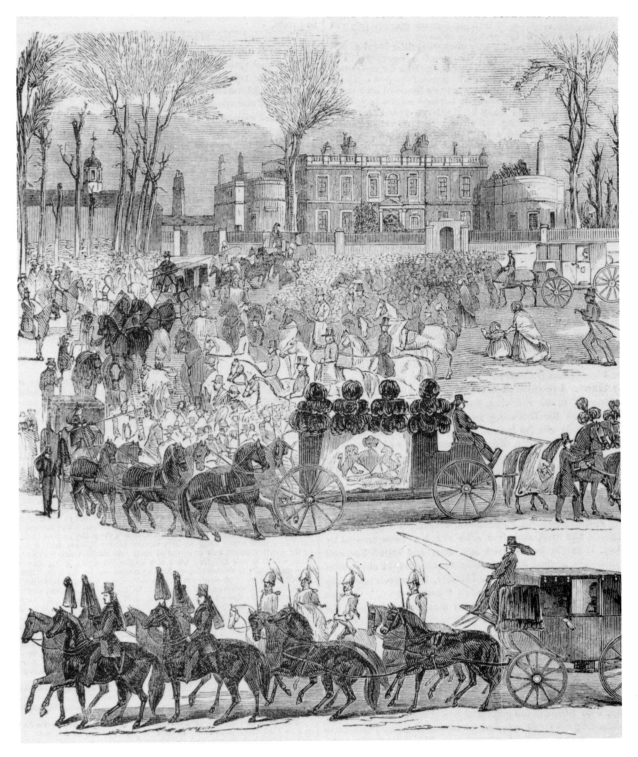

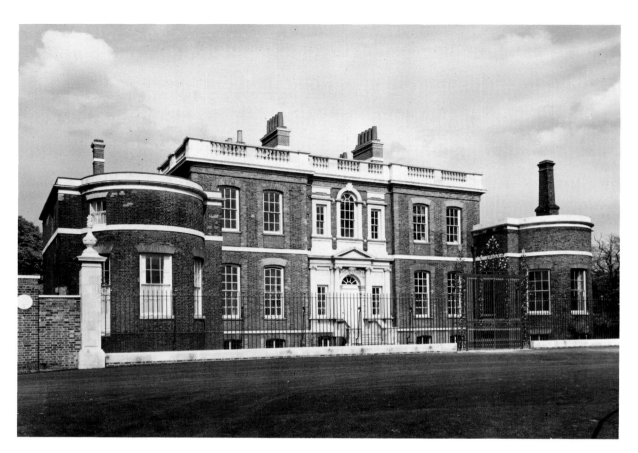

Fig. 11 (above)
Ranger's House,
from Blackheath
Fig. 12 (right) The
Gallery, Ranger's
House

Previous pages:
Fig. 9 (left) Jean
Rocque *Map of
London*, detail
showing Ranger's
House (outside the
west wall of
Greenwich Park)
1746
Fig. 10 (right) The
Pictorial Times *The
Funeral Procession of
Princess Sophia
leaving Ranger's
House* 1844,
Greenwich Local
History Library

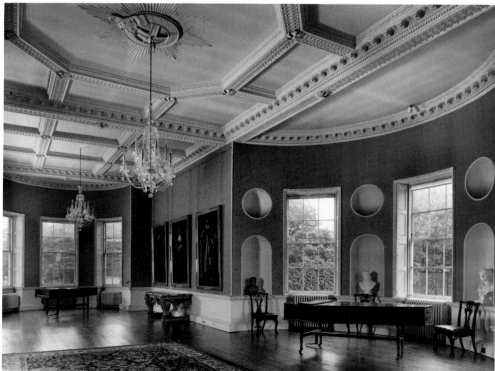

RANGER'S House stands aligned with the west wall of Greenwich Park, a rose garden on one side, Blackheath on the other. Many elegant villas fringe the two hundred and sixty-seven acres of flat heath which stretch from Lewisham to Woolwich, but to drivers leaving London today via the Dover road, Ranger's House on the left presents the first and most memorable landmark. Unlike Marble Hill and Kenwood, it cannot be identified with any one architect with certainty, neither has it sat for its portrait by artists such as Wilson and Wootton, nor has it been the subject of innumerable engravings. Nevertheless, it outshines them in at least one respect: in commanding not one, or two splendid views, but, as its most celebrated resident remarked in 1750: "three different, and the finest, prospects in the world".[1]

The prospect north from the top of Greenwich Hill, encompassing the park, Inigo Jones's Queen's House, Wren's Royal Hospital and the Thames with the City in the distance, holds as significant a place in the history of landscape painting as the prospects from Richmond Hill and Hampstead Heath. In fact, the relative quantity of seventeenth century paintings, drawings and prints gives it some historical primacy over its rivals for the artist's attention. However, the other prospects from Ranger's House to which Chesterfield referred, embracing the sweeping panorama of Blackheath from Crooms Hill in the north-west via Hyde Vale towards the village of Blackheath in the south, have inspired fewer paintings, while the views of the house itself which do survive are mostly taken from nineteenth century periodicals. To some extent this range of artistic interests reflects the changing fortunes of Greenwich and Blackheath, with which Ranger's House is inextricably mixed. As such it invites comparison with artists' responses to the prospects from London's other two leading suburbs, Hampstead and Richmond.

By the beginning of the eighteenth century the appeal which Greenwich had held for the fashionable nobility, since Henry VI made his palace here in 1447, had largely declined. This was largely due to the removal of the royal court to Kensington and Hampton Court under William and Mary. The building of the new Naval Hospital in place of the royal palace, combined with the attractions of the hill, ensured the continued use of the royal park which opened its gates to friends of the first pensioners in 1705. Judging from the well-dressed foreground figures in engravings after paintings by Tillemans and Rigaud, this restriction was not strictly enforced. Despite the park's popularity as a place of resort, as a residential area Greenwich at the beginning of the eighteenth century did not have quite the same attraction as Richmond, Twickenham, or Hampstead. Most prominent members of the community had specific local connections with shipping or the hospital; this was not the same kind of sylvan suburb of summer villas to which to retreat from business interests in the City or commitments at court in St. James's, Kensington, or Hampton Court. As Daniel Defoe observed in 1724:

> But the Beauty of *Greenwich* is owing to the Lustre of its Inhabitants, where there is a kind of Collection of Gentlemen, rather than Citizens, and of Persons of Quality and Fashion, different from most, if not all, the Villages in this Part of *England*. Here several of the most active and useful Gentlemen of the late Armies... are retired.... Several Generals, and several of the inferior Officers, I say, having thus chosen this calm Retreat, live here in as much Honour and Delight as this World can give. Other gentlemen still in Service, as in the Navy Ordnance Docks, Yards &c., as well while in Business, as after laying down their Employment, have here planted themselves.[2]

Ranger's House was built c. 1710 for Francis Hosier, later Vice Admiral of the White. Lord Chesterfield inherited the property from his brother in 1748 and would have sold it to live in Richmond or Twickenham, but for the fear of incurring a substantial loss. Most of the later residents had some local connections, whether as holders of the royal sinecure of Ranger of Greenwich Park (from which the house takes its present name) or military commitments in Woolwich. This difference in the area's appeal compared to that of Marble Hill and Kenwood must be appreciated if we are to understand not only the kind or residents attracted to Ranger's House, but the pictures the house and its prospects over Greenwich and Blackheath inspired.

The prospects towards London from Greenwich Hill, from 'The Point' on Blackheath and across Hyde Vale, are probably the oldest of the capital, and have a long history that goes beyond fashionable recreation. Since earliest times, Blackheath has been both a natural vantage point and an assembly ground for any force approaching London from the south coast. The beginnings of Greenwich as a community for the nobility dates from at least 1432, when Humphrey, Duke of Gloucester enclosed part of the heath to build a private palace close to the royal palace of Eltham. His watchtower at the top of the hill commanded views of the southern approaches to London by river and road. Margaret of Anjou, wife of Henry VI, confiscated Humphrey's palace in 1447 and Greenwich became the favourite summer residence of the Tudors with tournaments, deer hunting, masquerades and pageants. In 1613 James I settled the palace on his wife, Anne of Denmark who, finding it unmanageable, commissioned Inigo Jones to build The Queen's House as a summer residence. This classical villa, inspired by the designs of the Italian architect Andrea Palladio, is the direct ancestor of Lady Suffolk's Marble Hill, complete with its own cube room and river prospect. The building of any local imitators of the Palladian villa was, however, postponed by the fall of the monarchy and the occupation of Greenwich by Commonwealth forces, with whom the town at large was in sympathy. When the Roundheads made their valuation of the Royal Collection, more paintings were found of Greenwich than of anywhere else.[3] After the Restoration in 1660, Charles II reclaimed Greenwich. Impressed by Le Nôtre's work at Versailles, he commissioned the French designer to lay out the park in 1662, and in 1675 Charles II commissioned Christopher Wren to build the Royal Observatory. Following the Glorious Revolution of 1688, William and Mary chose to live at Hampton Court, to avoid the London air, and a new London palace was built at Kensington. From 1694 Wren continued the demolition of the Tudor palace to build in its place a Royal Naval Hospital, comparable to his Chelsea Hospital, for army pensioners, completed two years before. In 1690 the Queen's House was made the official residence of the Ranger of Greenwich Park.

This chequered history of the Crown's commitment to Greenwich helps to explain both the changing topographical appearance of the view from Greenwich Hill as recorded in paintings, and the residential character of the town by the time Ranger's House was built. But it is not the full story. In 1710, local residents appealed to the Crown for help to rebuild their parish church, which had collapsed in a storm.[4] In support of their request for charity, they claimed that over the past twenty years the wealthy had left the area, and their large houses had simply remained empty. Despite the gentlemen Defoe describes, there were no likely patrons to appeal to to commission a new church. According to their application, ninety per cent of the town was made up of the families of seamen, watermen and fishermen, and three thousand of these widows and children had lost their men at sea.

The conspicuous splendour of the new Royal Hospital cannot have helped the local poor, and probably ensured some exaggeration of statistics to secure their claim for charity. According to Daniel Lysons's *Environs of London*, by 1795 there were 2,350 pensioners, with a further 1,200 out-pensioners who "could not be received, for want of room, into the Hospital."[5] It is worth recalling the real purpose of the hospital when considering eighteenth century artists' treatment of the prospect from Greenwich Hill, and the fashionable society figures with which they fill their foregrounds.

Blackheath at the time Ranger's House was built was not a safe place, but the notorious haunt of highwaymen either on horseback or swinging from gibbets on nearby Shooters Hill. The present village dates from the end of the eighteenth century and appears as merely 'Dowager's Bottom', a well and cottages, on Rocque's map of 1746. The only notable exceptions to this lack of buildings around 1700 were Wricklemarsh, the home of Sir John Morden, and the substantial almshouse he built from 1695 for merchant seamen, Morden College.

The precise date when Ranger's House was built, c. 1710, remains uncertain, but it was one of several new houses built at this time on wasteland running south along the outside of the west wall of Greenwich Park from the crest of Crooms Hill. This hill had been favoured by court servants since the sixteenth century, not simply for the views it afforded of the Thames and its proximity to the palace, but more specifically because the Crown assigned building plots to court servants here. The prospects guaranteed the street's continuing appeal to local wealth. In 1652 John Evelyn wrote of a visit to Crooms Hill "Went to see the wretched house of Dr. Mason, so famous for its prospect"[6] and in 1665 Samuel Pepys described the nearby home of Mark Cottle as "a very pretty house with fine turret at top, with winding stairs, and the finest prospect I know about all Greenwich, save the top of the hill".[7]

Pepys also visisted The Grange, built after 1665 by Sir William Hooker, Sheriff of London during the Plague. He admired the gazebo overlooking the park wall, but considered Hooker to be "A plain, ordinary, silly man I think he is, but rich" who "kept the poorest mean dirty table in a dirty house that I ever did see".[8] From 1675 Hooker built three houses illegally at the top of the hill on Crown land, and then a further nine at the foot of the hill on land previously reserved for archery, again without bothering to obtain a lease. Among the later houses on this encroachment, Hillside, which incorporated one of Hooker's properties, belonged to John James, the architect who built the parishioners' new church of St. Alphege with Hawksmoor, before being appointed joint clerk of works (with Vanbrugh) of Greenwich Hospital. James also built the adjacent Park Hall. According to a newspaper advertisement for the house which appeared in 1730, "Both house and garden have a full prospect of the river Thames, and many miles about the cities of London and Westminster".[9]

Another neighbour to the present Ranger's House on Crooms Hill which helps to characterise the local residents is The Manor House, built in 1697 by Rear Admiral Sir Robert Robinson, Governor of Bermuda, later Lieutenant Governor of Greenwich Hospital (cat. 23)

Three houses on the level ground at the top of Crooms Hill were built illegally on 'The Waste' by Andrew Snape (d. 1689), Sergeant Farrier at the Restoration court of Charles II, and a speculator Evelyn considered to be "full of projects".[10] Snapes's houses existed by 1676, when the Manor Court threatened to demolish them unless

compensation was paid to the poor of Greenwich, which Snape duly agreed to do. Such speculative building coincides in date with both Hooker's development of Crooms Hill and the building of the Royal Observatory, and may well have been pursued in anticipation of the re-establishment of the Court at Greenwich Palace by Charles II. Any such hopes were disappointed, but Snape was not the only courtier to remain. In the grounds of one of his villas, Montagu House was built from 1701-2 as the home of Ralph, Earl of Montagu who had been made an earl in 1689 in recognition of his contribution to the Glorious Revolution of the previous year (cat. 14).

Ranger's House has traditionally been identified with one of Snape's three villas, at least in its foundations. However, the minutes of the Greenwich Vestry meeting of 2 September 1739 refer to the building as 'the house built by the late Admiral Hosier', and it has recently been suggested that the earlier vaulted basement in fact belonged to one of the outbuildings of one of these villas, now part of Macartney House, which still stands.[11] Rate books reveal that Hosier owned a property here by 1700.

Francis Hosier (1673-1727) was born locally in Deptford, the son of a naval storekeeper and rose to become Vice Admiral of the White. He seems to have been typical of the professional seamen who chose to live in the larger houses in Greenwich. Hosier must have found the house above Greenwich ideal for access to the dockyards and for viewing ships arriving up the Thames. The entrance to the house boasts a keystone mask of Neptune which reminds us of the early connection between the house and the sea. This may well date from Hosier's time, as it recalls the name of the ship he served on as a young lieutenant and that of another, to which he owed his substantial income from trade. He was also a shareholder in the South Sea Company. Hosier cannot have been resident for any great length of time as he pursued an active naval career, and did not retire, but died in action in Jamaica. The circumstances of his death became the subject of a ballad, 'Admiral Hosier's Ghost', published in 1739.

According to some sources the house passed to Hosier's nephew in 1727, while others say he bequeathed it to the Rt. Hon. Earl of Berkeley, Lord Commissioner of the Admiralty. By 1741 the building was occupied by John Stanhope, the younger brother of Philip, 4th Earl of Chesterfield (1694-1773), who inherited the house in 1748, complaining "I am obliged to keep that place for seven years, my poor brother's lease being for that time; and I doubt I could not part with it, but to a very great loss, considering the sums of money that he had laid out upon it. For otherwise I own that I like the country up, much better than down, the river".[12] Despite this preference to live up-river, presumably at Richmond or Twickenham, Chesterfield's initial reluctance was overcome, and an extension of the lease was obtained.

Chesterfield is best known today for the *Letters* he wrote to his illegitimate son, published by his son's widow in 1774. Full of advice on etiquette, deportment, finesse and schemes for success in life, they proved to be far more than just the worldly wisdom of an ambitious father, becoming almost as essential to a young gentleman's education as the 'Grand Tour' of Rome, Florence and Naples. Within two years they had been translated into French and German. The *Letters*, however, damaged Chesterfield's reputation. Dr. Johnson claimed they taught "the morals of a whore and the manners of a dancing master"[13] and Cowper considered their author to be a "polish'd and high-finish'd foe to Truth" and thus a "corrupter of our listening youth".[14] They were, of course, not intended for publication but for an illegitimate son, expected to make his own fortune in the complex world of eighteenth century

fashion and politics without the advantage of an inherited title. However, to Victorian readers the letters underlined the apparent hypocrisy in Chesterfield's personal and public life, by stressing social manners before morals. He was parodied by Charles Dickens in *Barnaby Rudge* (1841) as Lord Chester, guilty of marrying for fortune rather than love, and maintaining a polished veneer to society. Chesterfield's indifference towards Dr. Johnson's scheme for his Dictionary (the *Plan* of which was addressed to Chesterfield as a potential patron) led to Johnson's famous letter; his reputation was further harmed by Boswell's later account of the matter. Johnson's initial approach does, however, also testify to Chesterfield's pre-eminent position as a man of learning.[15]

Chesterfield's own attitude to the house was almost totally reversed after his initial sense of burden and displacement. But the adoption of Greenwich and Blackheath by this statesman and man of letters, with no nautical interests or involvement with the new hospital, was a gradual process, and one that is fascinating to plot today. Some idea of Chesterfield's personality is necessary to appreciate his dilemma. As a courtier he had known Mrs Howard, later Countess of Suffolk (for whom Marble Hill was built 1724-9) since 1715 when he was appointed a gentleman of the bedchamber to the Prince of Wales and she was a woman of the bedchamber to the Princess of Wales. They also had mutual friends in Pope, Gay and Arbuthnot. He maintained his correspondence with Mrs Howard, who became George II's mistress, while serving as ambassador to The Hague from 1728 to 1732. However, Chesterfield's marriage to the Countess of Walsingham, illegitimate daughter of George I, offended George II and he was dismissed from court in 1733. The following year, Mrs Howard, now Lady Suffolk, returned to private life, having been mistress of George II. Chesterfield's relations with the Crown further deteriorated when he threatened a lawsuit to recover the legacy George I had bequeathed to his wife's mother, and received an out-of-court settlement of £20,000. Chesterfield also contributed to the fall of Sir Robert Walpole, by becoming the acknowledged leader of the Opposition in the House of Lords.

In 1748, the year he inherited his brother's house at Blackheath, Chesterfield resigned as a Secretary of State and began to withdraw from politics in favour of architecture. The following year he built Chesterfield House in South Audley Street (demolished 1934) with the leading Palladian architect, Isaac Ware, and pioneered the current French taste in interior decoration in one of the earliest rooms in the rococo style in England. In his library a Latin inscription running below the cornice echoed the outlook of Pope's circle at Twickenham; as Chesterfield told his son that it indicated the life he intended to lead henceforth, it suggests the way he wanted to look upon his new house at Blackheath. Taken from Horace's *Satires* Book II, Satire VI, (which describes the peaceful comforts of the poet's Sabine farm in contrast to life in Rome) it ran: *"Now with books of the ancients, now with sleep and idle hours, to quaff sweet forgetfulness of life's cares"*.[16]

Apart from its location, one reason for Chesterfield's lack of enthusiasm at his inheritance may have been its modest size. As he wrote to his friend the Marquise de Monconseil, chatelaine of La Bagatelle near Paris, on 8 July 1749, after considering a name for his new house:

Je suis actuellement, pour me rétablir à une très petite maison, que j'ai à cinq petites milles de Londres, et que j'aurais appellé *Bagatelle* si ce n'eût été par respect la vôtre; mais que j'appele *Babiole* pour en marquer la subordination.[17]

The relative lack of land also contributed to his initial reluctance to retain the house. Unlike Marble Hill and Kenwood, the 'Babiole' had no farmland or extensive garden in which to act out the Horatian ideal of rural retirement, sandwiched as it was between 'General Withers's Walk' (as marked on Rocque's map of 1746) and the park wall. His awareness of the limited potential for gardening is apparent from a letter of 1748 in which he remarks: "The Canteloupes are, in my opinion, the best sort of melons: at least they always succeed best here. It is for Blackheath that I want it, where you can easily judge that my melon ground is most exceedingly small".[18] Nevertheless, he did succeed in growing melons, pineapples and grapes, as he came to realize that: "my acre of ground here affords me more pleasure than kingdoms do to kings; for my object is not to extend, but to enrich it".[19] By April 1753 Chesterfield was able to write: "I am now, for the first time in my life, impatient for summer, that I may go and hide myself at Blackheath and converse with my vegetables".[20]

The idea of concealing himself at Blackheath goes beyond the customary ideal of retreat from the City and West End, and underlines the relative isolation of the area from the preferred centres of fashionable society. Indeed, such isolation may have become the location's principal virtue in his eyes. Chesterfield's impatience to talk to his vegetables for the first time becomes less of a misanthropic whim when one realises that he went deaf the previous year. In the following year, 1754, the 'Babiole' had become "my hermitage", and when a mutual friend asked after Lord Tyrawley, resident on the opposite side of the park at Vanbrugh Castle, he replied "Tyrawley and I have been dead these two years but we do not choose to have it known."[21]

Given the limited potential of the land for expansion and the relatively modest scale of the building, it is not surprising that Chesterfield chose to make the most of the one undeniable attraction of the house: the exceptional views it afforded over Greenwich Park and Blackheath. As he wrote to the Marquise de Monconseil, with some exaggeration:

> Babiole est située dans un des parcs du Roi, à cent pas de la Tamise, ou l'on voit tout les jours une cinquantaine de gros vaisseaux marchands, et quelques vaisseaux de guerre, qui vent et qui viennent.[22]

Chesterfield made the most of this prospect by building a gallery, seventy-seven feet long, stretching the full depth of the house on the southern side, with an eastern bay window encroaching over the site of the park wall, for which he leased a plot of land from the Crown. Isaac Ware was probably the chosen architect, as work proceeded simultaneously with the building of Chesterfield House in Mayfair on which Ware was employed. On 19 June 1750 Chesterfield wrote with considerable satisfaction:

> I am very much *par voies et chemin* between London and Blackheath, but much more at the latter, which is now in great beauty. The shell of my gallery is finished, which, by three bow-windows, gives me three different, and the finest, prospects in the world.[23]

At least one of these prospects attracted admiration. As Dr. Richard Pococke wrote after visiting the 'Babiole' in 1754: "His Lordship has a house at the Park wall, to which he has built a fine room about 77 feet long and twenty-two broad, with a large bow-window at each end and one in the middle; that towards London commands a fine view of the city".[24] Unfortunately, no picture of the view is known to have been commissioned by Chesterfield, and none featured in the auction of contents held by

Christie from 29 April 1782 prior to the sale of the house by Chesterfield's heir in 1783.

By the time of Chesterfield's death in 1773, his house was sufficiently well known to feature in a poem of the same year by Robert Hill, which pointed it out as a local landmark, in a way that recalls attitudes to Pope's villa in Twickenham:

Here Chesterfield once held his noble Reign.
Here, where he liv'd, he fixt his wide Domain

. . .

Thee, Greenwich, thee! he grac'd, thy Park refin'd
Be his the Praise who there the Muses join'd[25]

Hill was writing for the more genteel visitors to the park, attracted in part by the continued building of the hospital. Vanbrugh's King William building was completed in 1728, James Stuart finished the south front in 1796, the pavilions were completed in 1778, and Yenn's west front was not built until 1811-14. Such architectural activity added to the appeal of parading through Le Nôtre's landscaped park and ascending to the Royal Observatory and One Tree Hill to enjoy the prospect of London. The observatory provided a further point of interest on such perambulations. Edmund Halley succeeded Flamsteed (cat. 7) in 1720 and a 'New Observatory' was built in 1749 for his successor James Bradley, to house instruments acquired through the patronage of George II. From here it was but a short walk to Chesterfield House, as it became known, clearly visible along the park wall with its gallery stretching into the lawns, as notable when Robert Hill wrote as it remains today.

A further major attraction for fashionable society was the Queen's House. The publication of Colen Campbell's *Vitruvius Britannicus* from 1715 (cat. 39) and of Ware's edition of Palladio's *Four Books of Architecture* in 1738 publicized the movement and must have brought a new generation of admirers to the Queen's House as England's first Palladian villa. From 1690 this served as the Ranger's house, part of a royal sinecure created by Henry VII in 1486. Lady Catherine Pelham held the post of Ranger from 1743 until her death in 1780, a period that marks the high point in the area's recovery.

The uncertainty of the area's appeal to fashionable society is revealed by the ill-fortunes of the Queen's House from 1780. A report to the Surveyor General of Crown Lands of 1792 complained that, as the post of Ranger had remained unfilled, the housekeeper and her husband "make a Hog stye of the House...converting everything to their own use" and selling milk and poultry. Finding the Queen's House "most convenient for smugglers, Wilkinson the tavern keeper... Yates the Gardener, and Cooper... were connected and carried on a very profitable smuggling trade". By the following year, 1793, the gardener was rich enough to pay £1600 for a public house adjoining the garden of the Queen's House and "by converting the Garden to the use of his Tavern makes £100 per annum by it, without being of the smallest service to the Park". A deputy responsible to the Office of Woods and Forests for supervising the park was "a drunken swab... fitter for the Navy than the Park" and an under-keeper responsible to the Surveyor General of Crown Lands was "too much at Public Houses" and too "often in liquor". By 1792 the park had become "an Asylum for the Riotous and a Receptacle for Whores and Rogues", in short, "a seminary of vice" full of "loose women and disorderly men,... sailors...watermen and fishermen... with their prostitutes" with the pensioners taking "all the Benches to play at cards upon".[26]

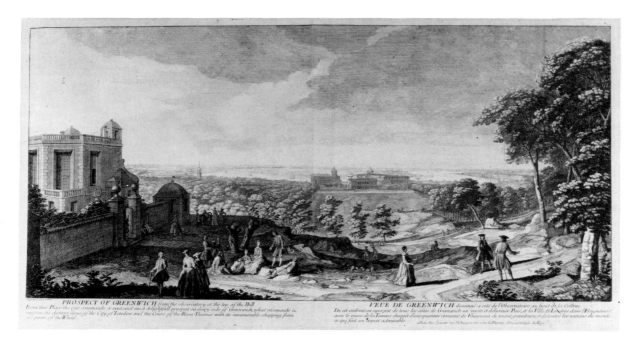

Fig. 13 Jean
Rigaud *Prospect of
Greenwich* c. 1730,
Guildhall Library

Such contemporary accounts of the park are worth recalling when admiring the
view from Greenwich Hill in paintings and engravings, with their groups of elegant
society figures at leisure, like the staffage in a *fête galante* by Watteau. Pensioners in
their three-cornered hats were not always as picturesque as they appear in such
views. The 'finest prospect' from Chesterfield House towards London cannot have
been quite the uninterrupted vista that Chesterfield and later residents might have
wished.

The first man to choose to live at Chesterfield's house for over half a century was
Richard Hulse (1727-1805). His local commitments as High Sheriff of Kent from
1768 and maritime interests that led to his appointment as Deputy Governor of the
Hudson Bay Company in 1799, suggest that his attitude to the house was more akin
to that of Hosier than of Chesterfield. Hulse formed a substantial collection of paint-
ings, including Richard Wilson's *Rome from the Ponte Mola,*[27] but the catalogue to the
two-day sale held by Christie from 21 March 1806 does not contain any identified
'prospects' of London, Greenwich or Blackheath. His chief contribution to the house
was the addition of the north wing to balance the gallery.

In 1807 Augusta, Dowager Duchess of Brunswick (1737-1813) took up residence
and henceforth the building became known as 'Brunswick House'. She too had a
specific local reason for living here, as her daughter Caroline, Princess of Wales, lived
next door. Formally estranged from the future George IV since 1796, Caroline had
been appointed to the vacant position of Ranger of Greenwich Park by her uncle
George III in 1806. Due to the sorry state of repair of the Queen's House, it was sold
to the Royal Naval Asylum in 1806 and a new Ranger's official residence was estab-
lished at Montagu House, immediately south of Chesterfield House.

Caroline had been living at Montagu House since 1799 as tenant of the Duchess
of Buccleuch in order to be near to her own daughter, who lived with her governess
on Shooters Hill. Caroline redecorated Montagu House and entertained the prom-
inent local residents on a scale sufficiently extravagant to bring complaints from her
estranged husband. Here she established a rival Regency 'court' which, with fre-

quent visits from George III, represented a royal presence not seen in the area since the seventeenth century, although her notoriously reckless behaviour, including horse-play with male visitors, finally necessitated an official Commission of Enquiry. One cannot help wondering just how watchful an eye the Duchess of Brunswick kept on her daughter's nefarious conduct from the bow windows of 'Brunswick House'.

Augusta died in 1813 and the following year Caroline left England with the encouragement of a Government allowance. The Duke of Clarence, afterwards William IV, was then Ranger. In 1815 the Crown surveyors reported Montagu House to be too expensive to maintain and recommended that it should be demolished to enlarge the grounds of Brunswick House as part of the new Ranger's House. The recommendation was approved and the Crown acquired the house, the site of Montagu House remaining vacant to this day. The demolition of Montagu House is popularly seen as an act of spite by the Prince Regent to prevent Caroline from returning to England.

In 1815 the royal associations of the house were strengthened by the appointment of another niece of George III as Ranger, Princess Sophia Matilda (1773-1844) daughter of the Duke of Gloucester. Various modifications were made to make it fit for a princess, including the construction of a covered way to the entrance and the division of Chesterfield's gallery into three rooms. In contrast to the society parties and indiscretions of Princess Caroline, Princess Sophia was a:

Meek Spirit of as noble charity
As ever grac'd the hand of royalty,[28]

noted chiefly for being "a kind and liberal benefactor to the poor of the town and its vicinity".[29]

Following the death of Princess Sophia, Ranger's House featured in the popular press on 14 December 1844. The "Royal corpse" lay in state in the dining room and the public filed through a house "hung with black cloth, and illuminated with wax lights, daylight being completely excluded". The departure of the funeral procession for Windsor inspired several illustrations in which the house appeared in the background (fig. 10). This may have been partly out of necessity rather than simply interest in the house itself, as the procession concluded at the less picturesque "Paddington terminus of the Great Western Railway" where the coffin was loaded aboard a "special train to Slough".[30]

This royal presence and the survival of Blackheath amid the expansion of London enhanced its appeal in the nineteenth century. Thomas Noble dedicated *Blackheath – A poem in 5 cantos* (1808) to Princess Caroline and in the introduction he described the variety of human activity to be admired from the heath's high vantage points. He found himself looking upon a microcosm of man, at once urban, maritime, and rural, fulfilled and at harmony with both mankind and nature:

Where will you find prospects more extensive, that at the same time abound with the like grandeur of luxurious cultivation? Behold the magnificence of a mighty city so intimately united with rural cottages of the surrounding labourers of agriculture! Your eye seizes at a glance... the riches of human society and manufactories; also the majestic vessels of the whole earth.[31]

Such published praises enhanced Blackheath's appeal to a wider public. A similar account can be found in *The General Ambulator and Pocket Companion for the tour of the Metropolis and its Vicinity* (1820) where Blackheath is described "commanding some

noble prospects, particularly from that part called 'The Point', which is a delightful lawn, situated behind a pleasant grove".[32] This survives at the north western corner of the heath by Blackheath Hill, and was the subject of published views (cat. 9). James Thorne's *Environs of London* (1870) also recommended The Point from which "there are extensive prospects: but the views are inferior to those from Greenwich Park". Thorne further observed "of the mansions, the first place may be given to the *Ranger's Lodge*".[33]

Far more people were able to enjoy London's prospects in the nineteenth century, particularly factory workers and shop assistants travelling from London's East End by rail. In 1838, the year the railway was brought from London to Greenwich, an estimated 200,000 people attended the local fair; this increased following the opening of Blackheath station in 1849. In 1866 the Metropolitan Commons Act helped secure London's commons. Blackheath was saved in 1871 following the extensive disfigurement of its surface by gravel digging, and in 1872 the fair was suppressed by order of the Home Secretary. As Thorne observed in 1876: "During the summer the heath is greatly resorted to by holiday-makers, but, under the new bye-laws of the Board, they are no longer the noisy nuisance they – or rather, the donkey-drivers, gipseys, and cock-shy men – sometimes used to be".[34] Blackheath was one of the first commons to be taken over by the Metropolitan Board of Works; its acquisition came in the same year as the saving of Hampstead Heath from speculative builders, and predated the preservation of the view from Richmond Hill by the same authority and its successor, the London County Council.

Four years after the death of Princess Sophia the house passed with the position of Ranger to Lord Haddo, who became George, 4th Earl of Aberdeen (Prime Minister 1852-55). He installed his son and his family at the house and only visited at weekends. Prince Arthur, Duke of Connaught, third son of Queen Victoria and godson of the Duke of Wellington, had the use of the house from 1862-73, from the ages of 12 to 22, years which spanned his period of studies at the Royal Military Academy in Woolwich and military service in Canada. After the residence of the Countess of Mayo from 1877-1888 the military connections continued with Field Marshal Viscount Wolseley in occupation. It is hard to imagine a greater contrast with Chesterfield than this professional soldier, best known for his expedition to relieve General Gordon at the seige of Khartoum. Like Aberdeen, Wolseley was frequently absent.

The house was vacant from 1896 and in the following year Queen Victoria presented it to the Commissioners of Woods and Forests in exchange for the restoration of Kensington Palace. The lease was then sold to the London County Council for the house to be a public tea room serving Blackheath, the sale being completed in 1902, the same year as the L.C.C. acquired Marble Hill.

Public interest in Ranger's House and the prospects it commands can be measured over the centuries by the number of paintings, prints, and drawings produced. Very few views of the house itself are known, but the adjacent prospects, from Greenwich Hill and One Tree Hill, have been recorded by most of this country's leading landscape painters. Court patronage from the royal palace at Greenwich accounts for the earliest views of London, painted from the park from the end of the sixteenth century.[35] Seventeenth century views include Hollar's long engraving of Greenwich of 1637 and oil paintings attributed to Vorstermans (cat. 4) and Danckerts (cat. 3) of which several versions are known. These look upstream and concentrate on the topography of old Greenwich with the skyline of London beyond, the Queen's House providing the point of focus and 'Humphrey's Tower' on Greenwich Hill

often closing the prospect on the left. In the eighteenth century the prospect from Greenwich Hill, south of Ranger's House, was particularly popular, partly due to interest in the Royal Observatory from fashionable visitors to the park. Their presence effectively made Greenwich an English counterpart to the elegant gardens around Paris in which Watteau set his *fêtes galantes* and something of the influence of the French painter can be found in engravings after the more picturesque views painted by Rigaud and Tillemans. The prospect of London was also a suitable backdrop for portraits, such as John Feary's *Conversation Piece with a View of Greenwich* of 1779. At the end of the eighteenth and beginning of the nineteenth centuries watercolour painters including Thomas Hearne, J.R. Cozens and Peter De Wint sketched the view from Greenwich Hill. Some were commissioned by publishers. Joseph Farington, for example, recorded the prospect in his set of views for Boydell's *History of the Thames* (cat 10.). The nineteenth century also saw an increase in the number of large 'exhibition' oil paintings of the prospect, as the scale of the scene, together with its time-honoured status, made it an irresistable challenge to ambitious landscape painters, most notably J.M.W. Turner. For Turner, whose *London* (fig. 6) was exhibited in his own gallery in 1809, the same year as his enormous painting of the rural prospect from Richmond Hill (cat. 67) the prospect of London from above Greenwich presented beauty obscured by commerce:

Where burthen'd Thames reflects the crowded sail,
Commercial care and busy toil prevail,
Whose murky veil, aspiring to the skies,
Obscures thy beauty, and thy form denies,
Save where thy spires pierce the doubtful air,
As gleams of hope amidst a world of care.[36]

Blackheath appealed to artists as a more rugged terrain, in contrast to the gently rolling lawns and fine architecture of Greenwich Park. It appears as wild country visited by sportsmen in a drawing by Jan Wijck of 1666 (British Museum), in which London is seen from nearer to Woolwich than Greenwich.[37] In Francis Place's plates from Flamsteed"s *Historiae Coelestis* Blackheath is a featureless extensive plain (cat. 7). It took the spectacle of a fine military review to prompt the well-known engraving *His Majesty Reviewing his Troops on Black Heath* after Mason of 1787. Paul Sandby sketched troops stationed on the heath during the Gordon Riots of 1780 and published a set of aquatints showing the military encampments here and at Hyde Park, St. James's Park and the Museum Gardens. Sandby did not have to travel far, as from 1768 he was Chief Drawing Master at the Royal Military College, Woolwich, and had lodgings in Old Charlton, while maintaining his home in Bayswater. He also sketched and engraved views of Montagu House (cat. 17) conspicuous at the southwest corner of the park wall with its gazebo and tower. Other views along the outside of the park wall were sketched by Jonathan Skelton and James Miller, including Vanbrugh's Castle and Mince Pie House, but none of Ranger's House have yet been located. Watercolours by Skelton and Alexander Cozens also present a very different Blackheath, the fresh sandpits providing their principal point of interest.[38] Nineteenth century oil paintings by James Holland (cat. 25), William Mulready, De Wint, Thomas Hofland (cat. 24) and E.J. Niemann reveal a similar interest in the heath itself, prompted by the pursuit of naturalism, in contrast to E.W. Cooke's polished topographical watercolours and oils of windmills on Blackheath. Although there was no artists' 'colony' at Blackheath to compare with Wyldes Farm on

Hampstead Heath, resident artists included James Holland, John Gilbert and R.W. Lucas. Two of the greatest British collectors, John Julius Angerstein and John Sheepshanks, also lived at Blackheath, the former attracting Henry Fuseli, Benjamin West and Thomas Lawrence to view and offer advice on a collection that became the nucleus of the National Gallery.[39]

Thomas Hofland's painting of the prospect of London over Hyde Vale now hangs at Ranger's House (cat. 24). Although he exhibited landscapes painted from One Tree Hill in Greenwich Park at the Royal Academy (1823) and British Institution (1824, 1833), this painting was not shown at either gallery, which may indicate the lesser appeal of this view. But more significant is the painting's recent reidentification, having long been considered to be a view of London from Hampstead Heath. This may indicate the fate of several paintings, and hence of a lost field of British landscape painting, waiting to be rediscovered.

Of the estimated two million people who climb to the top of Greenwich Hill each year to admire the view, many continue south beyond the Observatory to visit Ranger's House. The 'prospects' it commands are today less extensive, due to the growth of trees and spread of buildings. But some idea of the original attraction of the location can be gained from artists' impressions, and from writers' attempts to capture the panoramas in poetry and prose, particularly in tour books. One of the more vivid of these can be found in *The General Ambulator* of 1820:

> the views from the Observatory, and the One-tree Hill are beautiful beyond imagination, particularly the former. The projection of these hills is so bold, that you do not look down upon a gradually falling slope or flat inclosures, but at once upon the tops of branching trees, which grow in knots and clumps out of deep hollows and imbrowning dells. The cattle feeding on the lawns, which appear in breaks among them, seem moving in a region of fairy land. A thousand natural openings among the branches of the trees break upon little picturesque views of the swelling surf, which, when illumined by the sun, have an effect pleasing beyond the power of fancy to exhibit.... The eye then on all sides glances over a prodigious expanse, fields, villages, and spires innumerable.... bounded in the distance by the steep acclivities of Hampstead and Highgate.... In the middle of the picture, surrounded by a denser atmosphere, and stretched out in all its immensity and grandeur, is the huge Capital itself, apparently hemmed in by a forest of masts, and terminated by the mist of the indistinct country on the other side, glittering with the numberless gilded fanes of its churches; and glorying in the sublime circumference of its majestic cathedral,

"The pomp of Kings, the shepherd's humbler pride!"[40]

1. Chesterfield to Solomon Dayrolles, 19 June 1750; quoted in Dobrée, IV, p.1559
2. Defoe, I, Letter II p.3
3. Harris, 1979, p.11
4. June Burkitt, 'Greenwich at the end of the 17th Century' *Transactions of the Greenwich and Lewisham Antiquarian Society*, VIII, 6, (1978) pp. 223-233. See also: Platts, 1973, pp.196-8.
5. Daniel Lysons, *The Environs of London* (London, 1796) I, pt.II. p.446.
6. Quoted in Beryl Platts, 'The Oldest Road in London? Crooms Hill, Greenwich-I', *Country Life*, CXL (1966), p.1263
7. *ibid*, p.1264
8. *ibid*
9. Quoted in Frank Kelsall, 'Hillside and Park Hall, Crooms Hill, Greenwich' *Transactions of the Greenwich and Lewisham Antiquarian Society* VIII, 6, (1978) p.213
10. Quoted in J.M. Brereton, 'For a Horseman's Library' *Country Life*, CVII (1950) p.301.
11. Neil Rhind kindly made this suggestion

12. Dobrée, IV, p.1282
13. Dobrée, I, p.167
14. Quoted in Austin Dobson, *Eighteenth Century Vignettes* (London, 1892) p.148
15. For a discussion of E.M. Ward's painting *Dr. Johnson in Lord Chesterfield's Ante-Room* (1845, Tate Gallery) see: Kenneth Bendiner, *An Introduction to Victorian Painting* (New Haven & London, 1985) pp.27-31
16. Quoted in *Country Life*, CLXX, (1981) pp.1562-3
17. Quoted in *Country Life*, CXLI (1967) p.295
18. Dobrée, IV, p.1282
19. Dobrée, IV, p.1750
20. Dobrée, V, p.2015
21. Quoted in Beryl Platts, 'The Villas on the Waste. Crooms Hill, Greenwich-II' *Country Life*, CXL (1966) pp.1378-1380
22. Quoted in Platts, 1973, p.211
23. Dobrée, IV, p.1559
24. J.J. Cartwright, ed. *The Travels through England of Dr. Richard Pococke... during 1750, 1751 and later years* (London, 1888, 1889), II, p.67
25. Robert Hill, *Greenwich Park, A Poem in Imitation of Mr. Pope's Windsor Forest* published in *Poems on Several occasions* (London, 1775) p.182
26. Quoted in J. Mordaunt Crook and M.H. Port, *The History of the King's Works*, VI, 1782-1851, (London, 1973) pp.327-8
27. W.G. Constable, *Richard Wilson* (London, 1953) p.221
28. *The Illustrated London News*, 14 December 1844, p.379
29. *ibid*
30. *ibid*
31. Thomas Noble *Blackheath; A Poem in Five Cantos* (London, 1808) p.viii
32. *The General Ambulator* (London, 1820) p.30
33. James Thorne, *Handbook to the Environs of London* (London, 1876) pp. 48-9
34. *ibid*
35. Harris, 1979, p.25
36. Quoted in Martin Butlin and Evelyn Joll, *The Paintings of J.M.W. Turner*, revised edition, (New Haven and London, 1984) pp. 69-70. The painting is now in the Tate Gallery. For other nineteenth century artists' interpretations of the view from above Greenwich see, for example, Allen Staley and Frederick Cummings, *Romantic Art in Britain*, exhibition catalogue, Detroit and Philadelphia, 1968 (102), and Louis Hawes, *Presences of Nature*, exhibition catalogue, New Haven, 1982, p.53
37. British Museum. Engraved 1776 when in the collection of Paul Sandby
38. For Miller see Lionel Lambourne and Jean Hamilton, *British Watercolours in the Victoria and Albert Museum* (London, 1980) p.254. For Skelton see *Landscape in Britain*, exhibition catalogue, Tate Gallery, 1973 (77). For Cozens see Francis W. Hawcroft 'A Watercolour drawing by Alexander Cozens' *Burlington Magazine* CII (1960) pp.486-487
39. Cyril Fry 'Artists in Greenwich and Lewisham' *Transactions of the Greenwich and Lewisham Antiquarian Society*, VII, 6 (1972) pp.278-289
40. *The General Ambulator, op. cit.* pp. 122-3

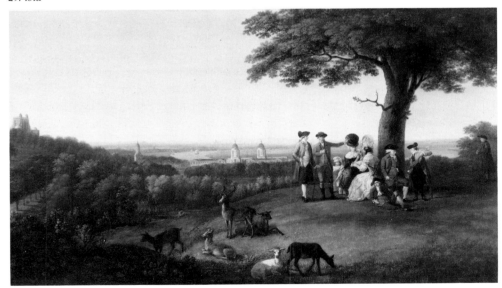

Fig. 14 John Feary *Conversation Piece with a View of Greenwich* 1779, Yale Center for British Art

Catalogue

Greenwich

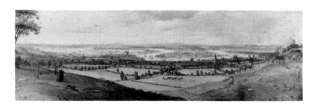

FLEMISH SCHOOL 17th Century

2. *Prospect of London and the Thames from above Greenwich*, c.1620-30
Oil on panel; 11¾×36½ in. (29·4×92·25 cm.)

PROVENANCE: Janet, Countess of Eglinton (d.1923); Sir Bruce Ingram; Ingram sale, Sotheby's, 11 March 1964 (12) bt. Colnaghi on behalf of the London Museum.
EXHIBITED: *Seventeenth Century Art in Europe*, Royal Academy of Arts, Winter Exhibition, 1938 (26); *Wenceslaus Hollar*, City of Manchester Art Gallery, 1963 (Works by other Artists 2); *The Growth of London*, Victoria and Albert Museum, 1964 (E4); *The Origins of Landscape Painting in England*, Iveagh Bequest, Kenwood, 1967 (6).
LITERATURE: John Hayes, *Catalogue of the Oil Paintings in The London Museum* (London, 1970) pp.84-88.

This panoramic view from Blackheath is one of the earliest painted prospects of London. Dating from the early seventeenth century, it is a vivid reminder that prospect viewing was a popular recreation for fashionable society long before the eighteenth century. Greenwich is shown on the right and beyond Crooms Hill stands the tower built by Humphrey, Duke of Gloucester after 1432. This was demolished during the reign of Charles II to make way for the Royal Observatory. Humphrey's original palace stood on the site today occupied by the Royal Hospital. At the time this view was painted, this 'manor of Plesaunce' had been a royal palace for nearly two centuries; later additions disguise the original building. In the distance, Southwark Cathedral, Old St. Paul's and the Tower of London are clearly visible, with the hills of Hampstead and Highgate forming the skyline.

The painting can be dated from the architectural details and from the costume of the figures shown admiring the prospect. The name of the artist, however, has proved more elusive. Wenceslaus Hollar has been suggested as one possibility, but despite the similarity with his wide engraving of Greenwich from the east, dated 1637, no oil painting by him is known. Another possible attribution is to Claude de Jongh, whose earliest important painting, *Old London Bridge* of 1630, is in The Iveagh Bequest, Kenwood. A similar view of Greenwich from further east, by the same artist, is in the National Maritime Museum.

Museum of London

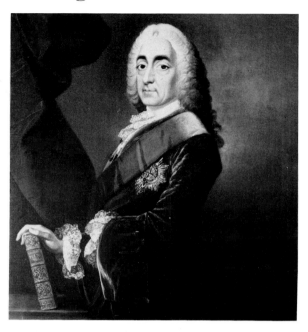

BENJAMIN WILSON 1721-88

1. *Philip Dormer Stanhope, 4th Earl of Chesterfield*, 1752
Oil on canvas; 41×34 in. (104×86·4 cm.)

SIGNED (bottom right): *B. Wilson fecit/1752*
PROVENANCE: The Earl of Cork and Orrery; Messrs Tooth, from whom bt. 1947
EXHIBITED: *The Countess of Suffolk and her Friends*, Marble Hill House, 1966 (10).
LITERATURE: Leeds City Art Gallery, *Catalogue of Paintings Part 1* Leeds, (1954) p.84

Lord Chesterfield (1694-1773), the most illustrious resident of Ranger's House, is shown wearing the Star of the Garter and resting his left hand on a copy of 'Orrery's Pliny Vol.I'. At the time this portrait was painted he had recently completed the addition of the gallery to Ranger's House (then known as Chesterfield House), the property he had inherited from his younger brother, John Stanhope, in 1748. A diplomat, politician and wit, Chesterfield held several distinguished appointments: Gentleman of the Bedchamber to the Prince of Wales from 1715; privy councillor in 1727; ambassador to the Hague from 1728-32 and in 1745; Lord Lieutenant of Ireland 1745-46 and Secretary of State for the Northern Department 1746-48. He is best remembered, however, for the 'Letters' written almost daily to his natural son, which the latter's widow published in the year after Chesterfield's death. They became an essential handbook on etiquette, deportment and other means to self advancement for ambitious youth, though in the opinion of Dr. Johnson they taught 'the morals of a whore and the manners of a dancing-master'.

Leeds City Art Galleries

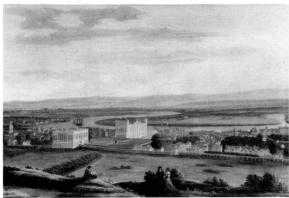

COL. PLATE I

HENDRICK DANCKERTS c.1625-c.1690 attrib.

3. *A view of the Queen's House, Greenwich, c.*1670
Oil on canvas; 33×46 in. (83·8×117 cm.)

PROVENANCE: Samuel Pepys?; Colonel M.H. Grant; Spink & Son 1932; presented by Sir James Caird.
EXHIBITED: *London and The Thames*, Somerset House, 1977 (3).
LITERATURE: *Art of the Van de Veldes*, exhibition catalogue, National Maritime Museum, 1982, p.16; Harris, 1979 pp.42-3.

On 16 March 1669 Samuel Pepys recorded in his diary:

Thence to Greenwich by water, and there landed at the King's house, which goes on slow but is very pretty. I to the Park, there to see the prospect of the hill, to judge of Dancre's picture, which he hath made thereof for me: and I do like it very well: and it is a very pretty place.[1]

This painting is traditionally held to be the original 'Landskip of Greenwich with the Prospect to London' painted for Pepys, of which several versions are known. The foreground figures are even popularly identified as representing a self-portrait of the artist at work, with Mr. and Mrs. Pepys on the right, and their maid approaching up One Tree Hill. The original picture was in a different medium, however, as Pepys earlier noted in his diary:

Thence to Dancre's, the painter's, and there saw my picture of Greenwich, finished to my very good content, though this manner of distemper do make the figures not so pleasing as in oyle.[2]

Pepys frequently visited Greenwich as Clerk of the King's Ships and later as Secretary to the Admiralty. The painting was part of a decorative scheme for his lodgings in the Navy Office, appropriate to his royal appointment. According to his diary:

Mr. Dancre.... took measure of my panels in my dining room, where... I intend to have the four houses of the King, White Hall, Hampton Court, Greenwich and Windsor.[3]

At the time Danckerts painted the prospect from One Tree Hill in Greenwich Park, the old Woolwich road still passed under the Queen's House, built by Inigo Jones from 1616-35, and seen here on the left. Immediately adjacent stands the King's House, designed by John Webb, which is nearing completion. The remains of the Tudor palace are still standing alongside. Old St. Paul's is visible in the distance, awaiting restoration, like the rest of the City, after the Great Fire of 1666.

Danckerts was among the first of a generation of Netherlandish painters to settle in London after 1666. Commissioned to produce topographical portraits of country houses and estates, they created a distinctive type of picture with which the term 'prospect painting' is traditionally identified. Danckerts proved highly successful in this genre; twenty-seven landscapes by him are listed in the inventory of the Royal Collection of 1688.

1. Richard, Lord Braybrooke, ed., *The Diary of Samuel Pepys* (London, 1906) pp729-30.
2. *op. cit.* p.723 (3 March 1669)
3. *op. cit.* p.710 (22 January 1669)

National Maritime Museum

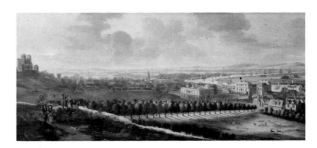

JAN VORSTERMANS c.1643-c.1699 attrib.

4. *Greenwich from One Tree Hill, c.*1676-86
Oil on canvas; 30×64½ in. (76·2×163·8 cm.)

PROVENANCE: Greenwich Hospital Collection.

Compared to Danckerts's earlier view (cat. 3), the prospect north from One Tree Hill has been extended east by Vorstermans, presumably in order to include the new Royal Observatory, built by Sir Christopher Wren in 1675. The change in viewpoint also enabled the artist to include a row of substantial private houses, which can be seen overlooking the park wall from Crooms Hill. Despite this more panoramic view, the focus of the painting is still the Queen's House, through which the Woolwich road continued to run until 1697. From 1690 to 1806 the Queen's House served as the residence of the Ranger of Greenwich Park. The old Tudor palace on the right includes a tower which obscures the view of the King's House; this does not appear in Danckerts's picture, and was presumably omitted through artistic licence to provide a full view of the portico.

Vorstermans worked in England from about 1673 to 1686, painting both topographical and ideal landscapes, for which he commanded high prices. Versions of this painting are now in the Royal Collection, the Guildhall, the Yale Center for British Art, and elsewhere. One is signed H.G. Vaughan, presumably the name of a copyist; alternative attributions for the original painting include Jan Griffier (1645?-1718).

National Maritime Museum

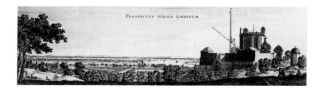

FRANCIS PLACE 1647-1728
after ROBERT THACKER d.1687

5. *Prospectus Versus Londinum* c.1676
Etching; 7⅞×24¼ in. (20×61·5 cm.)

INSCRIBED: *Prospectus Versus Londinum.*

One of a set of twelve views of the Royal Observatory at Greenwich, probably first published in 1676, this etching can also be found bound in a copy of the *Observations* of the Astronomer Royal, John Flamsteed, published in 1712 (cat. 7).

This 'prospect towards London' is taken from the main avenue of Greenwich Park, south-east of the Observatory, which at this time was Flamsteed's residence. This position gives a rear view of 'The Great Room', with its terrace and out-buildings. Beyond lies the park, with houses in Crooms Hill leading diagonally down from the left towards St. Alphege's Church, Greenwich and Deptford Dockyard. The City of London can be seen in the distance, silhouetted against the ridge on which stand Highgate and Hampstead.

In its format and accuracy, this prospect has affinities with Wenceslaus Hollar's first work in England, his wide view of Greenwich taken from the opposite side of the park, published in 1637 (fig. 3). Robert Thacker was employed by the Board of Ordnance "to draw drafts of the principal forts and other matters concerning fortifications"[1] from 1673. Like Hollar, the 'King's scenographer and Designer of Prospects' from 1667, Thacker worked in Tangier, a British possession since 1662. Thacker, however, is a far less familiar artist, otherwise known for a large wall map of Tangier, engraved in 1675, and eleven views of Longford Castle in Wiltshire, c.1680, which may be the first set of views of a country house ever produced in Britain.[2]

The engraver of this plate, Francis Place, is regarded as England's first native landscape artist, and his fame is such that the set of prints to which this view belongs is often attributed to him alone. Place studied etching under Hollar and toured the British Isles, Holland and France before settling in his native York. He produced many topographical views on this same wide format. The commission for the Observatory etchings came from Sir Jonas Moore, who had employed Hollar to illustrate his map of the Thames in 1662; probably he turned to Place, as Hollar's former pupil, before the master died in 1677.

1. Howse, p.23
2. Harris, 1979, p.89

The Trustees of the British Museum

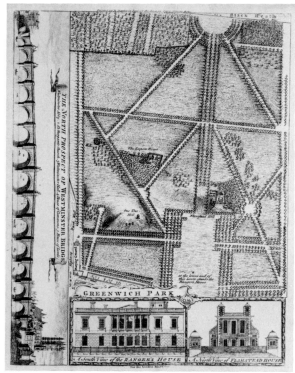

after ROBERT THACKER d.1687

6. *A Plan of Greenwich Park*, 1749
Engraving; image size: 10⅝×8¼ in. (27×20·6 cm.)

INSCRIBED: *Printed for R. Baldwin Jun′. at the Rose in Pater Noster Row For the London Magazine*

This derivative print embellished with architectural vignettes appeared as the frontispiece to volume XXIX of *The London Magazine* in March 1749. The original etching on which this plan is based formed part of a set of twelve views probably published to mark the opening of the Royal Observatory in 1676. (see cat. 7). The Astronomer Royal, John Flamsteed, later intended to include the set in a volume of his *Observations*, as he explained in a manuscript note of 1707:

the figures of the Park, the iconography of the house, and several prospects of it will inform the reader better than a long description.[1]

Greenwich Park dates from 1432 when Humphrey, Duke of Gloucester enclosed part of Blackheath to form a private estate. It became a Royal Park in 1447, following the Duke's arrest and death in prison. From 1662 to 1672 the park was laid out much as it appears in this plan, in accordance with a scheme commissioned by Charles II from the French landscape designer André le Nôtre. The geometrical arrangement of great, tree-lined avenues, suitable for horse-riding, recalls Le Nôtre's earlier work at Versailles for Louis XIV.

Today, the basic shape and plan of the park are little changed. Maze Hill runs south on the left and Crooms Hill

provides the opposite boundary to the right. At the time the original map was drawn, the Dover road ran along the southern (top) end of the park, and the Woolwich road formed the northern end opposite. The Observatory is clearly marked, as 'Flamstead House'. One Tree Hill, a popular prospect point and the subject of innumerable engravings and paintings, can be seen to the left. An illustration of the principal facade of the Observatory seen from the north is included. The 'Ranger's House' illustrated is in fact The Queen's House, built by Inigo Jones across the Woolwich road from 1616 to 1635. Montagu House adjoining Blackheath, became the official residence of the Ranger of Greenwich Park in 1806, but was demolished in 1815 (cat. 14). The building we know as Ranger's House today only acquired the title in 1815, when it became the residence of Princess Sophia Matilda, following her appointment as Ranger. It does not appear on this plan as it stands on Blackheath against the park wall, at the south-western corner (top right), just below the avenue of trees running east-west.

1. Howse, p.25

Greater London Record Office (Maps and Prints)

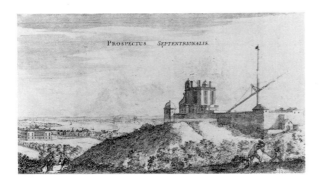

JOHN FLAMSTEED 1646-1719

7. *Historiae Coelestis... observante Johanne Flamsteedio*, 1712

The Royal Observatory at Greenwich was built in 1675 by Sir Christopher Wren on the site of a tower constructed in the fifteenth century by Humphrey, Duke of Gloucester, who had first enclosed the park. Charles II appointed John Flamsteed as the first Astronomer Royal and the Observatory, which included his residence, has been known as Flamsteed House ever since. This book of his observations is the only known copy bound with a set of Francis Place's etchings (cat. 5); these were described by the author as 'prospects of the Observatory'. The etchings were probably produced to mark the opening of the Observatory in 1676.

Flamsteed's *Observations*, written from 1676 to 1705, is one of the basic works of modern astronomy. Publication began under the patronage of Prince George of Denmark, Consort to Queen Anne, in 1704. The *Observations* was edited by Edmund Halley, Secretary of the Royal Society,

under the President, Sir Isaac Newton. Halley infuriated Flamsteed by abridging his results, withholding the printer's proofs, and by adding an incorrect catalogue of star positions and a preface. Four years after publication Flamsteed obtained all but 100 of the original 400 copies printed, and destroyed all but a handful of them after removing the sheets which had his approval. The satisfactory sheets were included in *Historiae Coelestis Britannica*, a revised and expanded edition written about 1715 and published posthumously in three volumes in 1725. As the pages Flamsteed approved of have been removed from this copy, we may assume this to be one of the handful he withheld from his fire, and the only one known to survive.

Twelve etchings were produced, representing the prospects around the Observatory and the equipment within. The plate displayed and illustrated here, *Prospectus Septentrionalis*, shows the view north-east from Crooms Hill Gate, just a few moments walk directly north from Ranger's House. The Queen's House, where Flamsteed lived before the Observatory was completed, can be seen on the left with the Isle of Dogs beyond.

Prospectus Australis (fig. 27), the prospect in the opposite direction southward, includes the earliest view of the site of Ranger's House; it can be seen between the houses beyond the park wall.

Greenwich Local History Library

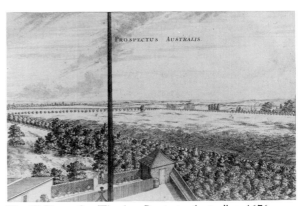

Fig. 27 Place after Thacker *Prospectus Australis* c. 1676, Greenwich Local History Library

ANON

8. *Decorated Fan; view towards London from One Tree Hill, Greenwich Park* verso: *a flower study*, c.1730
Gouache over outline etching; 8¾×18⅜ in. (22·3×47·5 cm.)

EXHIBITED: *Georgian Greenwich*, Ranger's House, 1967 (12); *230 years of drawings and watercolours*, Woodlands, 1972 (15); *From Palace to College*, Woodlands, 1973 (13); *English Watercolours and Drawings to 1840*, Woodlands, 1974 (17)

The fashionable pleasures of viewing the prospect of London from One Tree Hill in Greenwich Park are recorded in this hand-painted fan, in which the expansive distant

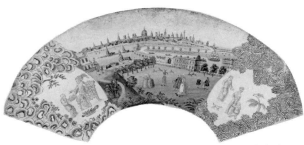

panorama of the City lends itself to the segmental design. The park is presented as an idyllic pleasure ground, with prancing deer, ladies with fans and a couple sharing a telescope on the neighbouring vantage point below the Observatory. It is easy to forget that this is no longer a Royal Park, but part of the seamen's hospital open to their guests and families from 1705.

Landscape fans were often sold locally at popular resorts, and could simply consist of printed outlines; these were intended for colouring, like porcelain, by ladies in their leisure hours. The chinoiserie vignettes flanking this landscape (including an oriental family with their dog) allude to the Eastern origins, and substantial imports, of folding fans, which came from Canton at this time.

Greenwich Local History Library

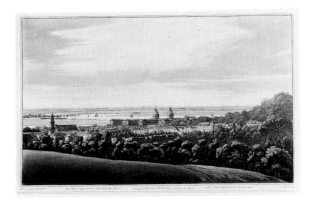

JOSEPH C. STADLER fl.1780-1821
after JOSEPH FARINGTON 1747-1821

9. *View of Greenwich, and down the River*, 1795
Aquatint; image size: 7⅝×12 in. (19·3×30·5 cm.)

INSCRIBED: *J. Farington, R.A. del./View of GREENWICH and down the River/Pub. June 1. 1975, by J.&J. Boydell, Shakespeare/Gallery, Pall-Mall, and Nº. 90, Cheapside/J.C. Stadler sculp.*

This prospect from The Point, at the northern tip of Blackheath, looking north-east towards the Royal Hospital and Greenwich Marshes, is largely unchanged today. Like Farington's *View of London from Greenwich Park* (cat. 10) it was published in *An History of the Principal Rivers of Great*

Britain, volume two (1796), a lavishly illustrated visual tour along the Thames; later projected volumes, devoted to the Severn, Forth and Clyde, were abandoned. Among the other prospects included in this volume are the views up and down river from Richmond Hill, and from Twickenham. Boydell's *History of the Thames*, as the two volumes are better known, was first advertised in the *Gentleman's Magazine* in January 1792 as "the first of its Kind that has been published, at any Time, or in any Country".[1] The quality of the plates, and the original text by William Combe, distinguished it from many earlier topographical tour books, while its success, even without the abandoned volumes, reflects the popularity of this and other Thames prospects at this time. The publisher, Alderman Boydell, Lord Mayor of London from 1790, was probably this country's most successful printseller.

Joseph Farington, who provided all the watercolours, came to London in 1763 to study under Richard Wilson (cat. 46) and first worked for Boydell a decade later. One of his earliest visits to Blackheath is recorded in a sketchbook dated 1764 in the Victoria and Albert Museum. By 1792 he had become an established member of the Royal Academy. As well as exhibiting topographical and picturesque landscape paintings, he had also completed two similar commissions for publishers: *Views of the Lakes in Cumberland and Westmorland* (1789) and *Views of the Cities and Towns in England* (1790-92). Farington's diary, spanning the years 1793-1821, is an indispensable source of gossip and 'art politics' within the Academy. References to the production of Boydell's *Thames* include his use of the Camera in Greenwich observatory. Stadler later worked regularly for Rudolf Ackermann (cat. 114), a fellow German whose publication of aquatint views both as illustrations and large decorative prints gained acceptance for a relatively new medium. Farington, however, regarded it as a 'low branch of the art'.

1. Quoted in Adams, p.117

Guildhall Library, City of London

JOSEPH C. STADLER fl.1780-1821
after JOSEPH FARINGTON 1747-1821

10. *View of London from Greenwich Park*, 1796
Aquatint; image size: 12×20½ in. (30·5×52 cm.)

INSCRIBED: *J. Farington, R.A. del./View of London from Greenwich Park/Pub. June 1. 1796, by J.&J. Boydell, Shakespeare/Gallery, Pall-Mall, and Nº. 90, Cheapside/J.C. Stadler sculp.*

Farington's depiction of the view from Greenwich Hill is here seen as it originally appeared, bound in volume two of Boydell's *History of the Thames* (1794-96). The accompanying text by William Combe described this popular prospect, in all its rich diversity:

the view possesses a rare combination of magnificent objects. The eye falls down the verdant slopes to the hospital, which sits in all its pride on the level beneath them; and, passing over its domes and porticoes, embraces those bold reaches of the Thames, where the fishing-

boat, the yacht, and the man of war, are borne on by the tide. Beyond the river is the green flat of the Isle of Dogs, bounded by those populous villages, which may now be considered as the eastern extremities of London. To the right the prospect presents the woods of Epping Forest, with the high ground of Woodford and Chigwell; and to the left, a long line of masts conducts the eye to the metropolis, with the hills beyond it.[1]

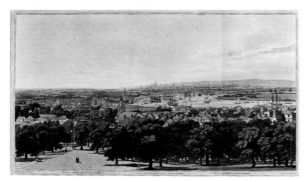

Whereas the river from Richmond Hill prompted comparisons with the Roman Campagna, and its painters Claude and Poussin, in eighteenth century texts, the more urban and active prospect which Farington and Combe record clearly appealed to the reader's confidence in the prosperity of the nation's first port and capital city. By the nineteenth century the prospect from above Greenwich also appealed to artists interested in analysing light, rather than in recording topography. For example, in 1810 Farington recalled visiting Greenwich Park with the President of the Royal Academy, Benjamin West:

we remained a considerable time, contemplating the view of London from Flamstead House, which West had formed a design to paint; as being the finest of its kind in Europe. He said He had had this in His mind from the time of His first coming to England, when on His way from Dover He left the carriage with a Gentleman who had spoken of this situation, and when He came to this point and saw the scene before Him He was struck with the magnificence of it. I told Him I had made a drawing, a Panorama of the whole scene, & that a part of it including London had been engraved & published in Boydell's History of the Thames, which might be of use to Him as all the buildings were correctly put in. He noticed the fine effect of the smoke rising in various forms and of various colours, & sd. Titian often introduced smoke into His landscapes for the beauty of the forms in which it might be represented, and for the advantage of the colour. He said that to paint this scene, the way to proceed after drawing in the outline wd. be to lay in flats of Arial colour beginning with the tint next the Horizon & making them stronger as they approached nearer the eye, a succession of Arial tints. We noticed the effect of smoke projected from furnaces, which being discharged like a shot, hung in the air a separated small Cloud. West proposed to make Greenwich Hospital with the Colonade of the building in the Park His Centre, having the advantages of this long line, & to include London on the left & Blackwall on the right of His picture. Edridge held a

Handkerchief while West measured the proportion of the Canvass which wd. be required, & determined it to be in the proportion of three wide to two deep. We walked to other points, affording very fine views of masses of trees with part of London in the distance.... West said that in painting this view from near Flamstead House.... He should omit many of the trees which stood in the way... to give the true character of the scene with all its magnificence, & not to allow it to be broken by these interruptions.[2]

West's interest at this time may be related to J.M.W. Turners' exhibition of his own painting of the view from One Tree Hill the previous year (fig. 6).

1. William Combe, *An History of the River Thames* (London, 1794-96) II, p.246
2. Kathryn Cave, ed. *The Diary of Joseph Farington* (New Haven & London, 1982) X, p.3680. I am grateful to Allen Staley for drawing this reference to my attention.

Guildhall Library, City of London

Blackheath and Ranger's House

SAMUEL TRAVERS fl.1696

11. *Petition to lease Waste Ground on Blackheath, 1696*
Pen and wash; 7¼×12 in. (18·4×30·5 cm.)

The three houses marked on this plan stood on waste ground between the western wall of Greenwich Park and Blackheath. All three were erected as a speculation by Andrew Snape (d.1689), Sargeant Farrier to Charles II, by 1676, when Snape was penalised for this encroachment onto Blackheath. The central house has traditionally been identified with Ranger's House, but this has recently been disproved. The plan is of further interest in showing a "Highway 50ft. broad from Greenw.[ch] towards Eltham"; this became Chesterfield Walk in the eighteenth century. The accompanying petition to lease the "Ground within the prickt line" submitted by Gabriel Oldingsel, points out that:

The Wast ground desired by the Peticoner, on Black Heath lyes near that wch was formerly enclosed by

Andrew Snape (and lately leased, by yo Lors. Order, to Nicholas Lock…) a piece of barren ground which offers very little profit (if any at all) to anybody.

Public Record Office (Crest 2/1642)

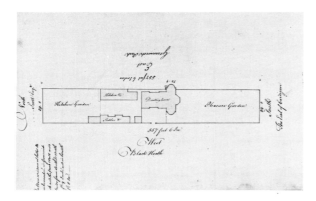

ROBERT HERBERT fl.1766

12. *Survey of Lord Chesterfield's house*, 1766
Pen and ink; 14¾×9¼ in. (37·5×23·5 cm.)

"The Memorial of the Right Honble Philip Dormer Earl of Chesterfield" was submitted to the Treasury in 1766. It consists of an application for a new fifty-year lease on a property described as "several small pieces or parcels of Wast Land within or near the Common called Blackheath with the Buildings erected thereon". The memorial was referred to the Surveyor General, Robert Herbert, whose accompanying report defines the boundaries of the property and its contents at this time, and sets out the history of the land's leasehold ownership. This is the the the earliest known description of Ranger's House (as it was later named) and it contains the earliest known plan of the property, exhibited here.

Herbert's report records that in 1694 King William III:

did demise to Nicholas Lock Citizen & Mercht. of London a certain parcel of Wast ground sitiate on Blackheath aforesaid. Abutting East on the Brick Wall of Greenwich Park… On which were then 3 houses lately erected by Andw. Snape or his Assigns with Gardens adjoining thereto… To hold the said parcels of ground with the Buildings erected thereon for a term of 99 years.

The actual date the house was built is not given, nor are any of its residents before Chesterfield named, but his neighbours in 1753 are listed:

the Memorialist by virtue of an Assignment bearing the date the 7th day of April 1753 is become intitled to part of the said premises which are therein described to consist of a piece of ground whereon stood a Messuage formerly in the Occupation of Doctor Stephen Waller lying between Greenwich park Wall on the East and Blackheath on the West, a house and ground heretofore of Sarah

West and since of Captain Evans on the South, and the garden Wall heretofore of Col. Stanly on the North.

Chesterfield's own property, "between the Park Wall and Blackheath is 557 ft. 6 in. in length and 89 ft. in breadth" and consists:

of a substantial Brick messuage with Coachhouse Stables and other offices… in good repair and the rest of the ground is employed as a Kitchen Garden and small pleasure ground.

The unauthorized addition of the gallery to the house, providing Chesterfield with his three 'finest prospects', did not pass unnoticed:

the Memorialist… has encroached about 9 ft. in breadth by the length of the premises on the Wast of Blackheath, and the Memorialist in building an Additional room to his house has encroached on the Park and Park Wall 11 ft. 8 in. in breadth & 24 ft. 9 in. in length.

Nevertheless, the Surveyor General recommended that a lease:

may be granted to this Noble Memorialist for… the sd. Encroachmt. on the Park and Park Wall which is now become a chief Ornament to his house.

The gallery is clearly marked on the plan, with one of its three bow windows breaking through the boundary wall of the Royal Park. Chesterfield's application proved successful, and the remainder of the original lease was extended by twenty-three years. In 1815 the property reverted to the Crown; it then became the official residence of the Ranger of Greenwich Park.

Public Record Office (Crest 6/60)

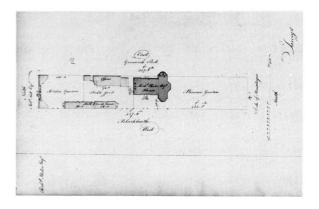

JOHN ST. JOHN and JONATHAN MARQUAND fl.1783

13. *Survey of Richard Hulse's house*, 1783
Pen and wash; 15×9⅝ in. (38·6×24·3 cm.)

Richard Hulse (1727-1805), High Sheriff of Kent from 1768 and Deputy Governor of the Hudson Bay Company from

1799, lived at Ranger's House from 1783 until his death. From 1773 to 1783 the house had belonged to Lord Chesterfield's heir, the fifth earl. Like Lord Chesterfield, Hulse applied to the Treasury for a full fifty-year lease on the property. His petition was then referred to the Surveyor General, who had this report and plan prepared. The plan is of particular interest in showing changes made to the property over the past seventeen years, since a similar record was made in response to Lord Chesterfield's own application. Steps have been added to the side of the main house, the coach house and service wing have been extended, and a greenhouse has been constructed. These improvements were presumably made by Chesterfield. The building was still asymmetrical at this time; Hulse later added the north wing to balance Chesterfield's gallery.

Public Record Office (Crest 6/75).

J. SMITH fl.1755

14. *South View of Montagu House*, 1755
Pen and wash; 7¼×16 in. (18·4×40·6 cm.)

SIGNED, DATED 1755 and INSCRIBED: *South View of the New Building of the RIGHT HONOURABLE The EARL of CARDIGANS Seat on Blackheath, Kent*
PROVENANCE: Bequeathed to the London Borough of Greenwich by A.R. Martin Esq., 1974
LITERATURE: Charles Alister "Montague House, Blackeath and 'The Delicate Investigation'" *Transactions of the Greenwich and Lewisham Antiquarian Society* VII (1978) pp 234-246

Montagu House was built between 1700 and 1702 on land adjoining the west wall of Greenwich Park, immediately north of the southernmost of Snape's three villas (cat. 11). It became the property of Ralph, Earl of Montagu in 1703 and was extended in the middle of the century, when these drawing were made, by George Brudenell, Earl of Cardigan, son-in-law of the 2nd Duke of Montagu. The original lease was subsequently inherited by Elizabeth, Duchess of Buccleuch, who let the house to Caroline, Princess of Wales, from 1799 to 1815. In 1806 George III appointed his daughter-in-law (and niece) to the sinecure of Ranger of Greenwich Park, and in the same year the 'Delicate Investigation' into Caroline's misconduct, following her separation from the Prince of Wales, was opened. Montagu House was demolished in 1815 after Caroline left for the Continent. The present Ranger's House then became the official residence of the Ranger of Greenwich Park. These drawings were probably commissioned by the Earl of Cardigan in 1755, to record improvements recently made. Park Corner House (built by 1701), with its tower commanding fine prospects over both Blackheath and Greenwich Park, had been added in 1729. Smith's drawings were made less than five years after Lord Chesterfield added his gallery, with its prominent bay windows, to Ranger's House further north along the same wall.

Greenwich Local History Library (Martin Collection)

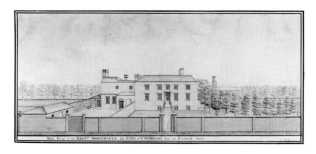

15. *West View of Montagu House*, 1755
Pen and wash; 7¾×16⅛ in. (19·7×41 cm.)

SIGNED, DATED 1755 and INSCRIBED: *West View of the RIGHT HONOURABLE the EARL of CARDIGANS Seat on Blackheath Kent.*
PROVENANCE: Bequeathed to the London Borough of Greenwich by A.R. Martin Esq., 1974

Greenwich Local History Library (Martin Collection)

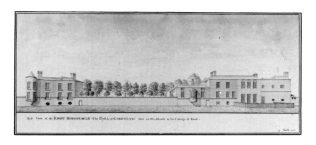

16. *East View of Montagu House*, 1755
Pen and wash; 7¼×16 in. (18·4×40·6 cm.)

SIGNED, DATED 1755 and INSCRIBED: *East View of the RIGHT HONOURABLE the EARL of CARDIGANS Seat on Blackheath in the County of Kent.*
PROVENANCE: Bequeathed to the London Borough of Greenwich by A.R. Martin Esq., 1974

Montagu House is seen here as it appeared from within Greenwich Park, with its tower and gazebo encroaching over the park wall.

Greenwich Local History Library (Martin Collection)

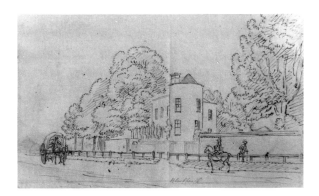

PAUL SANDBY 1725-1809

17. *Montagu House*, 1781
Pencil, pen and ink; 8¾×12⅝ in. (22·2×32 cm.)

INSCRIBED: *Blackheath*
PROVENANCE: Col. W. Gravatt, 1867; William Sandby; G.J.A.
Peake; Hubert Peake; Sabin, 1959.
EXHIBITED: *Paul Sandby 1725-1809*, Guildhall Art Gallery, 1960
(79); *Georgian Greenwich*, Ranger's House, 1967 (37); *230 years of
drawings and watercolours*, Woodlands, 1972 (50); *English
Watercolours and Drawings to 1840*, Woodlands, 1974 (46).

Before its demolition in 1815, Montagu House stood just to
the south of Ranger's House along the west wall of Green-
wich Park. The park wall can be seen on the right in this
sketch, with Blackheath to the west on the left. Paul Sandby,
one of the fathers of painting in watercolour, was appointed
chief drawing master at the Royal Military Academy,
Woolwich, in 1768, and held the post for twenty-eight years,
until he was succeeded by his second son, Thomas Paul
Sandby. This sketch, boldly heightened with a reed pen, is
a working drawing for an aquatint, published in 1781 as *On
Blackheath*, and reissued in 1812.

Greenwich Local History Library

18. *Duke of Montague's Blackheath*, 1812
Aquatint; 8⅞×12⅞ in. (22·5×32·7 cm.)

INSCRIBED: *Paul Sandby Fecit/Duke of Montague's Blackheath/published
by T. Palser, Surry side, Westminster Bridge 1812*

Sandby is often credited with having introduced the art of
aquatint engraving into this country after his patron, the
Hon. Charles Greville, purchased the secrets of the
technique from its inventor, Jean-Baptiste Le Prince, in
Paris around 1772. Sandby was not in fact the first, but he
certainly invented the name for the medium and estab-
lished it as the most suitable for the reproduction of topog-
raphical watercolours. This aquatint was first published in
1781 as a companion to Sandby's view of Montagu House
from the south (cat. 17). In the previous year Sandby had
published *Ten Views of Encampments in Hyde Park and Black-
Heath*, recording two of the points in and around London
where troops were stationed during the Gordon Riots of that

year. His *View of the Encampment on Blackheath* was exhibited
at the Royal Academy the same year.

Greenwich Local History Library

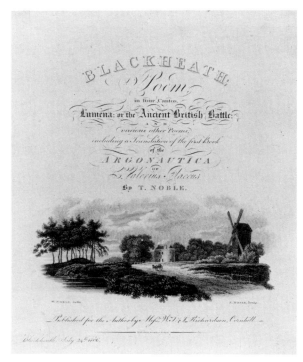

THOMAS NOBLE fl.1805-36

19. *Blackheath. A poem in four cantos*, 1806

The title page of this poem reproduces Montagu House,
described by Noble as "the retired residence of a lovely all
benevolent princess", namely Caroline, Princes of Wales,
to whom the work is dedicated. To the left lies Whitefield's
Mount, named after the methodist preacher George
Whitefield, who in the eighteenth century had drawn vast
crowds to his open air sermons on Blackheath. The poet's
preface evokes the pleasures of prospect viewing from
above Greenwich, and records the particular appeal which
this view held:

> Blackheath and its environs are better situated for a wide
> range of contemplation than any spot. Where will you
> find prospects more extensive, that at the same time
> abound with the like grandeur of luxurious cultivation?...
> yonder wide spreading buildings dedicated by individ-
> uals to the safety and protection of commercial wealth.
> Not only the riches of civilisation in all its forms in
> orchards, garden-ground, meadows, and corn-land, but
> the riches of human society and of the whole earth, in
> manufactories, majestic vessels, and the stores of univer-
> sal traffic.

Guildhall Library, City of London

ANON

20. *The Seat of Sir Gregory Page at Blackheath*, 1773
Engraving; image size: 4⅛×7½ in. (10·6×19 cm.)

INSCRIBED: *Vol. I.P. 65/The Seat of S'. Gregory Page at Black Heath.*

Wricklemarsh, a Palladian mansion designed by John James, was built in 1723 for Sir Gregory Page with a fortune acquired through the sale of stock in the South Sea Company, before the notorious 'Bubble' burst. Before its demolition in 1787, Wricklemarsh stood south-east of Ranger's House on the opposite side of Blackheath, where it would have been known to Chesterfield as one of the finest seats built in England in recent years.

This engraving is taken from *A New Display of the Beauties of England* (second edition, 1773, volume one), an early companion guide to house viewing which also included similar engravings of Marble Hill and Kenwood (cat. 43,80). In describing Blackheath the anonymous author first mentions Chesterfield's house before going on to discuss Wricklemarsh in detail:

> There are several noblemen's and gentlemen's seats on Blackheath; and in particular, those of the Earl of Chesterfield, and the Earl of Dartmouth. And not far from Morden College is a noble house built by Sir Gregory Page, Bart. This is a very magnificent edifice, built in the modern taste.... It stands in the midst of a park; with a large piece of water before it.... This is one of the finest seats in England belonging to a private gentleman; and the gardens, park, and country around, render it a most delightful seat; yet this fine edifice was begun, raised, and covered in the space of eleven months.[1]

Wricklemarsh was also sketched by George Robertson and published in the series which includes his view of Kenwood (cat. 87). Two years later, in 1783, *The British Magazine and Review* included an engraving of Wricklemarsh after Metz, again in the same series as a view of Kenwood (cat. 91). The house had cost Page between £90,000 and £135,000 to build, but as the text to this later engraving reveals:

> On the 10th of the present month, this capital mansion, with the park of the late Sir Gregory Page, were sold by auction, by Christie and Ansell, to John Cator, Esq. of Stump's Hill near Beckenham, in Kent, for £25,500....

The disposition of the grounds and gardens without, and the masterly paintings, rich hangings, marble bustos by Rysbrack, and alto-relievos, within this elegant and superb edifice, greatly attract the attention of all persons of genius and taste.[2]

Over 118 paintings, including works attributed to Rubens, Van Dyck and Titian, were removed. The house was then demolished. Its ruins stood firm into the nineteenth century and became the subject of engravings in themselves, including one in Noble's poem *Blackheath* (cat. 19).

1. *A New Display of the Beauties of England*, second edition (London 1773) I p.65
2. *The British Magazine and Review* II (1783) pp.269-270

Ranger's House

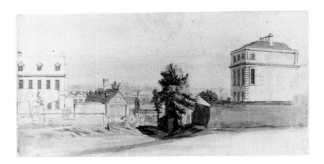

THOMAS SANDBY 1721-98

21. *View of Greenwich*, 1776
Pencil, pen, ink and watercolour; 7×13½ in. (17·6×34·2 cm.)

PROVENANCE: Bequeathed by Sir Robert Witt, 1952.
EXHIBITED: *English Landscape Drawings & Water Colours*, Courtauld Institute Galleries, 1979 (11).

The prospect north to Greenwich from the top of Crooms Hill is one of the most popular from Blackheath and has inspired several watercolours. The road uphill follows the west wall of Greenwich Park and turns into Chesterfield Walk where it joins the Heath, passing by Ranger's House itself as it continues south. The popularity of Crooms Hill, like Maze Hill on the opposite side of the park, ensured the building of some of the finest houses in the area; several of them were noted for their commanding prospects both north to the Thames and City and east over the park wall. On the left in Sandby's sketch stands the Manor House, built in 1697 for Sir Robert Robinson, Lieutenant Governor of Greenwich Hospital from 1705. Directly opposite is Park Hall, built in 1723 by the architect John James as an investment, rather than for his own use.

Courtauld Institute Galleries (Witt Collection no. 3918).

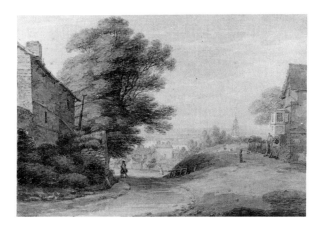

THOMAS HEARNE 1744-1817

22. *Crooms Hill*, c.1790
Watercolour; 5¾×7⅞ in. (14·5×20 cm.)

SIGNED: *Hearne*
EXHIBITED: *New Pictures for the Art Gallery Collection*, Woodlands,
1980-81 (20); *Thomas Hearne*, Bolton Museum and Art Gallery,
1985 (31).
LITERATURE: Frank Kelsall "Hillside and Park Hall, Crooms Hill,
Greenwich", *Transactions of the Greenwich and Lewisham Antiquarian
Society* VIII (1978) pp 210-222.

Greenwich and the Thames can be seen in the distance
beyond Crooms Hill. On the left is an outbuilding of the
Manor House, both of which survive, and on the right is
Hillside, which was extensively remodelled at the begin-
ning of the nineteenth century; this is apparent from the
later watercolour of this same view by Lucas (cat. 23).
Hearne's prolific output as an illustrator of topographical
publications included *A View of London from Flamstead Hill in
Greenwich Park*, published in 1786.

Greenwich Local History Library

RALPH W. LUCAS 1796-1874

23. *Crooms Hill*, 1829
Watercolour; 10⅝×14 in. (27×35·5 cm.)

SIGNED and INSCRIBED: *Crooms Hill*, with colour notes.
PROVENANCE: Bequeathed to the London Borough of Greenwich
by A.R. Martin Esq., 1974.
LITERATURE: Frank Kelsall "Hillside and Park Hall, Crooms Hill,
Greenwich", *Transactions of the Greenwich and Lewisham Antiquarian
Society* VIII (1978) pp 210-222.

The Manor House, seen here on the left, was built in 1697
for Sir Robert Robinson, Lieutenant Governor of Green-
wich Hospital from 1705. On the opposite side of Crooms
Hill stands Hillside, the former property of John James,
Clerks of Works (with Hawksmoor) at Greenwich Hospital
and architect of Wricklemarsh (cat. 20) and St. George's,
Hanover Square. The view down Crooms Hill is essentially

unchanged today. The colour notes written in pencil indi-
cate that Lucas may have coloured this work in his studio.
He exhibited regularly at the Royal Academy from various
local addresses from 1821 until 1852, when he lived in Hyde
Vale.

Greenwich Local History Library (Martin Collection)

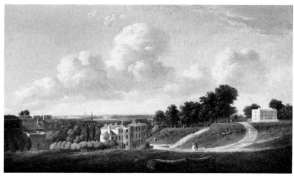

COL. PLATE II

THOMAS HOFLAND 1777-1843

24. *View of Crooms Hill overlooking Hyde Vale*, after 1824
Oil on canvas; 15¹⁄₁₆×30 in. (38·2×76·2 cm.)

PROVENANCE: Roy Miles Fine Paintings; purchased for Ranger's
House by the Greater London Council, with the aid of the National
Art-Collections Fund, and following a public appeal, 1985.
LITERATURE: Anne French, "Thomas Hofland's 'View of Croom's
Hill overlooking Hyde Vale", *National Art-Collections Fund Review*,
1986, pp 96-97; the following entry is a reduced version of this
article.

This delightful early nineteenth century painting depicts
the view over London from Blackheath, only yards away
from Ranger's House itself; the house stands just outside
the scope of the canvas, to the right. Remarkably, the group
of houses in the foreground and the distant view have
remained almost unchanged until today, although the band
of green in the distance reminds us that the sprawling south-
ern suburbs had yet to unite Blackheath with central
London.
 Hofland's viewpoint is from one of the most northerly
parts of the heath at the entry to Hyde Vale. The building
occupying the eminence on the right is the White House,
which stood at the top of Crooms Hill. This was built circa
1720 by Mr. Delamotte, on land enclosed from Blackheath
by George Shott, matchmaker to the King, in 1689. Despite
protests from conservationists, it was demolished, together
with two other houses immediately to the east of it, Clifton
House and The Yews, in 1938; a photograph in the
Greenwich Local History Library of that same year shows it
just prior to demolition. Today the site is occupied by a
block of flats.
 With this sole exception, Hofland's canvas is, almost fea-
ture by feature, recognisable to the visitor to Blackheath
today. The centre is taken up with a delightful group of
Georgian houses, poised in splendid isolation at the top of

Hyde Vale (or, more accurately, Cond it Vale). One suspects that it was the picturesque quality lent by the slightly off-centre placing of the bay window within this terraced group that attracted the attention of an artist whose most famous works were the decidedly picturesque views of Whiteknights, Reading, painted for the 5th Duke of Marlborough. Fortunately, the houses survive intact today, still largely unencumbered by later development. A comparison with a photograph of c.1938 in the Greenwich Local History Library (fig. 28) shows with what camera-like veracity Hofland has recorded the details of fenestration, roof lines and even tiles. Beyond the houses stretches the panoramic view of London itself, with the spire of St. Nicholas, Deptford in the foreground and St. Paul's hazy in the distance.

Hofland was as meticulous a recorder of landscape as he was of architecture. The two serpentine paths encircling a patch of heathland are paralleled exactly on a map by F.W. Sims in the Greenwich Local History Library, while the stately procession of trees extending downhill from the White House, and even the line of the fence, can still be seen in the photograph of c.1938. Today the pathways are rather less precise than in Hofland's day; the grass, a passage for human feet, not quietly grazing sheep, is more worn than are Hofland's verdant lawns; and the trees have gone. Nevertheless, anyone walking this part of Blackheath today will easily recognise the essential features of Hofland's landscape.

The artist was by no means unknown in his day. He was a founder member and later President of the Society of British Artists, and a frequent exhibitor at the Royal Academy. He painted a number of London topographical views and his interest in the Greenwich and Blackheath area is attested by the several views which he painted of nearby One Tree Hill, Greenwich. He exhibited the first of these at the Royal Academy in 1823 and then went on to show two more paintings with the same title at the British Institution in 1824 and 1833. Sadly, this view of London from Blackheath is not among his exhibited or recorded works, nor is the date when he painted the canvas known. One intriguing clue to the latter, however, is provided by the gas lamp placed so unobtrusively against a wall in the left foreground. Gas lighting was introduced only in 1824, so the painting must post-date that year; probably, given the date of the other Greenwich views, it dates to not long afterwards, and surely well before Hofland's visit to Italy in 1840.

Thomas Hofland belongs to the classical tradition of landscape painting: the feeling for geometric, almost abstract qualities in architecture, the identifiable yet generalised tree forms, and the ordered recession into space, all derive from the seventeenth century landscape paintings of Claude Lorraine and Gaspard Dughet. There is also another, perhaps more interesting, echo of this tradition in his choice of subject here.

Hofland lived from 1816 in Twickenham, where in the early eighteenth century the ordered relationship between villas, parkland and the surrounding countryside had found expression in a series of Thames-side villas, notably Pope's. This vision was soon translated onto canvas in the work of Richard Wilson (cat. 44), another devotee of the classical landscape tradition. Hofland's work, in particular his own Twickenham views, owes much to Wilson's example, and there is more than an echo of this persistent eighteenth cen-

tury theme in the pleasantly ordered sylvan setting which he depicts in this view of Hyde Vale. Appearances can be deceptive, however, and what is perhaps more interesting is to examine the differences. For Hofland has re-interpreted this Wilsonian vision in strictly contemporary terms. Blackheath is no longer seen as the retreat of Lord Chesterfield, who in the late eighteenth century had dubbed Ranger's House his 'Petite Chartreuse'. Instead, with the new century, the villas of the aristocracy have given way to the scaled-down domestic architecture appropriate to a new age. It is in fact no coincidence that this view, so close to Ranger's House, both literally and metaphorically turns its back on it, looking instead towards London over the rooftops of a simple yet elegant terrace of Georgian houses. It is pleasing to note that the figures, at least, gesture back up the hill towards the White House (and even, by a stretch of the imagination, towards Ranger's House itself). Painting and house share, however, something fundamental to each – the same magnificent prospect – and it seemed almost inevitable, when the painting came onto the market in 1984, that it should find a permanent home in the collection here.

Ranger's House. *A.F.*

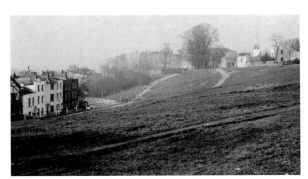

Fig. 28 Hyde Vale in 1938

JAMES HOLLAND 1799-1870

25. *London from Blackheath*, c.1835
Watercolour; 8½ × 14¼ in. (21·5 × 36·2 cm.)

SIGNED: *J. Holland.*

The dome of St. Paul's can be clearly seen beyond Hyde Vale, a descending road which marks the northern perimeter of Blackheath. The Point (cat. 9) lies out of view to the left, and Crooms Hill is a few yards to the right. The row of houses on the left still stands today, and the prospect is little changed but for additions on either side of these buildings. A similar view, only from higher up the vale, was painted by Thomas Hofland (cat. 24).

James Holland lived at 3 Union Place, Blackheath Road from 1830 until 1842. The many paintings he exhibited at the Royal Academy included *View of London from Blackheath* (1833), to which this study may be related. A large oil sketch entitled *Near Blackheath* (Victoria and Albert

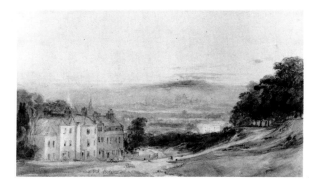

Museum) formed part of the collection presented to the nation in 1857 by John Sheepshanks, a prominent resident of Blackheath and a major collector of contemporary British paintings.

Harris Museum and Art Gallery, Preston

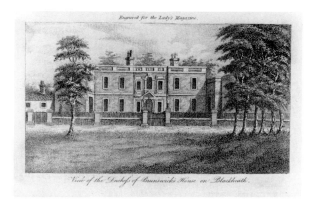

View of the Duchess of Brunswick's House on Blackheath.

ANON

26. *View of the Duchess of Brunswick's House on Blackheath*, 1808
Engraving ; 4⅜×7 in. (12×17·8 cm.)

INSCRIBED: *Engraved for the Lady's Magazine/View of the Duchess of Brunswick's House on Blackheath*

The earliest known view of Ranger's House, this engraving illustrated an article in *The Lady's Magazine* in 1808. The Dowager Duchess of Brunswick, sister of George III, came to live at Chesterfield House (as it was then known) in 1805 in order to be near her daughter Caroline, Princess of Wales. The Princess, separated from her husband, the future George IV, had been living next door at Montagu House since 1799, and was appointed Ranger of Greenwich Park in 1806. The Duchess of Brunswick had previously lived for a short time nearby in Conduit Vale, Blackheath. The great

attractions of 'Brunswick House' as it soon became known are clear from the article which accompanies this engraving:

> It is situated on the heath near that romantic spot called 'The Point', the prospect from which perhaps exceeds that from any part so near the metropolis. The house and grounds of the duchess are adjoining to those of her royal highness the Princess of Wales, and there is a private communication between them.... The back of the premises, and those of the Princess's, look into the beautiful park of Greenwich where a considerable quantity of ground is enclosed, and the style in which the Princess has caused the gardens to be laid out, does infinite honour to her taste.[1]

The article provides a rare account of the grounds and kitchen garden in which several boys were continually employed in return for their education. The Princess's grounds were laid out by John Meader "afterwards gardener to the Duke of Northumberland and subsequently to Russia, where the late Empress Catharine II, employed him in laying out an English garden."[2]

A companion engraving showing Montagu House from Greenwich Park, complete with peacocks, was also published in *The Lady's Magazine*. The residence of two members of the royal family at Blackheath gave the area renewed status in fashionable society. *The Lady's Magazine* remarked how "These illustrious personages frequently honour the public in the vicinity with their presence, both in their carriages and on foot."[3] The engraving would have carried with it certain other associations; the scandalous indiscretions committed by the Princess of Wales at Montagu House had forced the government to set up a 'Delicate Investigation' into her conduct in 1806. In 1808 one reception at least reached the height of respectability, according to a newspaper account:

> The fete on Thursday, given by her Royal Highness the Princess of WALES, at Blackheath, in honour of the birthday of her Royal mother, the Duchess of BRUNSWICK, was the most splendid and elegant entertainment that has been witnessed during the present season. All the Nobility and Gentry remaining in town, together with those of the surrounding country, were invited.[4]

This engraving is also of documentary interest in showing the old stables on the left, and a pillared fence.

1. *The Lady's Magazine*, XXXIX, Supplement (1808) pp.571-2.
2. *ibid.*
3. *ibid.*
4. Cutting dated 1808, Greenwich Local History Library.

Greenwich Local History Library

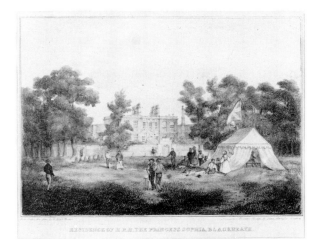

W. BLIGH BARKER fl. 1835-50

27. *Residence of H.R.H. The Princess Sophia, Blackheath*, c.1835
Lithograph; 6½×9 in. (16·5×22·8 cm.)

INSCRIBED: *Residence of H.R.H. The Princess Sophia Blackheath/From Nature & on Stone, by W.Bligh Barker/ Printed by C. Bellany, Bridge Hou. Place, Newington Causeway*
PROVENANCE: Bequeathed to the London Borough of Greenwich by A.R. Martin Esq., 1974

Princess Sophia Matilda, niece of George III, was the first Ranger of Greenwich Park to live at Ranger's House. The previous Ranger, Caroline, Princess of Wales, had lived next door at Montagu House. This was demolished in 1815, and the site then became part of the grounds of the present Ranger's House. Princess Sophia held the position of Ranger from 1815 until her death in 1844, when her elaborate funeral prompted several engravings of the house in the illustrated press (fig. 10). This lithograph shows the covered entrance added in 1815; on the right a tall chimney marks the division at this same time of Chesterfield's long gallery into three smaller rooms.

The cricket match shown in the foreground is wholly appropriate as this was the predominant sport played on Blackheath in the nineteenth century. Local residents included one of England's greatest players, Nicholas Wanostrocht, who ran a school in South Row and published the player's manual, *Felix on the bat*. The lithographer Bligh Barker may have had local connections; in 1835 he exhibited *Greenwich Hospital from the marshes* at the British Institution and in 1850 *Greenwich Hospital, Observatory and 'Dreadnought'* at the Royal Academy.

Greenwich Local History Library (Martin Collection)

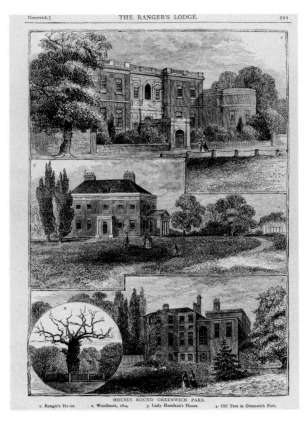

ANON

28. *Houses Round Greenwich Park*, 1878
Engraving; image size: 5⅝×8¼ in. (14·3×21 cm.)

INSCRIBED with caption

Ranger's House heads this page illustrating notable residences around Greenwich Park. Woodlands, shown in the middle, was built east of the Park in 1774 by John Julius Angerstein, the famous collector whose old master paintings formed the nucleus of the National Gallery. The house still stands in Mycenae Road, and is now the Greenwich Local History Library and Art Gallery. 'Lady Hamilton's House' remains a mystery. Lord Nelson's mistress, Emma Hamilton, who died in 1815, is not know to have stayed in the Greenwich area; however, a family connection is possible as the father of her husband, Sir William Hamilton, was Governor of Greenwich Hospital. The print is taken from *Old and New London* (London, 1878), volume VI, edited by Walter Thornbury and Edward Walford.

Ranger's House

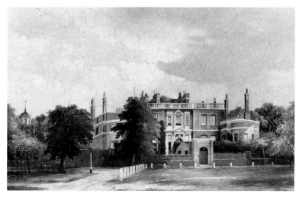

CHRISTABEL AIRY 1842-after 1924

29. *Blackheath from Chesterfield Walk*, 1880
Watercolour; 7⅛×10⅛ in. (18×25·7 cm.)

INSCRIBED: *Blackheath/1880, Aug.28*
EXHIBITED: *Watercolours from 1840 to 1914 of Places in the Borough of Greenwich*, Woodlands, 1975 (11).

Chesterfield Walk, named after Philip Stanhope, 4th Earl of Chesterfield, runs south along the west wall of Greenwich Park from Crooms Hill. It passes directly in front of Macartney House, Ranger's House and the site of Montagu House. It appears on Rocque's map of 1746 as *Gen. Withers' Walk*, after the then resident of Macartney House. The artist was the daughter of Sir George Biddel Airy, Astronomer Royal from 1836 until 1881.

Greenwich Local History Library

CLOUGH W. BROMLEY fl. 1870-1904

30. *Chesterfield Walk, Blackheath*, c.1880
Gouache on board; 6⅝×10¼ in. (16·8×26 cm.)

SIGNED: *Clough Bromley*
EXHIBITED: *230 years of drawings and watercolours*, Woodlands, 1972 (13); *Watercolours from 1840 to 1914 of Places in the London Borough of Greenwich*, Woodlands, 1975 (13).

Looking north-west along Chesterfield Walk, Ranger's House can be seen through the trees on the right. To the left the ridge of the horizon falls away into Hyde Vale. This grisaille was probably intended for engraving, but no published version is yet known.

Greenwich Local History Library

ANTHONY DE BREE fl. 1882-1913

31. *Chesterfield House, Blackheath*, 1884
Oil on canvas; 12⅛×17¹⁵⁄₁₆ in. (30·3×42·7 cm.)

SIGNED and DATED: *A de Bree/1884*
PROVENANCE: Painted for Blanche, Countess of Mayo; presented by Dermot, 7th Earl of Mayo, to the London Museum in 1923.
LITERATURE: John Hayes, *Catalogue of the Oil Paintings in the London Museum* (London, 1970) pp. 34-36

The only known oil painting of Ranger's House, this picture was commissioned by Blanche, Countess of Mayo in 1884. The Countess had lived here since 1876, following the assassination of her husband Richard, 6th Earl of Mayo, Viceroy and Governor-General of India, in 1872. The lease of the house was presented to her by Queen Victoria; she held the position of Extra Lady of the Bedchamber to the Queen. The previous resident had been the Queen's third son, Prince Arthur, who stayed here while studying at the Royal Military Academy, Woolwich. At the time this picture was painted the building was still popularly known in Greenwich as 'Prince Arthur's House'.[1]

De Bree has painted the house from Blackheath at an angle which gives prominence to the wing on the right, highlighted by a shaft of sunlight. This is the long gallery, added by Philip, 4th Earl of Chesterfield in 1750-1, with three bay windows affording the 'three finest prospects in the world'. The only significant difference today is the absence of the covered entrance, which was built for Princess Sophia Matilda in 1815 and was demolished soon after the house was acquired by the London County Council in 1902. The cupola with weather vane on the stable block on the left was removed in 1943 but is to be reinstated shortly. De Bree is said to have been discovered living in poverty by the Earl of Mayo. He subsequently worked as a copyist for him and for King Edward VII before returning to his native Holland. He seems to have had some independent success, as he also exhibited widely in London, as well as in Liverpool and Manchester.

1. T.R. Way & H.B. Wheatley, *Reliques of Old London upon the Banks of the Thames & in the Surburbs South of the River* (London, 1899) p.105

Museum of London

H.C.B.

32. *The Ranger's House, Greenwich Park*, 1888
Engraving; image size: 7⅛×9⅛in. (18 ×23cm.)

INSCRIBED: *HCB*, with caption

This periodical illustration dates to 1888, when Queen Victoria presented Lord Wolseley with Ranger's House as his residence for life. Although Wolseley lived until 1913 he cannot have remained long at Blackheath, as he was appointed Commander-in-Chief in Ireland in 1890. He retained the house, however, until at least 1896. Lord Wolseley was a distinguished army commander but is best known today for having led the unsuccessful expedition to relieve General Gordon at Khartoum in 1885.

The view of the house from the garden is of interest in that it shows a second flight of steps, leading from the gallery, which no longer exists. The view from the house showing the stables and clock tower includes the prospect of London over Hyde Vale, as seen from the roof.

Greenwich Local History Library

Way's lithograph can be found in *Reliques of Old London upon the Banks of the Thames & in the Suburbs South of the River* (London, 1899), a tour book in the eighteenth century tradition. In his accompanying text, H.B. Wheatley traces the various residents, including "the witty Earl of Chesterfield" and regrets that Ranger's House "is now unoccupied, and there is no Ranger of Greenwich Park".[1]

Thomas R. Way is perhaps best known for having introduced James Abbott McNeil Whistler to lithography in 1878. The painter used transfer paper to sketch a series of views of London and Paris on the spot; the designs were then transferred to the lithographer's stone for printing by Way. Way also published a memoir of Whistler, a critical appreciation of his work, and a catalogue of his lithographs.

1. Way and Wheatley, *op. cit.*, p.106

Ranger's House

THOMAS R.WAY 1862?-1912

33. *Ranger's Lodge, Greenwich Park*, 1899
Lithograph; image size: 5¼×6½in. (13·4×16·5cm.)

INSCRIBED: *TRW./Plate 22*

Ranger's House is here seen from Blackheath as it appeared in the second half of the nineteenth century. The obvious differences today are the lack of the covered entrance, and the absence of the tennis courts from the front lawn. At the time this lithograph appeared the house was vacant; its last private resident, General Wolseley, left soon after 1896. Three years after publication, in 1902, the house was acquired by the London County Council.

FRANCIS DODD 1874-1949

34. *Ranger's House, Blackheath*, c.1920
Watercolour; 10×14in. (25·4×35·5cm.)

SIGNED: *F. Dodd.*
EXHIBITED: *The Buildings of Greenwich*, Woodlands, 1975, (50); *Watercolours from 1914 to the present of Places in the Borough of Greenwich*, Woodlands, 1976 (33)

Greenwich Local History Library

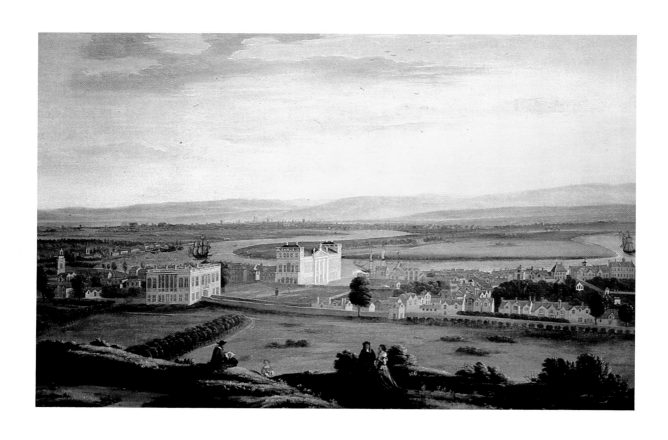

I Hendrick Danckerts *A View of the Queen's House, Greenwich*, c.1670 (cat. 3)

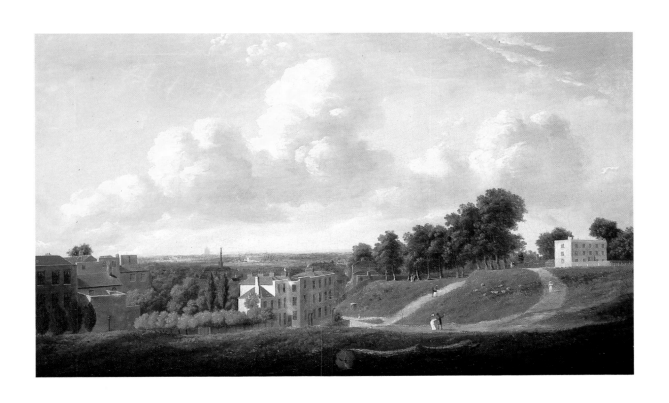

II Thomas Hofland *View of Crooms Hill overlooking Hyde Vale*, after 1824 (cat. 24)

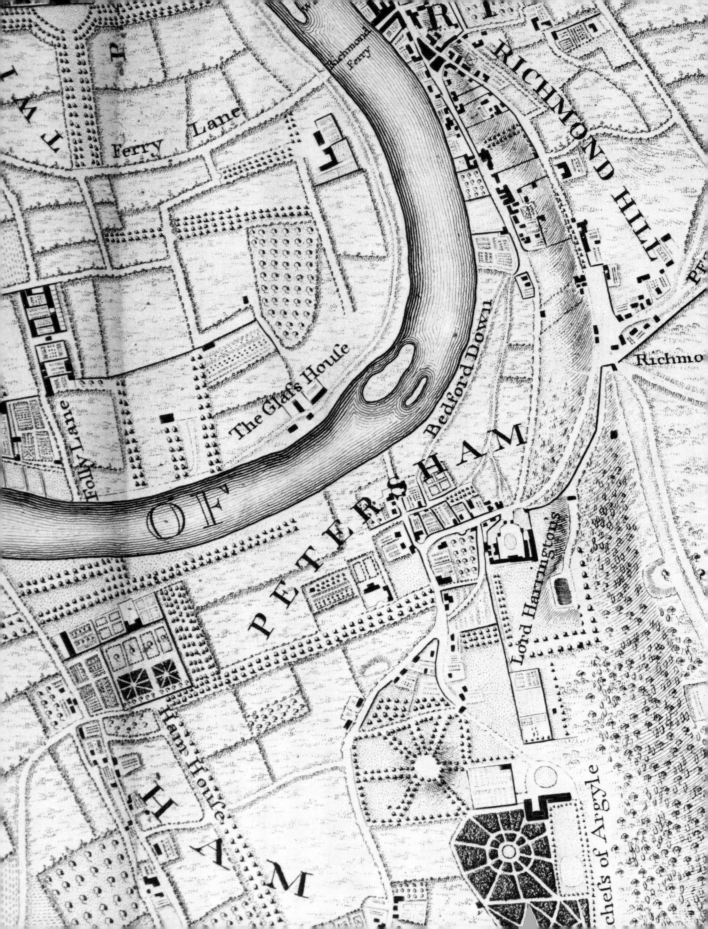

Marble Hill
The heart of the view from Richmond Hill

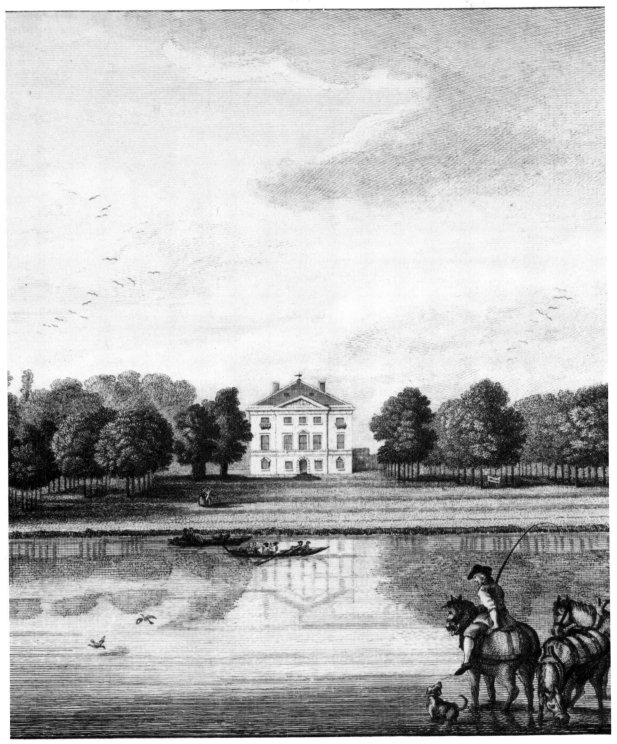

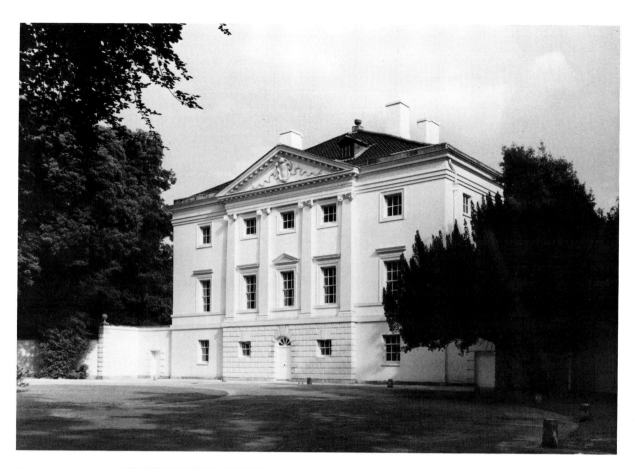

Fig. 17 (above)
Marble Hill, the
North Front
Fig. 18 (right) The
Great Room,
Marble Hill

Previous Pages:
Fig. 15 (left) Jean
Rocque *Plan of
London* detail,
showing Marble
Hill, (left of 'The
Glass House') 1746
Fig. 16 (right)
Augustin Heckell
Marble Hill House
detail, 1749

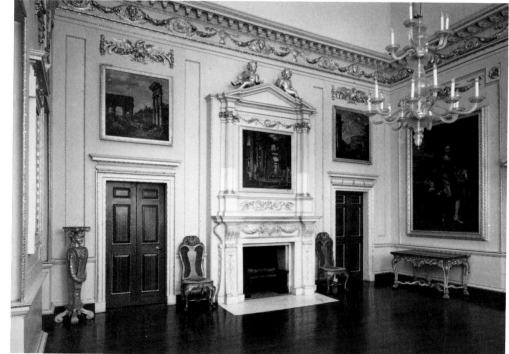

MARBLE Hill House in Twickenham, built from 1724-9, has long held a recognized position in the history of architecture as a perfect example of an English Palladian villa.[1] Less familiar today is its place in the visual arts of painting and engraving. The purchase of the house and estate by the London County Council in 1902 was prompted by the need to preserve the view from Richmond Hill, one of this country's most celebrated and often painted prospects, of which the sixty-six acres of Marble Hill form the heart. Seen from the Thames, the house also features in innumerable sketches, paintings and engravings, ranging from at least four oil paintings by Richard Wilson to illustrations on porcelain, and Victorian pocket guides for pleasure-boat trippers. Faced with the variety and sheer quantity of these views from Richmond Hill and from the river, one has to analyse the particular qualities which drew artists to this area and the associations their views of the villa would have had in the eighteenth and nineteenth centuries.

The earliest known prospect painted from Richmond Hill was executed by Jan Siberechts in 1677 (fig. 19), and was probably commissioned by the Duke of Lauderdale as a 'prospect' view of his house at Ham, seen in its enviable setting. The land on which Marble Hill was later built can be seen on the opposite bank from Ham House. By the eighteenth century this stretch of the river had become the most fashionable location for gentlemen's villas, to which they retreated from the cares of the City and Court. Whereas Greenwich had ceased to be a royal residence from 1688, Hampton Court continued to be favoured, and George II lived at Richmond Lodge when Prince of Wales. In 1724, the year the Marble Hill estate was purchased on behalf of Lady Suffolk, Daniel Defoe described the spread of fine villas:

> From Richmond to London, the River sides are full of Villages, those Villages so full of Beautiful Buildings, Charming Gardens, and Rich Habitations of Gentlemen of Quality, that nothing in the World can imitate it.[2]

Such a spectacle could be admired from the top of Richmond Hill, where the entrance to the royal park, and a spa close by, added to the attractions of this vantage point, making it a popular resort for fashionable society.

Painters were not only drawn to Richmond and Twickenham by commissions to paint views of the new villas. Successful artists, such as the portrait painters Sir Godfrey Kneller, and later Thomas Hudson, were themselves attracted to Twickenham, where they lived the lives of gentlemen in rural retirement while remaining within easy reach of London by river. Landscape painters living in Richmond in the eighteenth century included Tillemans (cat. 36) and the draughtsman Heckell (cat. 40); in Twickenham, William Marlow (cat. 48,65) succeeded his master Samuel Scott in living at the Manor House. Sir Joshua Reynolds (cat. 66) had a villa built on Richmond Hill in which to entertain guests while maintaining his studio and home in Leicester Fields.

The traditional appeal of the Thames at Richmond and Twickenham, as a rural escape from London, also attracted landscape painters keen to study the effects of natural light filtered through clouds, foliage and reflected in the river. From being a source of patronage for views of new seats and prospects from Richmond Hill, this stretch of the Thames became the subject of paintings in itself, as artists were drawn to explore the possibilities of evolving a type of landscape painting freed from topography and giving full rein to naturalism. Most notable were John Linnell (cat. 50), William Henry Hunt (cat. 51) and J.M.W. Turner (cat. 67). From 1810-14 Turner designed and built his own villa, Sandycombe Lodge, near Marble Hill, but in the

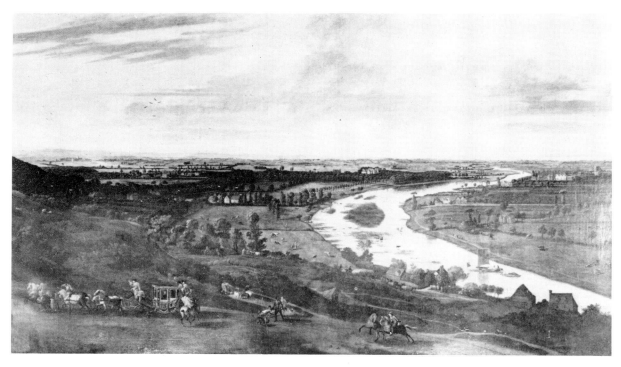

Fig. 19 Jan
Siberechts *View
from Richmond Hill
along the Thames
towards Twickenham*
1677, Lord
Hesketh, Easton
Neston

event did not retire here as successful artists had done before.[3] Hofland (cat. 24) lived alongside Marble Hill in Montpelier Row from 1817, having previously lived in Kew and Richmond, while George Hilditch (cat. 69) spent most of his life in the area, becoming known as 'The Richmond Painter'.

Given the amount of artistic interest in this stretch of the Thames, it is hardly surprising that Marble Hill, a fine white villa clearly visible from the river midway between Richmond and the village of Twickenham, should have featured as a prominent landmark in artists' views from Richmond Hill. As well as being the subject of popular engravings in itself, Marble Hill has also been inseparable in the public mind from the wealth of associations with the lady for whom it was built, Henrietta Howard, Countess of Suffolk, mistress of George II.

Marble Hill was first engraved when the architect's designs were published while it was still being built (cat. 39). These appeared in the third volume of Colen Campbell's *Vitruvius Britannicus* of 1725, where it is described as simply "A house in Twittenam midlesex near the River Thames".[4] The attempt to preserve anonymity, necessitated in part by the uncertain source of Mrs. Howard's fortune at this time, was short-lived. The earliest account of her personality is probably the *Character* by Jonathan Swift, while the earliest account of her villa is Swift's *Pastoral Dialogue between Richmond Lodge and Marble Hill;* both were written in 1727 and published in her lifetime. Poems were also devoted to her by Pope and the Earl of Peterborough. In addition to this circle of literary friends, Mrs. Howard's position at Court made interest in her new villa inevitable. Her influence over the king, however, was not as considerable as that held by her younger contemporary, Antoinette Poisson, Marquise de Pompadour, over Louis XV. Nevertheless, as Horace Walpole recorded, Mrs. Howard became a magnet for members of the Whig opposition:

> All those who had been disgraced at court, had, to pave their future path to favour,
> and to secure the fall of Sir Robert Walpole, sedulously, and no doubt zealously,

dedicated themselves to the supposed favourite: Bolingbroke secretly, his friend Swift openly, cultivated Mrs. Howard and the neighbourhood of Pope's villa to Richmond facilitated their intercourse.... Lord Bathurst, another of that connexion, and Lord Chesterfield, too early for his interest, founded their hopes on Mrs. Howard's influence.[5]

Her retirement from Court as Lady Suffolk, in 1734, shortly after the completion of Marble Hill, prompted Lord Hervey to observe:

> The true reasons of her disgrace were the King's being thoroughly tired of her.... her intimacy with Mr. Pope, who had published several satires, with his name to them, in which the King and all his family were rather more than obliquely sneered at; the acquaintance she was known to have with many of the opposing party, and the correspondence she was suspected to have with many more of them.[6]

Pope lamented: "There is a greater Court now at Marble Hill than at Kensington, and God knows where it will end".[7]

The identification of this glittering circle with Marble Hill was established for future generations by Horace Walpole, who came to live nearby at Strawberry Hill in 1748, and succeeded Pope (who died in 1744) as Lady Suffolk's friend and neighbour. At the age of thirty Walpole found this lady of sixty to be one of the last links with the early court of George II. As the rival and opponent of his father, the King's chief minister Sir Robert Walpole, Lady Suffolk proved to be a fount of first-hand accounts which he drew upon in writing the *Reminiscences*, published in 1798. Walpole ensured that Marble Hill's fame and association with the Augustan age continued long after Lady Suffolk's death in 1767. Much of that fame, however, rested more on anecdote than fact. For example, when her letters were published in 1824 the editor regretted that one fallacious tale "has found its way not merely into books of anecdotes, but, as we have already hinted, into respectable historical works".[8]

The strength of these political and literary connections made Marble Hill more prominent in the popular imagination in the eighteenth and nineteenth centuries than we tend to realise today. People who purchased engravings and paintings did not see it simply as a fine Palladian villa but, as the *Gentleman's Magazine* put it in 1794, "the celebrated and beautiful villa of Marble Hill, a classic spot, immortalized by Pope and Swift".[9] As the editor of Lady Suffolk's letters observed in 1824, it was built with:

> the only pecuniary favour she seems to have derived from her royal master.... Pembroke designed the house; Lord Bathurst and Mr. Pope laid out the gardens; and Gay and Arbuthnot, had constituted themselves superintendents of the household.[10]

From the time it was built, the design of the villa, together with its location, would have endowed it with a further set of associations in the minds of educated onlookers. Marble Hill was rich in allusions to the ideal of the classical villa, both of the sixteenth century Veneto and the ancient *campagna* of the Roman poets Virgil and Horace. A popular myth grew up in which Twickenham was seen not only as the most elegant suburb reserved for the capital's courtiers, men of wealth, letters and art, but as an ideal society in itself, an "Earthly Elesium"[11] in which "we seem to tread on classic ground".[12]

Alexander Pope, the most famous poet of the day, was the prime source and popu-

lar focus for this myth. He had leased a house at Twickenham since 1719 on the proceeds of his translation of Homer's *Iliad*, and he encouraged, through his own poetry, the ideal of rural retirement that had first been celebrated by the pastoral poets of classical Rome. Pope's house was remodelled in the Palladian style in emulation of the perfectly proportioned villas built in the sixteenth century by Andrea Palladio along the Brenta between Padua and the Venetian Lagoon. These in turn had been built for gentlemen retiring from commerce to cultivate landed estates, and were based upon classical architecture. Palladio had recommended that the most "agreeable, pleasant, commodious, and healthy situation" was to "build upon a river... it will afford a beautiful prospect".[13]

Besides designing and cultivating his own garden, which attracted many visitors from his own lifetime, Pope advised Lady Suffolk and the royal gardener, Charles Bridgeman, on the design of the grounds of Marble Hill, and acted as all but caretaker in Lady Suffolk's absence. Pope's villa was itself the subject of innumerable engravings and paintings,[14] but following its demolition in 1807, Marble Hill increased in importance for visitors to this 'classic ground' (cat. 36).

Amid this web of associations, the classical idea of architectural appreciation as the activity of gentlemen of taste ensured that Marble Hill attracted attention in its own right as a fine building. Indeed, this was how it first appeared in *Vitruvius Britannicus*. Recognition of the importance of this side of Marble Hill's appeal helps to explain the quantity of views produced, and the way in which they were originally seen.

Colen Campbell published the design (cat. 38) but Henry Herbert, 9th Earl of Pembroke is named as the architect of Marble Hill in Horace Walpole's *Anecdotes of Painting in England* (1762), while surviving bills reveal the actual construction to have been undertaken by the builder-architect Roger Morris. Lord Herbert had travelled to Venice in 1712 and was heir to Wilton House near Salisbury, a seventeenth century mansion enlarged by Palladio's greatest English admirer Inigo Jones, architect of the earliest Palladian villa in England, the Queen's House near the Thames at Greenwich (cat. 3). The essence of the Palladian style lay in the perfect harmony of classical proportions, both in the size of rooms and the exterior elevation. The almost exact realization of Campbell's published design, and the lack of substantial modifications over two and a half centuries, makes it possible to appreciate Marble Hill today much as Campbell intended.

Symmetry is immediately apparent in Marble Hill's principal facades which mirror each other; a suggestion of grandeur on the north front is achieved through the addition of bold Ionic pilasters above a rusticated ground-floor storey. The use of smooth stucco over brick emphasizes the precise geometry, punctuated by the Portland stone dressings to the windows and doors, and underlined by the finely ruled entablature. The clear division of the rectangular elevation of three principal storeys into one central and two flanking bays is maintained in the equally coherent rectangular plan.

Like the mirror-image achieved between north and south facades, each storey repeats the one above or below it with only minor variations. These changes emphasize the ingenuity of the design, which even manages to accommodate a long gallery (a non-Palladian requirement in English houses since Jacobean times) without disruption to the second floor. On the first floor, the parallel rooms are compactly arranged *en suite* around the Great Room, a perfect cube of twenty-four feet modelled on Inigo Jones's 'Single Cube Room' at Wilton. All the rooms are subordinate to this main cube, which penetrates into the third storey without disturbing the arrange-

ment of the three central windows on the south front, its high vault rendering them blind. Decorated with elaborate carvings, extensive gilding, and a set of five capriccio views of ancient Rome by G.P. Panini, the Great Room presents a spectacular contrast to the sense of serene repose carefully built up in visitors' minds before they enter from the staircase landing. This was not mere sensationalism, but again followed the Palladian ideal of the man of taste. As Inigo Jones wrote in one of his notebooks after returning from his Italian tour of 1613-14:

> as outwardly every wise man carrieth a gravity in public places, where there is nothing else looked for, yet inwardly hath his imagnacy set on fire... so in architecture the outward ornaments ought to be solid, proportionable according to the rules.[15]

The visual effect of Marble Hill would have made a distinct impression on people travelling to and from London by river. Whether they knew the owner or not, they would have recognized it as the home of a person of erudition and taste, familiar with the new classical revival in architecture. This primarily visual appeal of Marble Hill, in contrast to the associative interest outlined earlier, has a further dimension that helps to account for the continued production of popular views. The immediate setting within 'this Earthly Elesium' of Twickenham was a carefully landscaped park which emphasized the villa's 'prospect', both towards and from the river, while affording further fine views from the house to the north and east. Campbell's account of "A New House at Twittenham" that accompanies the engraving in *Vitruvius Britannicus*, begins "This House is situated very near the *Thames*, and has a good Prospect of that beautiful River."[16] The situation is further stated on the engraving where the two principal facades are labelled "front to Twittenham park" and "Front to the River". Judging from Heckell's engraving of 1749 (cat. 40), the design of the grounds clearly emphasized this river frontage. The careful planting of trees physically binds the house to the river while suggesting both the illusion of a grand avenue receding in perspective, and great wings reaching out from the house. The garden seats visible in the engraving suggest an informal park; behind the trees lay a working farm, with a corn-field to the north. No fences obscured the view to and from the Thames at this time, but instead the lawns were terraced down to the river. As Lady Suffolk's nephew, the 2nd Earl of Buckinghamshire, wrote from St. Petersburg in 1763 of these prospects:

> I hope tho' other countreys complain of the incessant rain, that the Marble Hill harvest has been fortunate. At the worst I comfort myself with thinking that you would cheerfully give up your prospect of wheat and barley for a green meadow and a full river.[17]

A further prospect from the house was the view towards Richmond Hill. J.H. Pye's *A Short Account of the Principal Seats and Gardens, In and about Twickenham* (1760) described Marble Hill:

> as white as Snow, a small Building without Wings... in a fine green lawn, open to the River, and adorned on each side by a beautiful Grove of Chestnut Trees... the Garden is very pleasant: there is an Ally of flowering Shrubs, which leads with an easy Descent down to a very fine Grotto; there is also a smaller Grotto, from whence there is a fine View of Richmond Hill.[18]

Lady Suffolk and her visitors could enjoy the prospect of Richmond Hill from her

grotto much as Pope was able to gaze out from his grotto onto the Thames and its traffic. The balconies visible in Heckell's engraving (an addition not included in Campbell's design) would have provided additional vantage points from which to enjoy the prospect of both river and hill.

Pye's account implies that the public were not confined to the road and river, but may have visited Marble Hill almost as they do today. It was not unusual for Pope's servants to admit the public to his villa and gardens in his absence, and a guide was published in 1745, the year after his death. Horace Walpole had a set of rules printed for visitors to Strawberry Hill in which his housekeeper had firm instructions to admit no more than one party of four per day by appointment. It seems highly likely that people visiting the Twickenham homes of Pope and Walpole would have wanted to visit the nearby villa of their friend Lady Suffolk, and so would have enjoyed the fine prospects Marble Hill commanded.

None of the later residents erased the wealth of memories Lady Suffolk left behind when she died at Marble Hill in 1767. A later royal mistress did, however, add to the villa's popular appeal. According to James Thorne's *Environs of London* (1876), "it was rented by Mrs. Fitzherbert whose irregular marriage ceremony with the Prince of Wales, afterwards George IV, it has been said was performed here".[19] In fact, Mrs. Fitzherbert's name first appears in the rate books as a resident of Marble Hill in 1795, ten years after her marriage.

Several further tenants occuped Marble Hill until 1816 when it passed to the 5th Earl of Buckinghamshire. In 1824 the property was sold to an army agent, probably as a speculation, as he sold it in the following year to General Jonathan Peel, Secretary of State for the War Department, brother of Sir Robert Peel and an outstanding breeder of racehorses. Peel lived here for fifty-four years, nearly twenty years longer than Lady Suffolk, during which time the house continued to be identified with Lady Suffolk on engravings and in guides to the area. After his death in 1879 his widow retained the estate until her death in 1887.

Fashionable interest in the reign of George II kept the memory of Lady Suffolk alive in the nineteenth century and encouraged a nostalgic attitude towards Marble Hill. Her letters were published in 1824 "with historical, biographical, and explanatory notes" which are at pains to correct accounts in Walpole's *Reminiscences*. The latter's *Memoirs of the last ten years of the reign of George the Second* appeared in 1822, and an edition edited by Lord Holland followed in 1847. A further key source of first-hand accounts of Lady Suffolk appeared in 1848, *Memoirs of the Reign of King George the Second* by John, Lord Hervey. The nineteenth century also saw editions of the letters of other members of Lady Suffolk's circle. The quantity of mid-eighteenth century engravings reissued at this time included the classic views of Marble Hill, and would have complemented these publications, keeping the associations with the Augustan age alive. Lady Suffolk's place in the Victorian public's imagination was fully established by Walter Scott's historical novel *The Heart of Mid-Lothian* (first published 1818) in which the heroine, Jeanie Deans, pleads with Queen Caroline in the company of Lady Suffolk for her half-sister's life. The avenue of lofty elms in which this crucial scene is set was long mistakenly sought out at Marble Hill, instead of in Richmond Park, as *The Builder* pointed out in 1890, although "thousands have scanned curiously from the deck of a river steamer".[20]

The Heart of Mid-Lothian is of further interest beyond confirming the place of Lady Suffolk, and hence Marble Hill, in the popular imagination in the nineteenth century. The novel contains the best-known prose description of the celebrated pros-

pect from Richmond Hill. On a clear day this commanding panorama of the Thames Valley reveals hills beyond Guildford to the west, Windsor Castle, and to the north, the church spire of Harrow on the Hill and the heights of Highgate. Scott described:

> a commanding eminence.... where the beauty of English landscape was displayed in its utmost luxuriance... A huge sea of verdure, with crossing and intersecting promontories of massive and tufted groves, was tenanted by numberless flocks and herds, which seemed to wander unrestrained and unbounded through the rich pastures. The Thames, here turreted with villas, and there garlanded with forests, moved on slowly and placidly, like the mighty monarch of the scene, to whom all its other beauties were but accessories, and bore on its bosom an hundred barks and skiffs whose white sails, and gaily fluttering pennons, gave life to the whole.[21]

Richmond Hill itself was not as unspoilt as Scott portrays it around 1730, when this scene takes place. Wealthy gentlemen lived on the hill from the sixteenth century but its wider attraction as a resort dates from the discovery of a medicinal spring in 1688. By 1696 concerts were being performed at 'Richmond New Wells'; a theatre opened on the hill in 1719 and in 1738 followed the best known of the several taverns, The Star and Garter. Among the most notable of the new Georgian houses is No. 3 The Terrace, built around 1760, probably by Sir Robert Taylor for Christopher Blanchard, cardmaker to George III, and later occupied by Mrs Fitzherbert.[22] The King's architect, Sir William Chambers completed Wick House in 1772 for the first president of the new Royal Academy, Sir Joshua Reynolds, and in 1775 The Wick was built by Robert Adam's rival Robert Mylne for Lady St. Aubyn. Richard Brinsley Sheridan lived at Downe House. The conflict of interest between pleasure-seeking day-trippers, the tradesmen they attracted, wealthy residents in search of privacy and 'men of taste' who wished to stand and admire the prospect in its entirety, must have produced many an amusing spectacle.

In addition to the wells, theatre and taverns, numbers were swelled by the publication of poems and exhibition of paintings inspired by the prospect. Scott was not, of course, the first to try and encompass the panorama in words, and the passage in *Summer* from James Thomson's *The Seasons*, first published in 1727, is the best known treatment in verse. Thomson lived in Richmond from 1736 until his death in 1748, and as a friend of Gay, Pope and Arbuthnot may well have known Lady Suffolk. In his poem the sense of exultation builds to an almost breathless exclamation, but then suddenly deflates with the recognition of London. His is a pastoral vision, a landmark of early romantic verse that reminds us that the outstanding appeal of such prospects lay in their being on the capital's doorstep, as an escape from the confines of London. The rural view from Richmond Hill thus provides a revealing contrast in both topography and attitude to the panoramic sweeps towards the city of London available from the other vantage points in the eighteenth century, Greenwich Hill and Hampstead. Thomson invites 'the raptur'd eye' to turn:

To where the silver Thames first rural grows,
There let the feasted eye unwearied stray:
Luxurious, there, rove through the pendant woods,
That nodding hang o'er Harrington's retreat
And stooping thence to Ham's embowering walks,
Here let us trace the matchless vale of Thames;
Far-winding up to where the muses haunt
To Twit'nam's bowers.

. . .

Heavens! what a goodly prospect spreads around,
Of hills and dales, and woods, and lawns, and spires,
And glitt'ring towns, and gilded streams, till all
The stretching landscape into smoke decays.

Extracts such as this were a regular ingredient in the picturesque guide-books that sightseers carried to Richmond and Twickenham. In the nineteenth century they were illustrated with engravings after paintings by De Wint (cat. 68), Turner (cat. 67), Clarkson Stanfield and others. Engravings after Turner's paintings of the view from Richmond Hill in particular, probably did as much to establish this prospect in the public mind as the writings of Thomson and Scott.

Some poets described the view as being beyond the abilities of great painters, setting a challenge to any ambitious artist. For example, the poem *Richmond Hill* of 1809 described how:

A brighter, richer landscape lies display'd
Than ever Poussin sketch'd, or Claude portray'd.[23]

Others were patriotic in interpreting their spiritual exultation in terms of national supremacy, enjoying a sense of national pride instilled by this "fair PARNASSUS of the BRITISH ISLES!"[24]

Marble Hill was clearly visible from Richmond Hill when the prospect was painted by Tillemans (fig. 20) and Joli (cat. 62) and although trees on the estate soon grew to conceal the white villa itself, they in turn provided an essential ingredient. The importance of Marble Hill to this prospect became increasingly apparent when the march of London's bricks and mortar reached Twickenham. While surrounding estates fell to the speculative developer, the residence of General Peel and then his widow at Marble Hill for over sixty years, from 1825 to 1887, postponed any real threat. Seen from the hill and river, its appeal can only have grown, not only in the eyes of potential developers, but in the nostalgic minds of readers of Pope, Walpole, Hervey, Scott and others, the associations being heightened by Marble Hill's survival, as a haven from suburban expansion.

In 1901 a local newspaper article opened with the following lines taken from Jonathan Swift's *Pastoral Dialogue between Richmond Lodge and Marble Hill* of 1727:

Some South Sea broker from the City,
Will purchase me, and more's the pity,
Lay all my fine plantations waste
To fit them to his vulgar taste

The writer went on to warn readers "it is not a South Sea broker, or a South African millionaire, who is going to give us some of 'his vulgar taste'. More's the pity! It is the demon builder who will in all probability destroy this historical demesne with his exhibition of latter-day villadom".[25]

The inevitable threat became a reality in 1888 when, following the death of Lady Peel, the estate was put up for auction. At first it failed to sell, but Marble Hill was finally purchased by William Cunard of the shipping family, then resident nearby at Orleans House. In 1901 trees began to be felled and roads laid. The house itself was to be saved as the centrepiece of a suburban estate, a long avenue from Richmond Road providing a prestigious new 'prospect' once the shield of trees had been cleared. The more familiar view of the house from the south was also safe from development as the lawn remained prone to regular flooding before the embank-

ment of the river. But the threat to the estate as a whole, as the sylvan heart of the prospect from Richmond Hill, aroused a public outcry, forcing Cunard to delay the development.

In the same year, the *Architectural Review* outlined the danger:

The centre and critical point of the view, the wooded promontory that forms the inside curve of the river is, it will be seen Marble Hill.... it is evident that the deep wedge of woodland formed by Marble Hill is its most necessary and indispensable part; that spoiled, the view tumbles to pieces, with an eyesore for its focus.[26]

As *The Daily Telegraph* later put it, "there was a danger of Marble Hill being built upon, and so forming a blot upon the magnificent landscape."[27] After such visual arguments came the historical associations of the king's 'favourite', who was, "able to set up her own little court by royal subsidy, and, have it shaped by her courtier artists and men of letters".[28] The house was seen to hold a significant place in English literature, for "Marble Hill is a monument of our poetry, where we may taste the orderly dream of eighteenth century classics".[29] As a building, Marble Hill was seen as "an architect's rendering of the feelings of Pope in the forms of Palladio".[30]

Such arguments for saving the estate echoed the attitudes of those past admirers who commissioned and collected engravings and paintings of the house. But they also summarized its appeal like an obituary.

In July 1901 the Richmond Hill View Executive Committee was formed, number-ing among its members the artists Sir Edward Poynter, P.R.A., and Sir William Blake Richmond, R.A. Negotiations ensued, donations were received, and the press kept up its campaign, reporting at one point the fear that "This might become a place for beanfeast parties".[31] Finally, in June 1902 following an Act of Parliament the property was secured. The official opening on 30 May 1903 was not auspicious. According to *The Daily Telegraph* guests took refuge:

inside the house, smelling damp and musty after having remained for so long a period untenanted.... Meantime the lightning flashed, the thunder thundered, and the inky clouds poured down their contents upon the already soaked earth as though they would never cease.[32]

The press accounts of the official speeches present Marble Hill's importance as part of the view from Richmond Hill in a bolder light than we have considered it hitherto:

They felt that a national view was at stake; that a historic view was at stake, nay, that a view that was necessary to the whole world was at stake; and they never relaxed their efforts till victory was won. (Applause)... It was not only the glory of London, but the glory of the British Empire; and it was one of those things which struck foreigners visiting this country with amazement and delight.[33]

In the history of British landscape painting, the prospect from Richmond Hill holds a distinguished place, as a challenge to which some of our greatest artists have responded. Like the views from Greenwich Hill, Blackheath and Hampstead Heath it presents an extensive plain through which the Thames gently winds towards dis-tant hills. But unlike these prospects of the City and Westminster it offers a more pas-toral outlook, rich in associations with the eighteenth century ideal of rural retire-ment in elegant villas. Judging by the quantity of paintings and engravings produced that included Marble Hill, this was arguably the most popular of all the villas spread

out in this 'classic ground', rivalling Pope's villa for attention, and gaining in importance after the latter was demolished in 1807. Marble Hill's appeal depended not only on such fine Palladian architecture set in a landscaped park, but on a web of ideas, anecdotes and attitudes focussed on Lady Suffolk and her circle. When first produced, the paintings and engravings would have evoked innumerable associations, familiar at the time but far more remote to us today. In the same way, the panoramic view from Richmond Hill itself inspired, as we have seen, a variety of responses to a finer prospect: "Than ever Poussin sketch'd, or Claude portray'd".

1. An 'epoch making-model' according to John Summerson, *Architecture in Britain 1530-1830* (Harmondsworth, 1979) p.360
2. Defoe, I, Letter II p.121
3. See: Patrick Youngblood, 'The Painter as Architect: Turner and Sandycombe Lodge', *Turner Studies*, II (1) pp.20-35, and Mordechai Omer *Turner at Twickenham* (London, 1975)
4. Colen Campbell, *Vitruvius Britannicus* III, 1795, p.9, pl.93
5. Quoted in J.W. Croker, (ed.), *Letters to and from Henrietta, Countess of Suffolk and ... George Berkeley* (London, 1824) p.xxiv
6. Hervey, I pp.426-7
7. Quoted in Melville, p.253
8. Croker, *op. cit.* p. xv
9. *Gentleman's Magazine*, LXIV (1794) p.182
10. Croker, *op. cit.* p.xvii
11. J.H. Pye, *A Short Account of the Principal Seats and Gardens In and about Twickenham* (London, 1760) p.53
12. Joseph Giles, by 1763, quoted in Solkin, p.80
13. Isaac Ware, *The Four Books of Andrea Palladio's Architecture* (London, 1738) pp.46-7
14. See: Morris R. Brownwell & Jacob Simon, *Alexander Pope's Villa*, exhibition catalogue, Marble Hill House, 1980
15. Quoted in J.Alfred Gotch, *Inigo Jones* (London, 1928) p.82
16. Campbell, *op. cit.*
17. Historical Manuscripts Commission *Report on the Manuscripts of the Marquess of Lothian* (London, 1905) p.177

18. Pye, *op. cit.*
19. James Thorne, *Handbook to the Environs of London* (London, 1876) p.633
20. *The Builder*, cutting dated 12 July 1890, Twickenham Reference Library.
21. Walter Scott, *The Heart of Mid-Lothian*, Waverly Novels, III (Edinburgh and London, 1843) p.563, (first published 1818).
22. H.E. Malden (ed.), *The Victoria History of the County of Surrey* (London, 1911) pp. 538-540; N. Pevsner *Surrey* (Harmondsworth, 1971) p.440
23. Quoted in Manwaring, p.118
24. Maurice, quoted in *The General Ambulator* (London, 1820) p.274
25. Cutting dated 1901, Twickenham Reference Library
26. D.S. MacColl, 'Richmond Hill and Marble Hill' *Architectural Review*, X (1901) p.25
27. *The Daily Telegraph*, cutting dated 1903, Twickenham Reference Libary
28. *Architectural Review*, *op. cit.* p.26
29. *ibid*. p.28
30. *ibid*.
31. *The Richmond and Twickenham Times*, cutting dated 20 October 1901, Twickenham Reference Library
32. *The Daily Telegraph*, cutting dated 1 June, 1903, Twickenham Reference Library
33. *The Herald*, cutting dated 6 June, 1903, Twickenham Reference Library

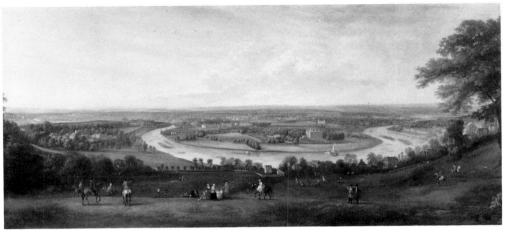

Fig. 20 Peter Tillemans *The Thames from Richmond Hill* c. 1720-23,
Government Art Collection

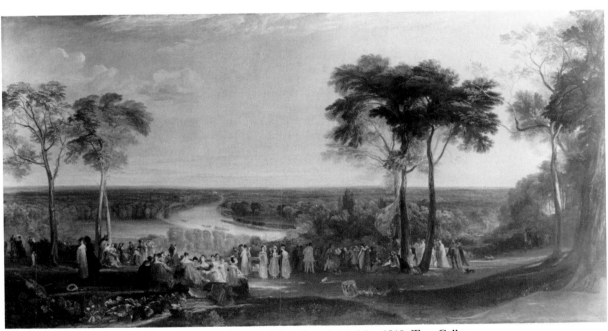

Fig. 21 J.M.W. Turner *England: Richmond Hill, on the Prince Regent's Birthday*, 1819, Tate Gallery

Catalogue

COL. PLATE III



CHARLES JERVAS c. 1675-1739 attrib.

35. *Henrietta Howard, 9th Countess of Suffolk*, c.1724
Oil on canvas; 38¼×46 in. (97.2×117cm.)

PROVENANCE: Strawberry Hill by 1784; Strawberry Hill sale, 18 May 1842 (4), bt. Earl of Buckinghamshire, thence by descent.
EXHIBITED: *The Countess of Suffolk and her Friends*, Marble Hill House, 1966 (21).
LITERATURE: John Kerslake, *Early Georgian Portraits* (London, 1977) pp.272-4

At the time this portrait was painted, Mrs. Howard (as she was then known), was Woman of the Bedchamber to the Princess of Wales, and mistress of the future George II. Marble Hill, the Twickenham villa built with her allowance from the Prince of Wales from 1724-9, was still on the drawing board. The setting for this portrait may be intended to evoke the prospect from Richmond Hill, with an imaginary view of her proposed villa in the background. If this is the case, the portrait can be dated before 1725 when Campbell published his design for Marble Hill (cat. 38) and even before 1723 when Mrs. Howard asked John Gay not to mention "the Plan which you found in my Room … its almost intirely finish'd to my satisfaction".[1] The castellated cube with corner pinnacles, set on a low cliff, is, however, so unlike Campbell's design that an alternative identification cannot be ruled out; there is no resemblance to Blickling, Henrietta Howard's childhood home in Norfolk. A building shown to the right of this gothick 'keep' is closer to Marble Hill in outline, but the only prominent feature in the estate grounds, The Priory of St. Hubert, designed by Horace Walpole's architect Richard Bentley, was not built until 1758.

The portrait is first mentioned as hanging in the Round Bed Chamber of Walpole's Strawberry Hill in 1784, when it was described as "Henrietta Hobart countess of Suffolk sitting; a view of her house at Marble-hill, Twickenham: by Jervas. It was Pope's: lady Suffolk bought it at Mrs. Martha Blount's sale, and gave it to Mr. Walpole".[2]

1. Quoted in Draper and Eden, p.13
2. Quoted in Kerslake, p.273

The Hon. Ian Hope-Morley

PETER TILLEMANS 1684-1734

36. *The Thames at Twickenham, with Pope's Villa* c.1730
Oil on canvas; 27¼×54⅛ in. (69×137.5cm.)

SIGNED: *P. Tillemans F.*
PROVENANCE: Duke of Bedford; Arthur Tooth & Sons, 1953; Richard Green, 1976; British Rail Pension Funds.
EXHIBITED: Doncaster Museum and Art Gallery; *Alexander Pope's Villa*, Marble Hill House, 1980 (2); *Twickenham 1600-1900 People and Places*, Orleans House Gallery, 1981 (74); *James Gibbs*, Orleans House Gallery, 1982 (81); *Blest Retreats*, Orleans House Gallery, 1984 (41); *35 Paintings from the Collection of the British Rail Pension Funds*, Agnew's, 1984 (33)
LITERATURE: Robert Raines, 'Peter Tillemans, Life and Work, with a list of representative Paintings', *Walpole Society*, XLVII (1978-80) pp.21-59 (58); Morris R. Brownwell and Jacob Simon *Alexander Pope's Villa*, , exhibition cataolgue, Marble Hill House, 1980 (2); Terry Friedman, *James Gibbs* (New Haven and London, 1985) pp.139-140.

Alexander Pope lived at Twickenham from 1719 and his villa, here seen left of centre on the north bank of the Thames, became a landmark of the area. The residence of this epic poet of the Augustan era enriched the associations of this stretch of the Thames, so often described as 'classic ground'. The proximity to Hampton Court and Richmond Palace, combined with the comforts and relative safety of travel by river, had long made Twickenham and Richmond fashionable for courtiers and retired businessmen, prompting the building of fine villas, such as Tillemans has painted. Between Pope's villa and, on the right, St. Mary's, Twickenham, we see here the domed summerhouse of Lady Elizabeth Shirley, widow of the 1st Earl Ferrers; the home of Barnaby Blackwell, banker and governor of the Foundling Hospital; and the house of William Batty, later known as Poulett Lodge. Marble Hill stands out of view downstream on the same bank beyond Twickenham village.

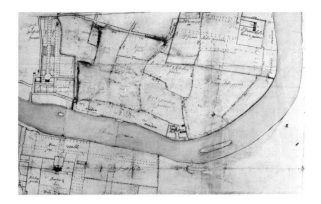

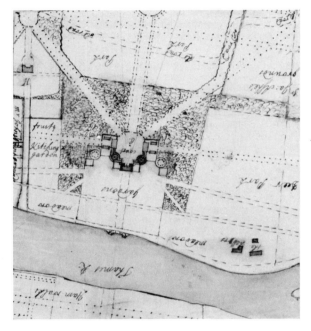

As a close friend and neighbour of Henrietta Howard, Countess of Suffolk, Pope advised on the design of the grounds of Marble Hill and frequently supervised the house during her absence at Court. Pope's villa was remodelled in the Palladian style by James Gibbs from 1719-20, and was demolished in 1807. Pope considered Tillemans, with John Wootton (cat. 76), to be one of "the two best landscape painters in England."[1] Tillemans came to England from Holland in 1708 and as a topographical draughtsman illustrated John Bridges's *History of Northamptonshire*. Like Wootton, Tillemans also responded to the demand for noble prospects of gentlemen's seats and estates. For Pope's neighbour, the Earl of Radnor (the future Radnor House is seen behind the 'aight' to the left in this picture) Tillemans painted *The Thames from Richmond Hill* (fig. 20), *View of Richmond from Twickenham Park*, and *Greenwich Hospital and the Thames from One Tree Hill*.[2] In 1734 the engraver and antiquary George Vertue noted that the artist's "late place of residence for the Air and his health was at Richmond".[3]

The wide horizontal composition of this painting and attention to architectural detail set it in the tradition of topographical drawings and etchings by Wenceslaus Hollar and Francis Place (cat. 5). The attention to local character, as in the contrast between elegant riders and labourers pulling a tow rope, together with the variety of river craft passing through reflections, enriches the impression of this idyllic setting. The painting might have been commissioned by Pope himself, as the inventory of his possessions included "a landskip by Titeman".[4]

1. Brownwell and Simon, *op. cit.*, p.22
2. Raines, *op. cit.*, pp.24, 53-54
3. *ibid* p.26
4. Brownwell and Simon, *op. cit.*

British Rail Pension Funds Works of Art Collection

JOHN ERSKINE, 11th EARL OF MAR 1675-1732

37. *Sketch of the Grounds at Twickenham*, 1711
Pen and wash; 20½×29 in. (52×73·6 cm.)

INSCRIBED: *Scatch of the Grounds at Twitinham from the Earle of Straffords to Richmond Ferry & also The Grounds of Haml/Octob. 1711* and on overlay *Postoria April 1719 Proposed to be purchased*
LITERATURE: Bryant, pp. 2-6
Photographs exhibited.

This plan records the traditional use of the land on which Marble Hill now stands, with meadows on the river bank, cornfields to the north and west, and fruit and kitchen gardens to the east. These fields belonged to the Manor of Isleworth Sion and the rich alluvial soil was probably tenant farmed.

The overlay, dated 1719, shows a plan to develop the estate before 'Marble Hill Shot' was purchased on Lady Suffolk's behalf for the building of her villa in 1724.

Both plans are bound in a volume of architectural designs dating from 1718-30 when the Earl of Mar, a former Twickenham resident, was in exile on the continent following his involvement in the Jacobite rising of 1715. These designs, which also include plans for a house, indicate that, had he remained in England, he may have developed the

area for his own use, with a larger house, grand avenues and a deer park, in contrast to the simpler scheme for the grounds which Charles Bridgeman and Alexander Pope later provided for Lady Suffolk.

The Keeper of the Records of Scotland

COLEN CAMPBELL 1676-1729

38. *Design for Marble Hill House*, c. 1723
Pen and wash; 8⅘×15⅕in. (22.5×40.2cm.)

Marble Hill House was built from 1724-9 for Henrietta Howard, later Countess of Suffolk, mistress to King George II. In July 1723 Mrs Howard wrote to the poet John Gay, after he had found a plan in her apartments at Richmond Lodge, asking him not to reveal "the Plan which you found in my Room. There's a Necessity, yet, to keep that whole affair secret, tho' (I think I may tell you) its almost intirely

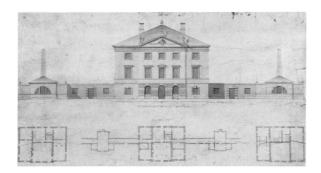

finish'd to my satisfaction".[1] The plan may have been this design, executed by Campbell or one of his assisants. The actual building of Marble Hill was undertaken by Roger Morris under the supervision of Henry Herbert, 9th Earl of Pembroke. No explanation for the withdrawal of Campbell after producing this design, and the revised version he published in 1725, has yet been given.

1. Quoted in Draper and Eden, p.13

The Rt. Hon. the Earl of Pembroke

the greatest exponent of the revival of classical architecture, contrasting him with the current Baroque style. Campbell's title refers to Vitruvius Pollio, a Roman architect at the time of Augustus, whose treatise *De Architectura* is the only technical work of its kind to survive from antiquity. Inigo Jones was the third figure Campbell held in high esteem, and the influence of Jones's Queen's House at Greenwich (1616-35, cat. 3) itself modelled on the villas of Palladio, can be seen in this design for Marble Hill.

The most significant difference between the published engraving and Campbell's original design (cat. 38) is the lack of pavilion wings. These, and the exterior staircase or 'perron' shown in the engraving, were never built, nor were the architectural finials added to the roof. The end result is a far simpler elevation; this may have been prompted as much by the uncertainties of the patron's income, as mistress to King George II, as by the pursuit of 'purity' in design.

Marble Hill House (Presented by Ben Weinreb)

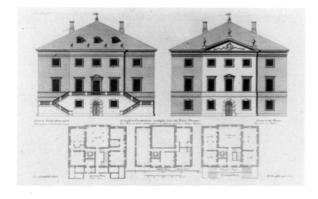

HENDRICK HULSBERG fl.1700-29
after COLEN CAMPBELL 1676-1729

39. *A house in Twittenham*, c. 1725
Engraving; 10×5in. (25.4×38cm.)

INSCRIBED: *p:93 Vol:3ᵈ./front to Twittenham park/A house in Twittenham midlesex near the River Thames./Front to the River./Elevation a Twittenham park/Un Maison dans Twittenham midlesex aproche le Rivier Thames/ Elevation a le Rivier/Ca: Campbell delin:/H: Hulsbergh Sculp:*

These elevations and plans of Marble Hill House first appeared as simply 'A house in Twittenham' in the third volume of *Vitruvius Britannicus*. This collection of designs for buildings, including the major new works in the Palladian style, was compiled by the architect Colen Campbell and published from 1715. In his introduction, Campbell praised the sixteenth century architect Andrea Palladio as

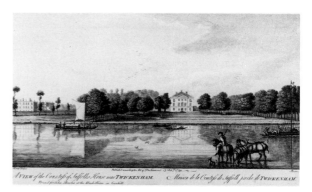

A VIEW of the Countess of Suffolk's House near TWICKENHAM. / Maison de la Comtesse de Suffolk proche de TWICKENHAM.

JAMES MASON c.1710-85
after AUGUSTIN HECKELL c.1690-1770

40. *The Countess of Suffolk's House near Twickenham*, 1749
Engraving (hand coloured); image size: 8¾×16in. (22.6×40.5cm.)

INSCRIBED: *A Heckell Delin.'/Publish'd according to Act of Parliament 13 Feb.ʳ./1749 Mason Sculp./A VIEW of the Countess of Suffolks House near TWICKENHAM./Maison de la Comtess de Suffolk proche de TWICKENHAM./Printed for John Bowles at the Black Horse in Cornhill.*

The south front of Marble Hill is seen here from the Thames as it has appeared to river traffic since its completion in 1729.

The view is little changed today, but for the towpath which now runs along the embanked river, and the loss of chestnut trees. The only difference from the architect's revised design of 1725, apart from the omission of decorative finials (cat. 38) is the addition of balconies to lengthened windows on the third storey. These were removed when the square windows were created in 1750-1 by Matthew Brettingham, senior. In their day they enabled Lady Suffolk and

her guests to step outside and enjoy the fine prospects south across the Thames to Ham, east towards Richmond Hill and west up-river. Heckell's view also records the terraced lawn and parallel rows of trees. These are the only surviving visual evidence of the contribution of the King's gardener, Charles Bridgeman, who laid out the grounds of Marble Hill with advice from Lady Suffolk's friend and neighbour, Alexander Pope.

This engraving after Heckell's drawing of 1748 (now in the Lewis Walpole Library) is listed in the publisher's catalogue of 1753, along with several similar views by Heckell. *Perspective Views in and about London* was "a collection of pleasant views of the most noted places in London and the adjacent parts drawn in Perspective by Gravelot, Rigaud, Heckell and Morier". Topographical engravings such as this, but on a smaller scale, were frequently used as illustrations to tour books from the last quarter of the eighteenth century. Bowles's catalogue, however, clearly states how these engravings were originally displayed; they were held "not only in esteem for furniture in frames and glasses, but are much used in proper colours without frames, for viewing in the Diagonal Mirror, in which method of looking at them, they appear with surprising beauty, and in size but little inferior to the real places".[1]

The enormous success of this engraving and, by implication, the popularity of this view of Marble Hill, is indicated by the number of later impressions issued and the quantity of derivatives, in which there are minor alterations to the boats. Later impressions were published by Bowles's successors, Bowles and Carver, and in turn by Robert Wilkinson. Frances West included it in *A Collection of Views of old London and its environs* (c.1840).

1. John Bowles and Son, *A Catalogue of Maps, Prints, Copy-Books* (London, 1753) pp 43-6.

Marble Hill House

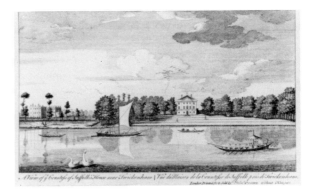

J. WOOD 1720-80

41. *A View of ye Countess of Suffolk's House near Twickenham*, 1753
Engraving; image size: 6⅛×10⅜in. (15.5×26.5cm.)

SIGNED (in pencil within sail): *J Wood of Hampton court 1753*
INSCRIBED: *A View of yᵉ Countess of Suffolks House near Twickenham/Vüe*

du Maison de la Countesse de Suffolk prés de Twickenham./London Printed for & Sold by Henʸ. Overton without Newgate

While clearly derived from Heckell's view of 1749 (cat. 40), this engraving differs in certain details, most noticeably the inclusion of a pleasure barge, in which four oarsmen row three ladies seated beneath a large parasol, to the accompaniment of a French horn. This motif replaces the watering horses and working barge in the original.

London Borough of Richmond upon Thames

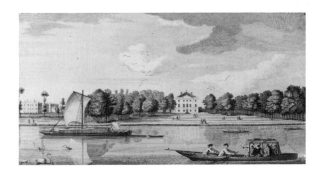

ANON

42. *Marble Hill House from the River*, after 1749
Engraving (hand coloured); image size: 8⅝×15⅛in. (22×38.4 cm.)

A vivid impression of the extent of popular interest in Marble Hill in the eighteenth century is conveyed by this coloured engraving derived from Heckell's view of 1749 (cat.40). The more elegant figures added by the later artist include gentlemen discoursing on the villa's beauties to their admiring companions.

The rich colouring and black border suggest that this print may have been used for occassional display, like the Heckell engraving, 'in proper colours without frames, for viewing in the Diagonal Mirror...'[1].

1. See cat. 40.

Greater London Record Office (Maps and Prints)

ANON

43. *Marble Hall, Seat of the Earl of Buckinghamshire, late the Countess of Suffolk's*. 1773
Engraving; image size: 4×7½in. (10×19 cm.)

INSCRIBED: *Vol. 1 Pa 23./Marble Hall, Seat of the Earl of Buckinghamshire, late the Countess of Suffolks.*

The third known derivative from Heckell's engraving (cat. 40), this view of Marble Hill is an illustration to volume one of *A New Display of the Beauties of England*, the second edition

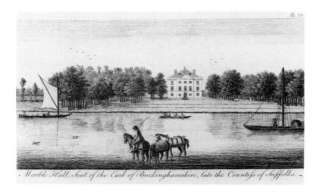

Marble Hall, Seat of the Earl of Buckinghamshire, late the Countess of Suffolks.

of which was published in 1773. This early tour book for country house visitors also included Wricklemarsh at Blackheath (cat.20) and Kenwood (cat. 80).

London Borough of Richmond upon Thames

RICHARD WILSON c.1713-82

44. *The Thames near Marble Hill, Twickenham* c.1762 COL. PLATE IV
Oil on canvas; 22¼×34½in. (56×88 cm.)

PROVENANCE: (?) Lord Frederick Campbell; Louisa Campbell; Miss Campbell-Johnstone; Christie's 1887 bt. General J.H. Campbell-Johnstone; Mr. Campbell-Johnstone, Sotheby's 1955 bt. Fine Art Society; Malcolm MacDonald, O.M.; Sotheby's 16 July 1975 (21), bt. Agnew.
EXHIBITED: *London and the Thames*, Somerset House, 1977 (32); *Richard Wilson*, Tate Gallery, 1982-3 (102)
LITERATURE: W.G. Constable, *Richard Wilson* (London, 1953) pp.187-8; David H. Solkin, *Richard Wilson*, exhibition catalogue, Tate Gallery 1982, pp 187-8, 213-4

When Wilson exhibited a picture entitled *A View of the Thames, near Richmond* at the Society of Artists in 1762 Horace Walpole noted in his catalogue '& part of Marble Hill'.[1] At this time Walpole was a regular visitor to Marble Hill, the home of Henrietta Howard, Countess of Suffolk, then aged seventy-four. Given the quantity of engravings of Marble Hill in circulation at the time, other people probably made the same observation about the picture. The quantity of autograph replicas Wilson painted (of which this is one) together with the later copies it inspired, makes this one of his most popular British views.

Wilson is acclaimed as the greatest British landscape painter of the eighteenth century, but no paintings by him of three of the most celebrated prospects this country can boast are known. This picture is the nearest he came to painting the view from Richmond Hill, even though we know that on at least one occasion he stood on Richmond Terrace alongside Sir Joshua Reynolds, admiring the prospect (cat. 66). Like Reynolds, Wilson had little interest in the expansive topographical approach of Siberechts and Tillemans (fig. 19,20), preferring to create an ideal impression of the scene worthy of the seventeenth century paintings of the Roman campagna by Claude Lorraine. This was wholly

appropriate to an area regarded as an English arcadia of summer villas, already rich in associations with classical poetry. Unlike Reynolds, Wilson came down from the hill and approached his subject even closer than Joli had done (cat. 62), condensing the prospect into a study of light filtering through cloud and foliage and reflected in clear water.

The extent of his idealisation is obvious by comparison with Tillemans's view from further up-river (cat. 36), and with Heckell's print of Marble Hill (cat. 40) and its derivatives. For example, river traffic, including hay barges, travellers and pleasure trippers, has been omitted. Barge horses are almost concealed by the near bank and, in place of the labourers Tillemans showed pulling on a tow rope against the current, two bathers now lounge on the bank, while a further figure reads in the shade. Perfect lawns stretch from Marble Hill to meet the river, leaving none of the silt banks visible in the engraving after Joli. Wilson's idyllic illusion is further achieved by the omission of the other houses Heckell included, and of distant Twickenham. In contrast to the exposed river frontage recorded in engravings, Marble Hill itself is almost concealed by foliage, the more oblique viewpoint creating a sense of sylvan seclusion; even the foreground tree holds an elegant pose, worthy of Claude.

In reworking this popular subject, Wilson escaped the limitations of house portraiture but without reducing the importance of Marble Hill itself. Owing to the dark foliage, the eye is immediately drawn to the white house, small as it is, as if to a setting sun, reflected in the water, when in fact it stands much further back. The normal process of reading a picture from left to right is thus reversed, enabling us to follow the line of the Thames up-river to the horizon. The tall tree frames the house like a separate portrait, like a comment in the margin of the main text, with a second landscape painting alongside. Proceeding left towards the true source of light, we reach a straight trunk and a block of dark foliage that holds our attention on the horizon; here the curving river diverts us back along the line of trees to Marble Hill. In contrast to the less directed overview of a 'bird's eye' prospect, or the simplicity of a frontal house portrait, Wilson's compositon leads the eye through a deep vista; he evokes the character of this corner of the Thames, more as it was 'seen' by Lady Suffolk, Walpole and others, than as it actually appeared.

1. Quoted in H. Gatty, "Notes by Horace Walpole..." *The Walpole Society* XXVII (1938-9) p.82

Marble Hill House

45. *The Thames near Marble Hill*, c.1762
Oil on canvas; 22¼×35in. (56.5×88.8 cm.)

PROVENANCE: Sir John St. Aubyn, Bt. by 1816, thence by descent.
EXHIBITED: (?) Society of Artists, 1762; Royal Academy, 1882 (48)
LITERATURE: W.G. Constable, *Richard Wilson* (London, 1953) pp. 187-8

On 22 May 1816 Joseph Farington noted in his diary:

> Thence to Biggs where I saw a View of the Thames & c by Wilson belonging to Sir J. St. Aubyn & 3 pictures by Barrett. Calcott & Turner came there – Turner much admired the Wilson.[1]

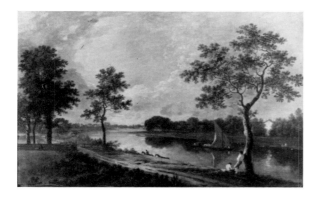

This painting, showing a stretch of the Thames near Twickenham with Marble Hill on the right, is almost certainly the work Farington describes. Four autograph versions are known, of which this is now considered to be the original, on the basis of *pentimenti* left by the artist in the course of conceiving the composition. In 1775 Robert Mylne built The Wick on Richmond Hill for Lady St. Aubyn, widow of Sir John St. Aubyn, 3rd Bt., to whom this painting may have belonged.

1. Kathryn Cave, ed. *The Diary of Joseph Farington*, XIV (New Haven and London, 1984) p. 4840.

Lt. Col. Sir Arscott Molesworth – St. Aubyn, Bt.

46. The Thames at Twickenham, c.1762
Oil on canvas; 23½×36in. (59.7×91.5 cm.)

PROVENANCE: Jeremiah Meyer; Benjamin Booth; Rev. R.S. Booth; Lady Ford; Richard Ford; Sir Francis Clare Ford; Capt. Richard Ford; Christie's, 14 June 1929 (10) bt. Gooden & Fox; Ernest Edward Cook, bequeathed by him to the National Art-Collections Fund and presented to Norwich Castle Museum, 1955.
EXHIBITED: *London and the Greater Painters*, Guildhall Art Gallery, London, 1971 (14)
LITERATURE: W.G. Constable, *Richard Wilson* (London, 1953) pp.89,187

This particular view, up-river towards Twickenham village, proved so popular that four versions are known to have been painted by Wilson; a further twelve copies dating from the eighteenth and nineteenth centuries have been identified. As Wilson's fortunes declined in the 1760s he frequently painted versions, as opposed to copies, of his own work in response to demand; like several of his other subjects, he must have regarded this view as "a good breeder". This version has long been regarded as the first the artist painted, both on account of its ownership by Benjamin Booth (1732-1807), the artist's early patron, and because it was etched by Thomas Hasting as *On The Thames* in 1823. Certainly, the minor differences between this and the painting belonging to Marble Hill (cat. 44) make the latter a better picture suggesting that the Norwich version is the earlier. However, a version at Pencarrow has recently been proposed as the original by David Solkin (cat. 45). As yet, there is no way of knowing with certainty which, if any, of these four paintings is the work Wilson chose to exhibit at the Society of Artists in 1762 as *A View of the Thames, near Richmond*.

Norfolk Museums Service (Norwich Castle Museum)

47. The Thames near Marble Hill, Twickenham, c.1762
Oil on canvas; 18¼×28¾in. (46.3×73cm.)

SIGNED with monogram: *R.W.* (R reversed) lower centre
PROVENANCE: Fonthill sale, 14 October 1823 (243) purchased by the Duke of Newcastle; Earl of Lincoln; Christie's, 4 June 1937 (124) bt. National Gallery.
EXHIBITED: Manchester 1857 (37 D); and most recently British Council, Hamburg etc., 1949-50 (116)
LITERATURE: Martin Davies, *National Gallery Catalogues: The British School* (London, 1946) p. 179; W.G. Constable, *Richard Wilson* (London, 1953) pp.187-8

Although painted by Wilson, this picture has long been recognized as of replica quality. Apart from the obvious reduction in size, the most obvious difference from the painting belonging to Marble Hill is the more cursory treatment of light through foliage and in reflections, making trees seem more solid and the water less shimmering. The far bank has been expanded and the boat's sails now reach the tree above and cut into the bank below, making it rival the house for our attention. The distant boat seen in Marble Hill's picture has been omitted, as has the third swimmer included in the painting from Norwich. The overall effect is not entirely one of simplification, however, as swans have been added to the far bank, and more figures can be seen strolling towards the villa.

The Trustees of the Tate Gallery

WILLIAM MARLOW 1740-1813

48. The Thames looking towards Richmond Hill, c.1775-80
Oil on canvas; 16⅛×25in. (41×63.5 cm.)

PROVENANCE: Bequeathed to the former Borough of Twickenham by The Hon. Mrs Ionides, 1962.
EXHIBITED: *An Exhibition of Paintings and Drawings by William Marlow*, Guildhall Art Gallery, 1956 (37); *Richmond and Twickenham Riverside*, Marble Hill House, 1967 (50); *Where Thames Reflects*, Orleans House Gallery, 1972 (7).

Marlow's view down-river from the Surrey bank of the Thames towards Richmond Hill invites comparison with Richard Wilson's more idyllic paintings showing the same towpath continuing in the opposite direction, up-river past Marble Hill (cat. 44-7). The 'aight' and summer house help to identify Marlow's exact position, clearly visible in Heckell's view from Richmond Hill (cat. 63). Marlow exhibited views of Richmond Hill at the Society of Artists in

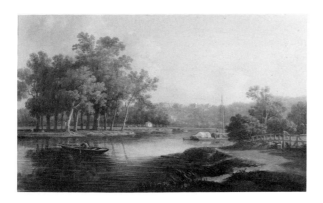

1776 and at the Royal Academy in 1791. The prospect of Richmond Hill was admired from Marble Hill in the eighteenth century, from the balconies on the south front, from the three windows in the gallery along the eastern side of the third storey, and, as an author of a local guide noted in 1760, from a "Grotto, from whence there is a fine View of Richmond Hill".[1]

1. J.H. Pye, *A Short Account of the Principal Seats and Gardens, In and About Twickenham* (London, 1760) pp.19-20.

Orleans House Gallery (Ionides Bequest)

ANON

49. *Marble Hill*, c.1770-93
Watercolour; 6×8in. (15.2×20.3 cm.)

INSCRIBED: *Earl of Buckingham* and *Twickenham*.
EXHIBITED: *Twickenham 1600-1900 People and Places*, Orleans House Gallery, 1981 (33); *Blest Retreats*, Orleans House Gallery, 1985 (101)

The 2nd Earl of Buckinghamshire, nephew of Lady Suffolk, effectively inherited Marble Hill on her death in 1767. However, the complex provisions in her will, which only left the property in trust to Lord Buckingham for life, and also prevented the sale of its contents, led initially to the leasing of the house to a tenant. This watercolour can be dated between 1770, when Lord Buckingham took up residence, and his death in 1793.

Leslie R. Paton

JOHN LINNELL 1792-1882

50. *At Twickenham*, 1806
Oil on board; 6½×10in. (16.5×25.5 cm.)

SIGNED and INSCRIBED (*verso*): *By J. Linnell 1861at Twickenham*
EXHIBITED: *A Decade of English Naturalism 1810-1820*, Norwich Castle Museum and Victoria and Albert Museum, 1969-70 (29); *John Linnell and his circle*, Colnaghi, 1973 (4); *Painting from Nature*, Fitzwilliam Museum and Royal Academy, 1980-1 (72)

In the summer of 1806 the watercolourist John Varley rented a house near the Thames at Twickenham, and daily sent his pupils John Linnell and William Henry Hunt out to sketch, direct from nature in oils. At this time the medium was normally reserved for finished pictures worked up in the studio from pencil and watercolour sketches. The result of the exercise was to close the gap between outdoor studies and studio work in Linnell's landscape paintings.

Sketching in oil, as opposed to pen or watercolour, was still uncommon in England at this time. Although employed by French and Italian artists since the seventeenth century, it was first practised in this country by Thomas Jones, a pupil of Richard Wilson, some thirty years before this sketch was painted. Constable began painting in oil direct from nature in 1802; at the same time as Linnell and Hunt made their studies near Twickenham, J.M.W. Turner was painting from a boat moored nearby. The popularity of the medium reflects the potential demise of prospect painting in favour of naturalism, as artists pursued the effects of changing light on a world which existed entirely as colour, without independant forms or subjects.

This sketch by Linnell can be identified with an inlet on the Middlesex bank of the Thames, west of the Marble Hill estate. Like Wilson, (cat. 44-7) Linnell resists the traditional challenge of the local prospect from Richmond Hill, and has instead stepped straight into its heart, finding near Twickenham an ideal setting in which to study the play of light along the river bank and in the water itself. Unlike Wilson, an old fence is sufficient; the wealth of associations presented by Twickenham's villas is now less relevant. Like Constable's oil sketches (cat. 110-1) this is, however, a private study, not intended for public display in the way Impressionist paintings were half a century later. This dis-

tinction prevented the loss of prospect painting from English exhibitions as artists, including Linnell, continued to paint extensive landscapes to realise their more public ambitions (see cat. 112).

The Trustees of the Tate Gallery

WILLIAM HENRY HUNT 1790-1806

51. *Study from Nature at Twickenham*, c.1806

Oil on board; 13½×6⅝in. (32.9×16.8 cm.)

INSCRIBED (*verso*):*Study from Nature/at Twickenham By Wm.*
Hunt/about 1806
EXHIBITED:*John Linnell and his circle*. Colnaghi, 1973 (130); *Painting from Nature*, Fitzwilliam Museum and Royal Academy, 1980-1 (71)

Like Linnell's contemporary study (cat. 50), Hunt's sketch of the Thames was probably painted west of the Marble Hill estate, and gives some idea of the 'prospect' south across the lawns below the house. In contrast to Linnell's study, Hunt has composed his picture along more traditional lines. Instead of presenting reflections in water, his foreground is uncertain; the tree and fence then provide two clear landmarks beyond, while a third, the boat, is not cut off but is complete, as a final point of focus. Hunt still sees in depth, in the tradition of Wilson (cat. 44-7), whereas Linnell's interest in light, as an overall play of colour without physical form, represents the key to naturalism, an outlook that makes a corner of nature seen from close to as challenging as a fine prospect.

The Trustees of the Tate Gallery

T. MATTHEWS fl. 1815-19
after JOHN PRESTON NEALE 1779-1847

52. *Marble Hall*, 1815

Engraving; image size: 4×6in. (10.2×15.2 cm.)

INSCRIBED:*Engraved by Matthews. from a Drawing by J.P. Neale/for the Beauties of England & Wales./MARBLE HALL./The Seat of Charles Augustus Tulk, Esqr./Middlesex./London, Published by John Harris, St. Pauls Church Yard. Octr 1 1815* and on the boat *J.P. Neale.*

'Marble Hall', as this engraving is entitled, is a corruption of the name of this area, which is first recorded in 1350 as *Mardelhylle*.[1] This later name also derives from the use of white stucco over the brick walls of the house and was only used in the nineteenth century.

This is only the second engraving of Marble Hill to be based on an original view; earlier prints were derived from Heckell (cat. 40). Even allowing for artistic licence in the pursuit of picturesque effect, various changes have clearly taken place over the past sixty-seven years. Most obvious is the growth of trees which blurs the original formal arrangement, the softening of the lawn's terraces and the erosion of the river bank. On the third storey, the balconies in Hec-

kell's engraving are no longer visible; these were removed in 1750-1 when the architect Matthew Brettingham, senior, made several alterations to the house. Where Heckell showed fashionable figures strolling or sitting on shaded benches, J.P. Neale presents watering cattle and grazing sheep. Trees almost obscure the geometrical silhouette of the house and a shadow breaks the symmetry of the fenestration.

The source for this print is Britton and Brayley's *Beauties of England and Wales* which includes a similarly rural impression of Kenwood (cat. 106). The editor's introduction to the series alerts us to the dangers of reading the engravings too literally:

> We sought a new style of *embellishment;* in which accuracy of representation should be combined with picturesque effect.... The bird's-eye views, by Kip, Knyff, & c. and the Views by S. and N. Buck, are highly useful and interesting; but this class of embellishment is at present 'out of fashion'[2].

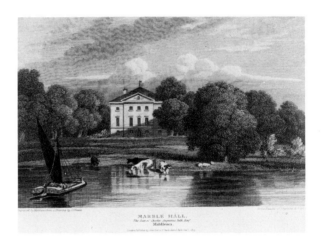

J.P. Neale had become the chief artist of the series by the time this engraving was produced. He was also a friend of the watercolourist John Varley, whose pupils studied near Marble Hill (cat. 50). Recognised today as one of the leading topographical draughtsmen of the Gothic Revival, Neale also exhibited landscape paintings and insect drawings at the Royal Academy, such as *Insects, with a distant view of Castle Hedingham, Essex* (1803).

The accompanying text by J. Norris Brewer provides a valuable description of the appearance of the grounds at the time. It further records the prime associations the area and house presented to people passing along the Thames or seeing the estate from Richmond Hill. Brewer began his account of Twickenham by exclaiming:

> At the name of this village the Imagination glows! Learning, wit, and poetical genius have rendered the neighbourhood classic ground.[3]

On the engraving, the house is presented as *The Seat of Charles Augustus Tulk, Esq.*, but in the text, Marble Hill is identified more with Lady Suffolk and Alexander Pope:

This villa was built by King George II, for his mistress, the Countess of Suffolk.... The grounds are of a pleasing character, and contain much venerable wood. This portion of the premises will be viewed with additional interest, when it is observed that the gardens were laid out by Pope.[4]

In the original volume, Marble Hill is followed by engravings of Pope's villa at Twickenham and of Horace Walpole's Strawberry Hill.

1. Draper and Eden, p.14
2. Quoted in Adams, p.236
3. Britton and Brayley, *op. cit.*, X (1816) p.384
4. *ibid.* pp.388-9

Marble Hill House

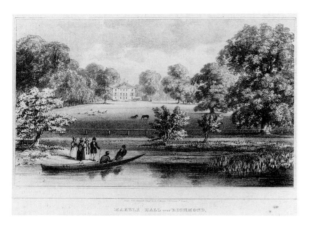

G.E. MADELEY fl. 1830-37

53. *Marble Hall near Richmond*, 1837
Lithograph; image size: 5⅞×9⅝ in. (15×24.5 cm.)

INSCRIBED: *Drawn from Nature & Lithog^d. by G.E. Madeley, 3. Wellington S^t. Strand./MARBLE HALL near RICHMOND/For Sale by Auction by M^r. GEO. ROBINS, at the Auction Mart, on Tuesday July 11^th 1837*

According to the inscription, this print was issued on the occasion of the auction of the house on 11 July 1837. The sale presumably proved unsuccessful as Marble Hill remained the property of General Jonathan Peel, who was resident from 1825-79. A fence and public footpath have been constructed since the earlier views were engraved.

London Borough of Richmond upon Thames

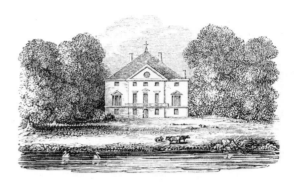

ARTHUR FREELING (ed.) fl. 1835-47

54. *Picturesque Excursions*, 1839

Freeling's *Picturesque Excursions* was one of many Victorian pocket companions, published to meet the increasing demand for guided tours by pleasure-boats along the Thames. Marble Hall, as it was then called, is illustrated among over four hundred other views, and is briefly described as the home of Peel "built by Lady Suffolk, the Mistress of George the Second. Here Swift, Pope, Gay, and many others of the wits and literati of their day often met".[1]

The same wood engraving of Marble Hill appeared in G.W. Bonner's *Picturesque Pocket Companion from London to Richmond, Twickenham and Hampton Court*, of 1832; it is the earliest visual record of full-length windows and a balcony on the south front at first-floor level.

1. Freeling, p.320

London Borough of Richmond upon Thames

Little Marble Hill

SAMUEL MIDDIMAN 1746-1818
after WILLIAM WATTS 1752-1851

55. *Twickenham Meadows, Middlesex*, 1794
Engraving; 7½×5½ in. (19×14 cm.)

INSCRIBED: *Plate 50. Engraved by Middiman, from an Original Drawing by W. Watts./Published Feb^y. 1^st 1794, by Harrison & C^o. N^o.18. Paternoster Row, London/TWICKENHAM MEADOWS, Middlesex.*

Marble Hill Cottage, or 'Little Marble Hill' as this picturesque villa was more often known, stood south-east of the main house from the first half of the eighteenth century until it was demolished around 1882-3. Traces of the original well and ice house in Marble Hill Park indicate its precise location today. From 1782 to 1789 it was the home of Lady Diana Beauclerk, widow of Topham Beauclerk and

from 1790 of Lady Tollemache, probably Frances, unmarried daughter of Lionel, 4th Earl of Dysart of Ham. It continued as the residence of a single lady in 1793 when Henrietta Hotham, grand-neice of Henrietta Howard, Countess of Suffolk, inherited Marble Hill itself and preferred to live here rather than in the main house. In 1806 it was let to Sir John Lubbock, MP, a city banker. When Marble Hill was sold in 1824 to an army agent, Timothy Brent, the purchaser gave 'Little Marble Hill' as his address. His heirs demolished the property and sold the site and grounds in 1883, probably to a speculative builder, but three years later the grounds were reunited with Marble Hill by the owner of the main house, General Jonathan Peel.

When *The Copper Plate Magazine* published this engraving of Little Marble Hill in 1794 the accompanying text evoked its striking setting:

> Among the variety of fine villas, on this splendid bank of the Thames, TWICKENHAM MEADOWS bears a very distinguished rank. Its prospect of Richmond Hill is delightful beyond all power of description.

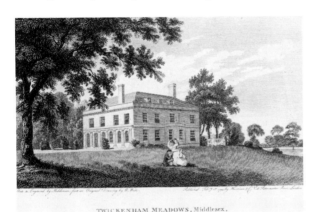

TWICKENHAM MEADOWS, Middlesex.

The gentleman shown holding a telescope is clearly intended to remind us of this fine view. The text continues by attributing this figure, and the two groups of fashionable ladies, to Lady Diana Beauclerk, who lived here when this engraving first appeared in Watts's *Picturesque Views of the Seats of the Nobility and Gentry, in England and Wales. The Copper Plate Magazine* reminds us how:

> From the pencil of her ladyship, indeed, the world has long since been honoured with some exquisite drawings, which are universally admired. One of these elegant productions will be recognized in the minute figures which enrich the present view, and which have been most tastefully sketched in by Mr. Burney, on Mr. Watts's drawing of the house and gardens.

A later engraving of this view, by W.B. Cooke, was published in 1831 and included a sign nailed to the left-hand tree warning onlookers that "steel traps are set in these Grounds."

Marble Hill House

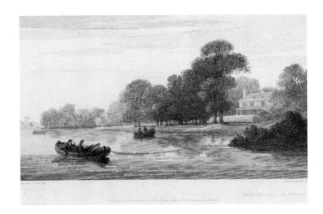

WILLIAM BERNARD COOKE 1778-1855 after SAMUEL OWEN 1768-1857

56. *Marble Hill Cottage, near Richmond,* 1809
Engraving; image size: 5⅞×9½ in. (15×24 cm.)

INSCRIBED: *Drawn by S. Owen, Esq. Engraved by W. Cooke./Marble Hill Cottage, near Richmond./London; Published Nov. 1. 1809 by Vernor, Hood & Sharpe, Poultry, & W. Cook 2 Clarence Place Pentonville.*

Owen's engraving is taken from volume one of *The Thames: or Graphic Illustrations of Seats, Villas, Public Buildings and Picturesque Scenery, on the Banks of that Noble River,* originally published in numbered parts from 1809 to 1811. This visual tour, from the source of the Thames in Gloucestershire to the sea, comprises eighty-four plates by the marine artist Samuel Owen, and a supporting text by William Combe. Combe also contributed the text to Boydell's *History of The Thames* (cat. 9), an earlier work which proved so successful that it inspired this and many similar luxury publications. Intended for fashionable sightseers, these were the precursors of today's 'coffee table' books.

Combe's text provides a vivid impression of attitudes towards this area at this time, and the associations this house would have carried for people passing on pleasure trips along the Thames, or enjoying the prospect from Richmond Hill (cat. 68):

> This charming place is one of those fashionable habitations, called cottages; where, however, opulence may dwell, and luxurious hospitality preside.... A real cottage there once was on this spot, which was then distinguished by its being the habitation of Mrs. Catharine Clive, who, for a long series of years, was the comic charm of the English stage... till the friendship of Mr. Horace Walpole, afterwards Earl of Orford, gave her a superior retreat.... To the right is Marble-hill, which, in more senses than one, may be considered as a classic spot.... It is an Arcadian scene, not indeed inhabited by shepherds, but by high rank, and great opulence; by refined taste and courtly beauty.[1]

1. William Combe, *The Thames* (London, 1811) I, unpaginated.

Marble Hill House

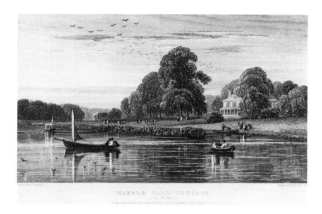

WILLIAM BERNARD COOKE 1778-1855
after PETER DE WINT 1784-1849

57. *Marble Hall Cottage*, 1819
Engraving; image size: 6⅛×9½ in. (15·5×24 cm.)

INSCRIBED: *Drawn by P. Dewint./Engraved by W.B. Cooke/MARBLE HALL COTTAGE./near Richmond./London, Published Feb.ʸ 1, 1819, by W.B. Cooke, 13 Judd Place, East, New Road.*

In the second edition of *The Thames* by William Combe (1822) this engraving replaced the similar view by Samuel Owen included in the first edition (cat. 56). The text remained the same for this plate, but the improvements De Wint made can be seen in the addition of a pleasure ferry, couples in small boats and figures strolling along the bank in contrast to the fishing boats with their nets in Owen's picture. De Wint thus present the Thames as a place of recreation, as it had indeed become, thanks in part to the popularity of tour books such as this.

Of Owen's eighty-four plates in the original edition, only thirty-four remained; other artists employed included Reinagle, William Havell and Louis Francia. The technique also differed in that plates were printed on tissue paper pasted onto impressed card to resemble plate marks. Cooke was one of the leading engravers of his day; he contributed to *The Beauties of England and Wales* (cat. 52) and to J.M.W. Turner's *Picturesque Views on the Southern Coast of England* (1814-26).

Marble Hill House

JOHN JAMES CHALON 1778-1854

58. *Marble Hall Cottage, Twickenham, the summer residence of Robert Vernon, Esq.*, 1839
Oil on canvas; 20×40 in. (50.8×101.6 cm.)

SIGNED and DATED: 1839.
PROVENANCE: Appleby Brothers Ltd., 1965; Private Collection.
EXHIBITED: Royal Academy, 1839 (194)

The splendid prospect of Richmond Hill that Marble Hill Cottage commanded rivals the house itself in this portrait of a summer residence in full bloom. Besides passing boats,

grazing cattle and rustic garden furniture the artist has included portraits of the residents and their pets, set amid flowering shrubs, strong shadows and sunlight. The wealth of detail and observed light makes this topographical view into a souvenir of summer, presumably to last the patron through the winter months.

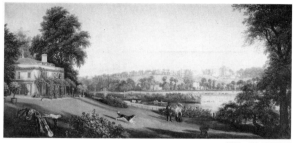

COL. PLATE VI

Although named in the title, Robert Vernon is not listed in the local ratebooks, so he must have rented the property each summer from William B. Brent, nephew of the army agent Timothy Brent who bought and sold Marble Hill House and the estate in 1824. The fact that rates were paid by a series of Brent's tenants from 1845 indicates the end of Vernon's summer visits. He is probably the same Robert Vernon as the army horse dealer who became a major patron of contemporary British painting by buying works direct from artists from 1820; his collection now hangs at the Tate Gallery.

Private Collection

59. *The Garden Front of Mr. Robert Vernon's House at Twickenham,* c. 1840
Watercolour; 20⅛×14⅞ in. (51.1×37.7 cm.)

EXHIBITED: *'Blest Retreats'*, Orleans House Gallery, 1984 (105)

Chalon's studio sale of 1861 included an upright watercolour entitled *Marble Hall Cottage, Twickenham, the residence of Mr. Vernon* (70), which may be identified with this work, and two related watercolours: *Marble Hall Cottage and the Thames* (7) and *The grounds and front of Marble Hall with Mr. Vernon and a dog* (75). The group to which this watercolour belongs, presumably commissioned by Vernon, also includes an oil painting of the cottage with Richmond Hill in the background (cat. 58) and an oil painting of the cottage seen from Richmond Hill (cat. 70).

A Hand-Book to Richmond & Twickenham of 1842 gives the following account of the house:

After walking through Twickenham Meadows we arrive at a beautiful green terrace-walk on the margin of the Thames, where our attention is immediately attracted by Marble Hill Cottage, belonging to W.B. Brent, Esq., seen through the stately trees which surround it. This charming retreat, so justly esteemed for its fine situation and tasteful arrangement, is screened by a rustic verandah, completely covered by the jessamine, woodbine,

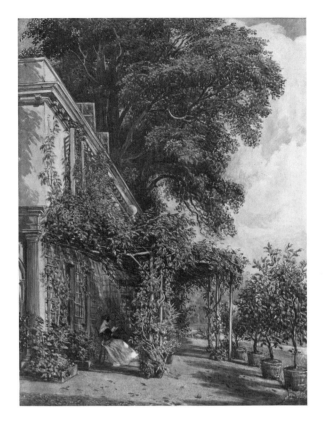

clematis, and rose, and its lawn bedecked with lovely flowers; while over the bower itself immense trees spread their giant arms, as if to protect a cabinet of beauties destined to be the dwelling of Flora herself.[1]

1. Anon., *A Hand-Book to Richmond & Twickenham: with hints to visitors* (London, 1842) p.18

The Trustees of The Victoria and Albert Museum

Richmond Hill

LEONARD KNYFF 1650-1722

60. *The Terrace and the View from Richmond Hill,* c. 1720
Oil on canvas; 23¼×47in. (59×119.4 cm.)

PROVENANCE: Bequeathed to the former Borough of Twickenham by The Hon. Mrs. Basil Ionides, 1962.
EXHIBITED: *Richmond and Twickenham Riverside*, Marble Hill House, 1967 (1); *Where Thames Reflects*, Orleans House Gallery, 1972 (9); *Rich Habitations*, Orleans House Gallery, 1973 (30)

Knyff's panoramic prospect down river and down hill towards Richmond sweeps from Windsor Castle on the left to Harrow on the Hill in the distance on the right. The Roebeck Inn stands in the foreground, with the Bishop Duppa Almshouses beyond, and Mount Ararat to the right. The horseferry can be seen where Richmond Bridge spans

the river today, while on the Twickenham bank stands Cambridge House, with Twickenham Park and Syon House in the middle distance. A similar view painted by Knyff looking up river (fig. 29) reveals open fields where Marble Hill stands today, on the north bank of the Thames opposite Ham House. It also shows the point where Knyff painted this picture, near the entrance to Richmond Park.

The elevated 'bird's-eye' viewpoint and topographical accuracy are typical of the Dutch school of landscape painting to which Knyff belonged. He arrived in London between 1676 and 1681 and specialized in painting and engraving prospects of gentlemen's houses and estates. In 1707, eighty plates by Knyff and Johannes Kip were published as the first volume of *Britannia Illustrata, or, Views of Several of the Queen's Palaces, also of the Principal Seats of the Nobility and Gentry of Great Britain*. This precursor of today's 'coffee table' book, was one of the first of many eighteenth century topographical volumes that appealed to the growing interest in viewing country seats and town prospects.

Orleans House Gallery (Ionides Bequest)

Fig. 29 Leonard Knyff *The View from Richmond Hill* c. 1700, unlocated

JOHN WOOTTON 1682-1764 attrib.

61. *Richmond Hill*, c. 1740
Pen and wash; 12⅔×17½ in. (32·1×44·4 cm.)

Marble Hill can be seen on the right in the middle distance. Judging from the height of the rows of chestnut trees leading down to the Thames from the house, this is the earliest known drawing to include Lady Suffolk's villa. Its prominence as a feature in the celebrated prospect from Richmond Hill is clear in this view from the Star and Garter Tavern. No engraving after this finished drawing is known; it may have been prompted by the completion of the tavern in 1738. The Star and Garter was enlarged in 1770 and again

83

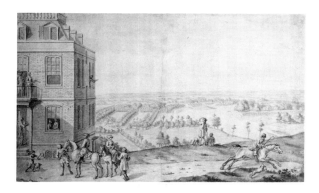

in 1864. The Star and Garter Home, built in 1921-4 for retired servicemen, stands on this site today.

and became a leading engraver, particularly after paintings by Claude and Gaspar Poussin. The effect of this collaboration can be seen here in the preference for tonal contrast and silhouette alongside the broad curve of the river, as compared with the more factual documentation of the prospect seen in engravings hitherto.

The popularity of this view is clear from the number of later editions of this print. First published in 1749, it was reissued around 1819 by Robert Wilkinson in a set of miscellaneous engravings aimed at the fashionable pastime of 'grangerizing' county histories by adding prints and drawings between the appropriate pages. After appearing in Wilkinson's *List of Views, Portraits, & c. to illustrate Manning and Bray's 'History of Surrey'*, this print was reissued around 1840 in *Views of Old London and its Environs*, published by Francis West; this also included Heckell's view of Marble Hill (cat. 40). An undated edition of this print was also issued by Robert Sayer. Such later editions would have kept Marble Hill in the public's mind, long after this view had been obscured by the growth of trees.

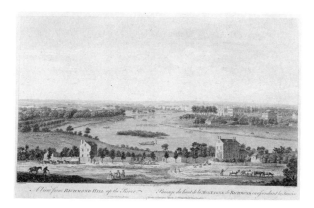

FRANCIS VIVARES c.1712-82
after ANTONIO JOLI c.1700-77

62. *A View from Richmond Hill up the River*, 1749
Engraving (hand coloured); 11⅜×16¾in. (29×42.5 cm.)

INSCRIBED: *Jolly Pinxit/Publish'd according to Act of Parliament/E. Vivares Sculp'./A View from RICHMOND HILL up the River./Paisage du haut de la MONTAGNE de RICHMOND en ascendant la Tamise/Printed for John Bowles in Cornhil, & Carington Bowles in St. Paul's Church Yard, London.*

Marble Hill House can be seen on the far right, partly concealed by trees. To the left stands the home of George Pitt, M.P. (known as Orleans House since 1815) with its distinctive octagonal summer house, built by James Gibbs; Twickenham lies beyond. Joli's view up-river is taken from further down Richmond Hill than is Heckell's contemporary engraving (cat. 63). Joli worked in Rome with Panini and in Venice before coming to London in 1744, two years before Canaletto. He found employment as a scene painter, and decorated the Richmond home of his patron, John James Heideggar, manager of the Haymarket Opera House, with Italian, Swiss and Chinese landscapes painted direct onto the wainscot. Vivares trained under Chatelain (cat. 74)

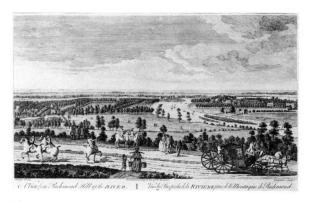

CHARLES GRIGNION 1717-1810
after AUGUSTIN HECKELL c.1690-1770

63. *A View from Richmond Hill up the River*, 1752
Engraving; 10¼×15¾ in. (26.1×40 cm.)

INSCRIBED: *Heckel Delin/Publish'd according to Act of Parliament/Grignion Sculpt./A View from Richmond Hill up the RIVER./Vüe du Pais proche de la RIVIERE prise de la Montagne de Richmond./Robt Sayer, at the Golden Buck, opposite Fetter Lane, Fleet Street & Henry Overton, at the White Horse without Newgate, 1752.*

Heckell's record of the prospect up-river from Richmond Hill complements the engraving after his view of Marble Hill House from the river (cat. 40). Seen from the east, the estate is clearly distinguishable on the right in this engraving. The quantity of traffic Heckell presents does not consist entirely of visitors coming to enjoy the prospect and its attendant attractions (namely the spa, theatre and taverns), for Richmond Hill also provided the main thoroughfare to Petersham and Kingston until 1767. Augustin Heckell, the prosperous son of an Augsburg goldsmith, lived locally and

painted a group of views of the area to which the drawing for this engraving belongs. Three of these are now at Orleans House Gallery and six in the Lewis Walpole Library in Connecticut. They are thought to have been commissioned by Horace Walpole, who lived nearby at Strawberry Hill from 1747 and became one of Lady Suffolk's closest friends in her old age. However, as three of Heckell's sketches are known to have been engraved soon after completion, a commission from the publisher Robert Sayer cannot be ruled out.

The popularity of this engraving is apparent from the existence of at least four different editions, the last of which, dating from around 1840, appeared in a compilation originally published by Sayer c.1750-3. Topographical engravings of London reached a peak both in quality and quantity in the middle of the eighteenth century, and the reprinting from old stock plates by nineteenth century publishers must have kept the eighteenth century character and associations of the most popular prospects alive. *Views of the City of London*, as the Victorian compilation was entitled, also included an engraving after Heckell's *West View of Richmond & Surrey from the Star and Garter on the Hill* and Tilleman's's *View from One Tree Hill* in Greenwich Park.

Greater London Record Office (Maps and Prints)

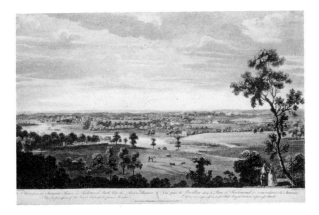

PETER PAUL BENAZECH c.1730-83 after
JOHN BAPTISTE CLAUDE CHATELAIN c.1710-71

64. *A View from the Summer House in Richmond Park Up the River Thames*, c.1755
Engraving; image size: 12⅝×18¾in. (32×47·6 cm.)

INSCRIBED: *Chatelain Delin/ P. Benazech Sculp./A View from the Summer House in Richmond Park Up the River Thames/Taken by permission of Her Royal Highness the Princess Amelia/Vüe prise du Pavillon dans le Parc de Richmond en remontant la Tamise/Dessinnee avec la pamission de son Altesse Royale Madame la Princesse Amelie Printed for R. Wilkinson, at N°. 38 in Cornhill, London*

Marble Hill House is clearly visible in the centre of this view, with Little Marble Hill to the right.

Orleans House Gallery (Ionides Bequest)

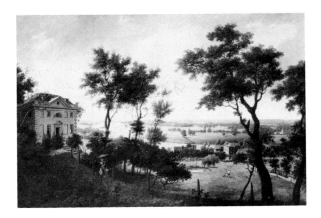

WILLIAM MARLOW 1740-1813

65. *A View from Richmond, looking towards Twickenham*, 1776
Oil on canvas; 35×50in. (89×127 cm.)

EXHIBITED: *Society of Artists, 1776 (59)*

Charles, Earl of Sefton may have commissioned this painting of the view from the slopes below Richmond Hill looking towards Twickenham, as he leased the house on the left in the 1770's. It had been built some twenty years before for Edward Collins, a Richmond brewer. Cambridge House can be seen between trees on the right and the Marble Hill estate lies left of centre. The painting was exhibited at the Society of Artists in 1776 with two related works: *A View of Richmond Hill from the grounds of Richard Owen Cambridge, Esq. at Twickenham* and *A View of the Thames, near Sion House*, together with two views near Naples.

From 1775, the year he probably began this painting, Marlow leased The Manor House opposite Twickenham church. For another ten years he maintained his studio in Leicester Fields, near to his friend Sir Joshua Reynolds, before retiring permanently to his Twickenham home. The Manor House had previously belonged to the painter Samuel Scott, under whom Marlow served his apprenticeship, but as Joseph Farington noted in his diary, Marlow had other reasons for staying in this substantial house:

> Marlow resides at Twickenham, with a man whose name is Curtis. He was a Butcher when Marlow first became acquainted with His wife, who he met at Vauxhall. He Has lived more than 20 years with them, and there are now 6 or 7 children, some of them very like Marlow. A strange instance of infatuation. He still applies to painting, but with very little of His former power[1]

The topographical accuracy and clear light which distinguish his views of gentlemen's seats, Italian towns and London, reveal the extent to which Marlow absorbed the influence of Canaletto, whose work he studied so faithfully that at least two copies were sold as originals in the eighteenth century. In this painting, however, it is the picturesque approach of Richard Wilson (cat. 44), under whom Marlow is often said to have studied, that predominates,

particularly in the elegant trees and smooth estates of unbroken sunlit lawns that are worthy of the idyllic Roman campagna painted by Claude Lorraine.

1. Kathryn Cave, ed., *The Diary of Joseph Farington* (New Haven and London, 1982), IX, p.3302 (23 June 1808)

Spink & Son Limited

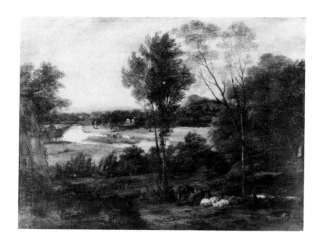

SIR JOSHUA REYNOLDS 1723-92

66. *View from Sir Joshua Reynolds's House, Richmond Hill*, c.1780
Oil on canvas; 27½×35¾ in. (69.8×90.8 cm.)

PROVENANCE: Studio sale, Christie's, 18 May 1821 (63), bt Samuel Rogers; his sale, Christie's, 2 May 1856 (702), bt Bentley; Thomas Baring by 1857; by descent to Lord Northbrook and Maurice Baring; presented to the National Gallery by the National Art-Collections Fund, 1945; transferred to the Tate Gallery, 1951.
EXHIBITED: Society for Promoting Painting and Design, Liverpool 1783; *Landscape in Britain*, Tate Gallery, 1973 (44); *Reynolds*, Royal Academy, 1986 (99)
LITERATURE: Nicholas Penny, ed., *Reynolds*, exhibition catalogue, Royal Academy 1986 (99), entry by David Mannings.

In 1771, three years after Reynolds's appointment as first president of the new Royal Academy, the Academy treasurer, Sir William Chambers, completed Wick House on Richmond Hill. Reynolds's new villa included a large room on the first floor with a bow window "made at considerable expense" according to the architect.[1] J.T. Smith records an exchange between the painter and his former teacher which underlines the prestige of Reynolds's new address and the view his house commanded:

> Hudson observed to his pupil, Sir Joshua Reynolds, who had a villa on the summit of Richmond Hill, "Little did I think we should ever have had country-houses opposite to each other," to whom Sir Joshua replied, "Little did I think, when I was a young man, that I should at any time look down upon Mr Hudson."[2]

Like many gentlemen, Reynolds used his Richmond villa chiefly to entertain guests rather than as a regular residence, and although Samuel Rogers recorded that the artist "always wanted to get back to town among *people*"[3] he recognized the advantage its unique setting held over his studio in Leicester Fields. Fanny Burney described a dinner party held in June 1782 at which Reynolds "was desiring my opinion of the prospect from his window, and comparing it with Mr Burke's".[4] The disadvantages of the setting were apparent to the artist's neice, who described her inheritance as "a house stuck upon the top of a hill without a bit of garden or ground near it but what is as public as St. James's Park".[5]

This painting is the best known of all Reynolds's landscapes, very few of which (for example *The Entrance to Mrs Thrale's Garden* of c.1780-5, Victoria and Albert Museum) can be firmly attributed. More landscapes may survive than Reynolds intended, however, as on at least one occassion an admirer cut the background out of a portrait and framed it separately.[6]

In this painting Marble Hill is concealed by its own chestnut trees but Little Marble Hill and a summer house may be identified in the centre of the picture. Lady Diana Beauclerk lived at Little Marble Hill from 1782 to 1789. To the right are the lawns of Cambridge House, home of Richard Owen Cambridge, who, like his neighbour, was a close friend of Reynolds, Dr. Johnson, Boswell and Horace Walpole.

The fluency of execution leaves little room for topographical details, as Reynolds sought a broader effect. He believed artists should:

> paint from nature.... This was the practice of Vernet, whom I met at Rome; he then showed me very much, for that truth which those works only have which are produced while the impression is warm from nature.[7]

The result of this warm impression is very different from later works by Constable or the Impressionists. Reynolds saw the prospect in terms of tonal values, like a painting by Claude or Rembrandt. Like Gainsborough, he had no need for extraneous details that might detract from the unity of effect. As Uvedale Price recorded in his *Essays on the Picturesque*:

> Reynolds told me, that when he and Wilson the landscape painter were looking at the view from Richmond terrace, Wilson was pointing out some particular part; and in order to direct the eye to it, "There," said he, "near those houses – there! where the *figures* are." – Though a painter, said Sir Joshua, I was puzzled: I thought he meant statues, and was looking upon the *tops* of the houses; for I did not at first conceive that the men and women we plainly saw walking about, were by him thought of as figures in the landscape.[8]

It is tempting to identify the 'particular part' in question as the subject of Wilson's own paintings of the Thames near Marble Hill (cat. 44).

Reynolds's picture was engraved by Birch and published in 1788, in the same volume as Birch's view of Kenwood (cat. 93). Of all the paintings of this prospect produced in the seventeenth and eighteenth centuries, this is the one cited in the texts to volumes of engraved views published at the beginning of the nineteenth century. Just as Thomson

had evoked Claude when describing this prospect in his poem *The Seasons* (1726-30), so Reynolds is cited in tour books. In *The Thames*, for example (cat. 9), admirers of Joseph Farington's aquatint are reminded how:

> the pencil of Sir Joshua Reynolds, relaxing from the more dignified toil of history, has produced a view of the Thames, from a window of his villa: near the summit, full of effect, of truth and beauty.[9]

Likewise, Samuel Owen's engraving in a similar publication of 1811 stands in the shadow of this picture, in which Reynolds:

> exercised his power of colour with the happiest effect, and appears to have had in his mind at the time of this amusement of his genius, the style and character of *Francesco Mola*[9]

To ambitious painters like Turner (cat. 67), the fame of Reynolds's painting must have added to the challenge already set by this celebrated prospect.

1. John Harris, *Sir William Chambers* (London, 1970) p.242
2. J.T. Smith, *Nollekens and his Times* (London, 1920) II, p.128
3. Quoted in Mannings, *op. cit.*, p.270
4. *ibid.*
5. W.T. Whitley, *Artists and Their Friends in England 1700-1799* (London, 1928) II, p.198
6. K. Garlick & A. Macintyre, eds., *The Diary of Joseph Farington* (New Haven and London, 1978) II, p.557 (26 May 1796)
7. Quoted in Gage, p.40 n.3
8. Quoted in Barrell, p.17
9. William Combe, *An History of the River Thames* (London, 1794-96) II, p.27
10. *The Thames* (London, 1811) II, p.1

The Trustees of the Tate Gallery

J.M.W. TURNER 1775-1851

67. *Thomson's Æolian Harp*, 1809

Oil on canvas; 65⅝×120½in. (166·7×306 cm.)

PROVENANCE: James Morrison by 1857; by descent until acquired from the Trustees of the Walter Morrison Picture Settlement in lieu of Estate Duty by Manchester City Art Galleries, 1979.
EXHIBITED: Turner's gallery 1809 (6); and most recently, Turner at Manchester, Manchester, 1985 (1).
LITERATURE: Martin Butlin and Evelyn Joll, *The Paintings of J.M.W. Turner*, revised edition (London and New Haven, 1984) pp.64-5

Among the generations of artists' attempts to capture one of this country's finest prospects, Turner's painting of the view from Richmond Hill shines out as the supreme achievement. In scale it is second only to the same artist's *England: Richmond Hill, on the Prince Regent's Birthday* (1819, fig. 21); in fame, it stands today second to none. The combination of an ideal Claudian composition with a variety of observed light and topographical detail, together with a classical scene that evokes a wealth of literary associations, makes this the masterpiece of English prospect painting.

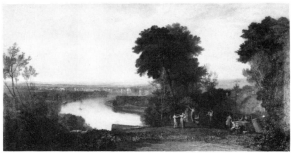

COL. PLATE V

The title refers to the Richmond poet James Thomson (1700-48), whose poem *Summer* from *The Seasons* (1726-30) includes the most popular evocation of this prospect ever written. Closest to the scene in Turner's painting is his invitation:

> Here let us trace the matchless vale of Thames
> Fair-winding up to where the muses haunt
> In Twitnam's bowers.
> . . .
> Heavens! what a goodly prospect spreads around,
> Of hills and dales, and woods, and lawns, and spires,
> And glitt'ring towns, and gilded streams

In classical mythology, Æolus was the god of the winds and inventor of sails; his harp played as the winds stirred its strings. Turner presents an imaginary monument, a harp on a pedestal, inscribed 'THOMSON' being crowned with a poet's laurels, while maidens in classical dress dance alongside. The classical ruins are imaginary, but in the distance Twickenham's riverside villas catch the sun, reminding us of the residence of a greater poet, Alexander Pope (1688-1744), whose celebrated villa had been demolished in 1807. This destruction prompted Turner to exhibit *Pope's Villa at Twickenham* (Walter Morrison Picture Settlement) in his own gallery in 1808, the year before he unveiled this painting. The distant village has in fact been exaggerated to emphasise this connection, just as the bank on which Marble Hill stands has been compressed and partly concealed by foliage and vegetation so as to focus our attention within the extensive panorama.

Turner made at least six attempts at writing his own poem on this scene, which proved to be the longest he ever wrote; the opening lines of the version that accompanied the painting in 1809 convey a sense of melancholy appropriate to the picture:

> On Thomson's tomb the dewy drops distil,
> Soft tears of Pity shed for Pope's lost fame.[1]

In Turner's notebooks the last word is in fact 'fane' (meaning temple) an allusion to the demolition of Pope's villa.

This work is one of Turner's earliest attempts to challenge, rather than simply imitate, the ideal Italianate landscapes of Claude Lorraine which represented the connoisseur's idea of an 'old master' landscape at this time. Turner's previous Claudian essay, *The Festival upon the Opening of the Vintage of Macon* (Sheffield City Art Galleries) was painted in 1803, the year after he visited the Louvre, and is a direct source for this painting.

In choosing this celebrated prospect of the Thames, Turner presented the glories of the native landscape; he also invited comparison with the masters of the native school, from Siberechts and Tillemans to Wilson, Reynolds and Marlow, all of whom had sought to capture the same boundless scene on canvas before his time. In the same year, Turner exhibited in his gallery a less ambitious interpretation of the other great prospect in British landscape painting, the view from Greenwich Hill (fig. 6). Considered in this context, the two paintings underline Turner's recognition of the artistic status these British prospects had acquired by the nineteenth century.

The key to Turner's ability to present the view afresh, while acknowledging tradition, is his keen observation of changing effects of light, in the sky, through foliage and in the glassy blue reflections of Twickenham in the river. Turner knew this stretch of the Thames intimately; from 1804-5 he lived at Sion Ferry House, Isleworth and from 1806 he painted oil sketches on a boat near Richmond. Around 1808 he purchased a plot of land near Marble Hill and built an Italianate villa there to his own design, Sandycombe Lodge, completed in 1814, which still stands today. He returned to the more distant view in 1815 in a series of sketches made along Richmond Terrace and, after his even larger oil of 1819, painted a finished watercolour in 1825 (Walker Art Gallery, Liverpool). Engravings published in *The Literary Souvenir* (1826) and *The Picturesque Beauties of England and Wales* (1832) took Turner's own vision of the view from Richmond Hill into the popular imagination and established him as the master of one of Britain's finest prospects.

1. Quoted in Butlin and Joll, *op. cit.* p.64

Manchester City Art Galleries

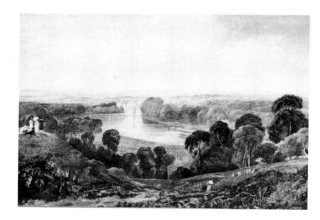

the boast of the vicinity of the Metropolis.... Though the pen cannot attempt to give an adequate description of its beauties... the masterly drawing by Mr. Dewint ... gives at once the true feeling, sentiment and character of this delightful scene.[1]

1. W.B. Cooke, *The Thames* (London, 1822) I, unpaginated

Orleans House Gallery (Ionides Bequest)

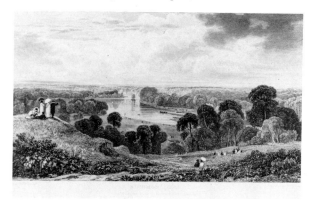

Fig. 30 W.B. Cooke after Peter De Wint *Richmond Hill*, 1817, Museum of London

PETER DE WINT 1784-1849

68. *The Thames from Richmond Hill*, 1817
Watercolour; 12¼×18¾in. (31·1×47·6 cm.)

PROVENANCE: Bequeathed to the former Borough of Twickenham by The Hon. Mrs. Basil Ionides, 1962.
EXHIBITED: *Historic Richmond*, Town Hall, Richmond, 1959 (48); *Richmond & Twickenham Riverside*, Marble Hill House, 1967 (43); *Where Thames Reflects*, Orleans House Gallery, 1972 (26)

Like the same artist's view of 'Marble Hall Cottage' (cat. 57), this watercolour was commissioned to illustrate the revised edition of *The Thames* (1822). W.B. Cooke's engraving after De Wint replaced his earlier print after Samuel Owen's sketch of the same view, published in the first edition of 1811. The most obvious difference between the two artists' illustrations is De Wint's inclusion of a group of onlookers admiring the prospect on the hill to the left, directing our gaze up-river, as does the couple in the lower foreground. In the finished engraving, Cooke strengthened the suggestion of figures on the far bank, and the pleasure boats, and so underlined the character of the area as a fashionable resort, in contrast to the more rural impression evoked by Owen. The accompanying text is secondary to the engraving and reminds us of Richmond Hill's proximity to London as:

GEORGE HILDITCH 1803-57

69. *The Terrace, Richmond Hill*, 1837
Oil on panel; 17×21¾ in. (17·8×55·2 cm.)

PROVENANCE: J.B. Hilditch (Asgill House); presented to the former Borough of Richmond by G.W. Hilditch Esq., grandson of the artist, 1961.
EXHIBITED: Royal Academy, 1837 (79); *Rich Habitations*, Orleans House Gallery, 1973 (32)

On the left stands The Wick, built by the architect Robert Mylne for Lady St. Aubyn in 1775. Next door, but out of view, stands Wick House, built for Sir Joshua Reynolds (cat. 66).

Hilditch spent much of his life in Richmond, and became known as 'The Richmond Painter'. His prolific output included many views connected with Richmond Hill, and a

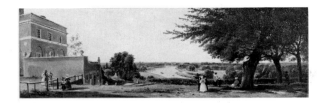

painting of *Marble Hall Cottage*, exhibited at the Royal Academy in 1846. According to the label on the reverse, this painting at one time hung at Asgill House in Richmond, one of the finest Palladian villas, built by Sir Robert Taylor c.1760; it belonged to the artist's son, Alderman J.B. Hilditch, Mayor of Richmond from 1899 to 1900.

Richmond upon Thames Art Collection

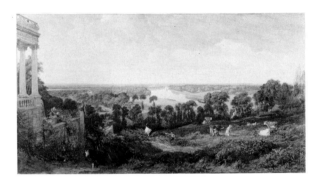

JOHN JAMES CHALON 1778-1854

70. *The View from Richmond Hill*, 1837
Oil on canvas; 47¼×83½ in. (120×212 cm.)

SIGNED and DATED: 1837
EXHIBITED: (?) Royal Academy 1837 (304); *Historic Richmond*, Town Hall, Richmond, 1959 (3)

Chalon produced a group of views of Little Marble Hill, to which this painting belongs (cat. 58,59). *Richmond – autumnal morning*, exhibited at the Royal Academy in 1837, may be the correct identification for this painting. *A View from Richmond Hill* was included in Chalon's retrospective exhibition, held at the Society of Arts in July 1855, and six years later the artist's studio sale included 'Richmond Hill: brilliant effect of the evening sun. The chef d'oeuvre of the Artist, of gallery size' (284). Both of these may again refer to the present painting. Three related views depicted *Richmond Bridge – moonlight*, *The Thames at Twickenham* and *Party landing from a Boat at the Duke of Buccleuch's villa at Richmond*.

Richmond upon Thames Art Collection

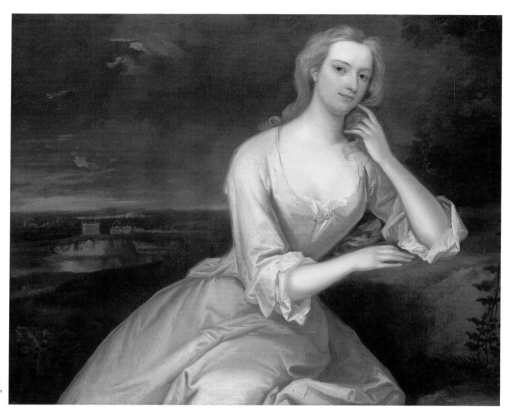

III Charles Jervas
Henrietta Howard,
9th Countess of Suffolk,
c.1724 (cat. 35)

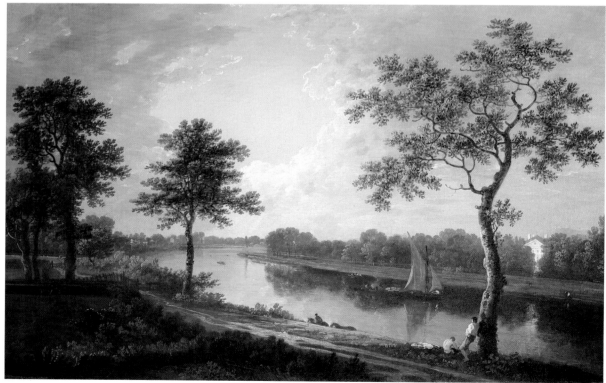

IV Richard Wilson *The Thames near Marble Hill, Twickenham,* c.1762 (cat. 44)

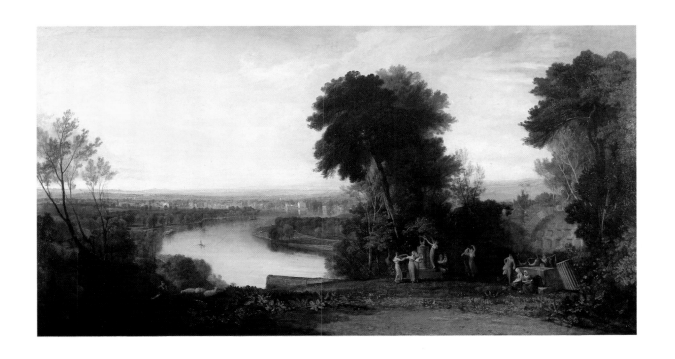

V J.M.W. Turner *Thomson's Æolian Harp*, 1809 (cat. 67)
VI John James Chalon *Marble Hall Cottage*, 1839 (cat. 58)

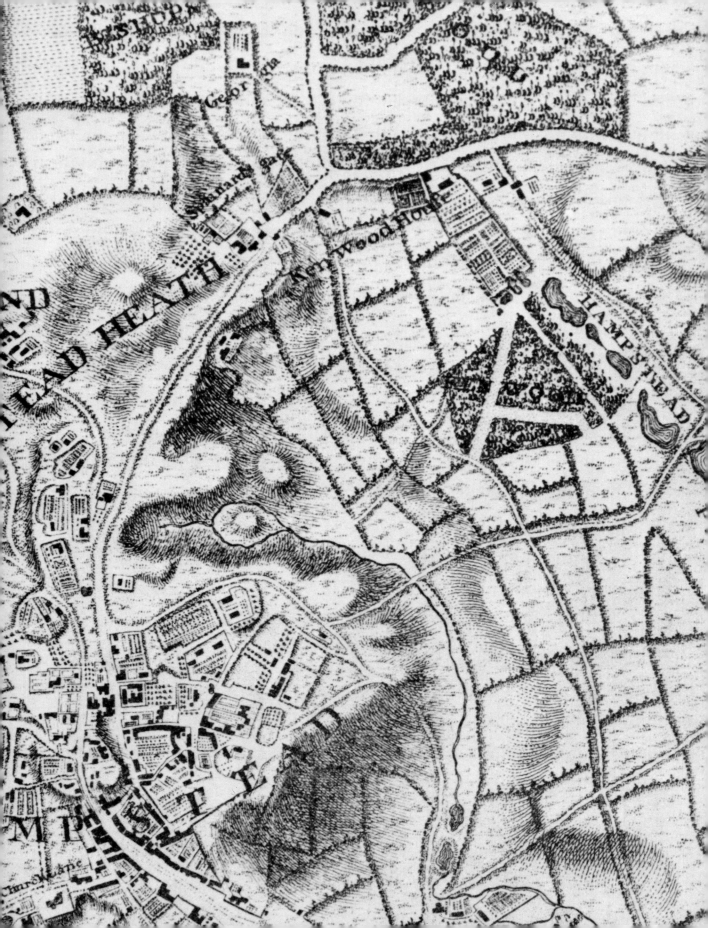

Kenwood

A 'noble seat' by Hampstead Heath

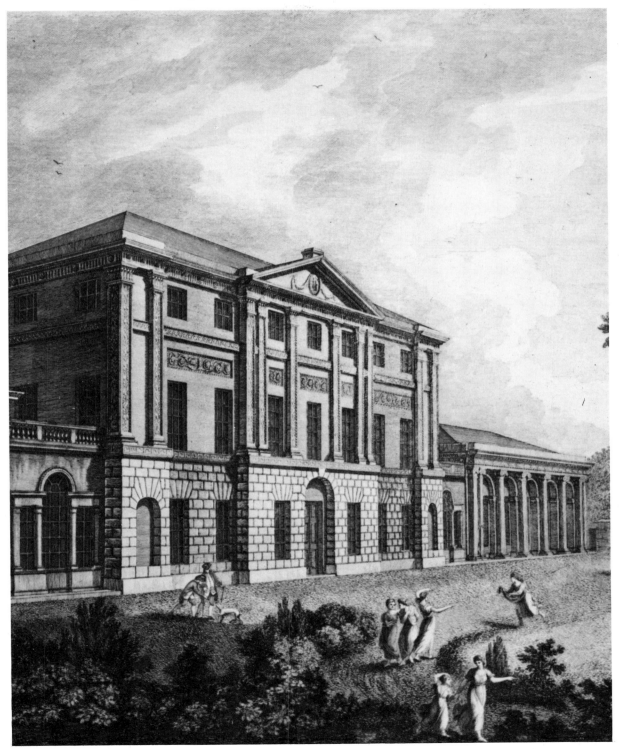

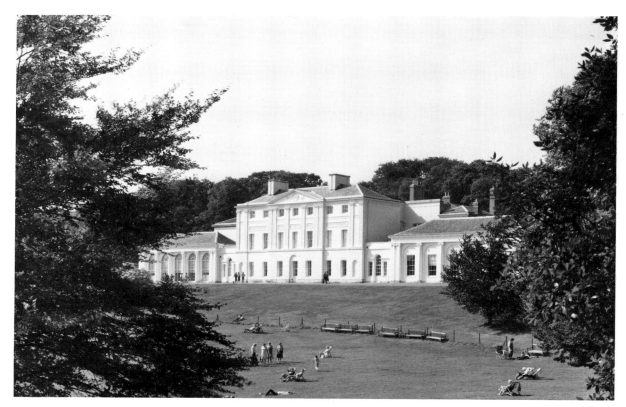

Previous pages:
Fig. 22 (left) Jean
Rocque *Plan of
London* detail,
showing Kenwood,
1746
Fig. 23 (right) G.
Vitalba and B.
Pastorini after
Robert Adam *View
of the South Front of
the Villa at Kenwood*
detail, 1774

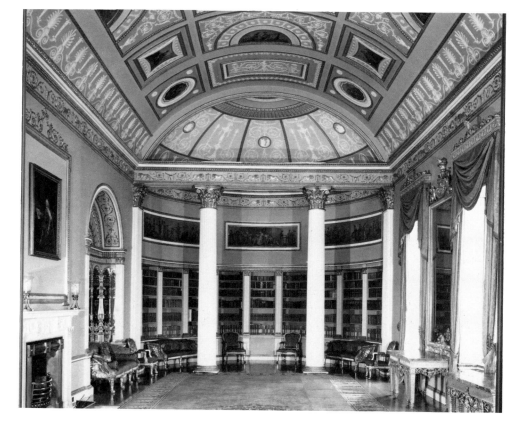

Fig. 24 (above)
Kenwood, the
South Front
Fig. 25 (right) The
Library, Kenwood

IN 1774 Robert Adam, the architect who remodelled Kenwood for the 1st Earl of Mansfield, described the view from the house facing south as follows:

> Over the vale, through which the water flows, there is a noble view let into the house and terrace, of the city of London, Greenwich Hospital, the River Thames, the ships passing up and down, with an extensive prospect, but clear and distinct, on both sides of the river. To the north-east, and west of the house and terrace, the mountainous villages of Highgate and Hampstead form delightful objects. The whole scene is amazingly gay, magnificent, beautiful, and picturesque. The hill and dale are finely diversified; nor is it easy to imagine a situation more striking without, or more agreeably retired and peaceful within.[1]

Given this 'extensive prospect' of London it is surprising to discover how rare paintings of this scene are, compared to the views from Richmond Hill, Greenwich Hill and Blackheath. The few known eighteenth century paintings of London from Hampstead Heath cannot compare with the generations of views towards the capital taken from above Greenwich, nor with the tradition of painting the prospect from Richmond Hill. Whereas the first known painting from Greenwich Hill dates from the end of the sixteenth century,[2] and the earliest known view from Richmond Hill was produced a century later,[3] paintings of Hampstead Heath are scarce before the nineteenth century. Even then, most artists were more interested in the Heath itself and the view north than the distant panoramas of London it afforded.

By contrast, Kenwood, long the most conspicuous house standing between Hampstead and Highgate, was frequently engraved from around 1770. Prints are plentiful and vary far more than those of Marble Hill and Ranger's House, ranging from the 'passer-by' portraits of the main entrance seen from Hampstead Lane, to distant views of the south front seen as little more than a dot within a landscaped estate. This production of original engravings is evidence of considerable public interest in the house. While Kenwood's residents and guests looked out, admiring the prospect the exceptional setting afforded, the public looked on from different directions, guided by early illustrated books and periodicals whose texts reflect a diversity of approaches. The changing appearance of the house and Heath as they appear in such books and in paintings can partly be explained by variations in topography; but it also results from the variety of ways in which artists and the public regarded Kenwood, Hampstead Heath, and the distant prospects they command.

Kenwood stands on the southern side of a steep ridge, 443 feet above sea level, linking the villages of Hampstead and Highgate. Three miles from central London, it lacks the convenience of access to the Thames, and the relative comforts and safety of travelling to London by boat enjoyed by residents of Greenwich, Richmond and Twickenham in the seventeenth and eighteenth centuries. Nevertheless, lying directly north of Westminster; and linked by road to the City via Highgate since the fourteenth century, the area was long favoured by successful merchants who built villas here from the sixteenth century onwards, with impressive views of London.[4] The location also proved convenient for gentlemen travelling to Westminster Hall and the Inns of Court, and in the eighteenth century several eminent lawyers came to live between Highgate and Hampstead on the southern fringes of the Bishop of London's forest. Most prominent of these was William Murray (1705-93), 1st Earl of Mansfield, and Lord Chief Justice (1756-88), who acquired Kenwood in 1754.

Hampstead largely developed in the eighteenth century as a spa and resort, on the strength of its mineral springs and rural proximity to the capital. As at Blackheath,

development had been postponed by the wildness of the heath, with its high-waymen, swinging gibbets, and wild beasts. But by 1714 an observer was able to write:

> One cannot be at *Kensington* without visiting Hamsted, three Miles off, on the Brow of a Hill, from whence you have the fullest View of London. It's a large and pleasant Village with Mineral Waters as at *Tunbridge;* but the company on the Walks are not near so good. Its nearness to *London* brings so many loose Women in vampt-up old Cloaths to catch the City Apprentices, that modest Company are ashamed to appear here even with their Relations... adjoining to this Village the Duke of *Argyle* hath a fine Seat called *Caen-Wood*.[5]

By 1746, when Rocque's map of London was published, the village had expanded up the hill to Whitestone Pond, as seen in Ramsey's painting of 1755 (cat. 75). This was the point from which to look towards London, to promenade, to see and be seen, much as fashionable society did on Richmond Hill and in Greenwich Park. Rocque's map also includes Judges' Walk, an avenue near Whitestone Pond described in 1787 as:

> the mall of the place, a kind of terrace, which they call Prospect Walk, [this] commands a most extensive and varied view over Middlesex and Berkshire, in which is included, besides many inferior places, the majestic Windsor and lofty Harrow.[6]

This view away from London over Branch Hill is probably the most familiar image of Hampstead Heath today, thanks to John Constable, who frequently painted this traditional prospect from 1819.

Among the inns established in response to the swelling numbers of visiting Londoners, some catered to this interest in prospect viewing. One in particular, the Spaniard's Inn, near Kenwood, boasted a Pleasure Garden with an artificial mount from which customers could see to Hanslope near Northampton. The view south from the Spaniard's was engraved and published by J.B.C. Chatelain in 1750 (cat. 74). Artists' interest in the Heath in the eighteenth century is evident from dated inscriptions on drawings; but oil paintings and engravings are rare compared to the views from Greenwich and Richmond. Sufficient works exist, however, to indicate the extent to which Constable was following fashion, rather than discovering new territory, when he first stayed at Hampstead in 1819. Although no seventeenth century Flemish works are known, Tillemans made a number of sketches of views 'From Hampsted' in the 1730s;[7] William Taverner painted various watercolours around 1770[8]; while the following year Alexander Cozens made several studies of trees and scrub and a dramatic study of the setting sun 'from Hampstead Heath'.[9] Richard Wilson is said to have had a favourite oak on the Heath[10] and his pupil Robert Crone exhibited a *View of Hampstead and Highgate* at the Royal Academy in 1777 (see cat. 84). John Webber sketched on the Heath in 1790,[11] Girtin in 1792,[12] and in 1808 Paul Sandby exhibited *A Scene near Hampstead* at the Academy. The most prominent artist to live here before Constable was the portrait painter George Romney, who made Hampstead his home in 1797.

One of the earliest oil paintings of the Heath is Ramsey's view of Heath House and Whitestone Pond looking from Hampstead towards Highgate (cat. 75). Although Kenwood is not in fact visible from this point, the distant villa has been included in the painting through artistic licence; it appears as it did before Robert Adam remodelled the house from 1764. The original house was built soon after 1616 when the

estate was purchased by John Bill, the King's printer. Kenwood passed through a succession of owners before John, 3rd Earl of Bute inherited the estate in 1746. The best known resident before Mansfield, Bute is the source of the earliest known comment on Kenwood's fine prospect. As he wrote to the Dutch scholar Gronovius in 1751:

> you may remember hearing of the Villages of Hampstead and Highgate, plac'd on two high hills; the house is betwixt them defended from the north by a great wood; tho in anothers possession, to the south an old wood of 30 Acres belonging to me; over which the whole city with 16 miles of the River appears from every window.[13]

Bute sold Kenwood to William Murray, later 1st Earl of Mansfield, his ally and fellow Scot, in 1754.

Robert Adam's remodelling of Kenwood for Mansfield has been admirably discussed elsewhere,[14] but it has not been discussed in terms of the 'prospect' before. From the passage quoted at the beginning of this essay, it is clear that Adam recognized the 'noble view' of the City, Greenwich and the Thames as the distinguishing virtue of the site, the 'genius of the place' Alexander Pope earlier advised landscape gardeners to seek out. Mansfield owned Kenwood for ten years before employing Adam, so the immediate view the architect described was probably the product of a decade of change in which Mansfield had priorities other than architecture. Rocque's map shows a modest house set back from Hampstead Lane by a forecourt, with formal gardens leading down from the house to four ponds on the south side. Ken Wood, beyond the ponds, is divided by three broad avenues, presumably designed for riding. By the time Adam described the view in 1774, broad lawns had swept the gardens away and the four fish ponds had turned into two lakes. It was probably in these years that the avenues were replaced by the serpentine paths to create a 'circuit' of two miles from which to enjoy prospects of London, the home farm, and neighbouring estates. Some of this had been achieved by 1755, when Wootton painted the prospect from the terrace (cat. 76).

Mrs Delany's drawing of 1756 records Kenwood as a two storey building with an attic floor lit by dormer windows (cat. 77). In essence, Adam added a third storey to this older house, balanced the Orangery by building a library and ante-room on the east side, refaced the whole of the south facade to pull these elements together, and added a portico to the north front to aggrandize the house's appearance from the road. He extensively remodelled the interior to achieve similar unity, adding chimneypieces and dado rails to the old south front rooms and entrance hall, together with an elaborate ceiling to distinguish the latter.

Today's visitor arriving by road along Hampstead Lane first discovers Kenwood's prospect by walking through a leafy arbour adjoining the Orangery and onto the south terrace. But in Adam's day, and before, a forecourt wall concealed service buildings lying on this side of the house and guests could only discover the grounds by walking through the house itself. First they would have passed from the entrance hall left into the tall stairwell and then through the right hand door into an ante-room.[15] In this way a series of contrasts in scale was experienced, with the view through the vestibule entrance at first suggesting a narrow colonnade (with a niche on the left) leading to another single door. In fact, guests would be drawn by the opening in the middle of the colonnade to turn right and there discover, through a large Venetian window, the panorama of the grounds and distant City, just as Adam described it.

The real climax then came on entering the Library itself, described in Adam's works as "the great room", recalling the earlier room of the same name at Marble Hill. The name also recalls remarks made by Isaac Ware, the architect who added a long gallery to Ranger's House in 1750-51, in his study *A Complete Body of Architecture* (1768). Ware noted "We see an addition of a great room now to almost every house of consequence.... This is an essential point in the practice of modern architecture. The builder sees every body wants a large room".[16] A parallel can be drawn between Chesterfield's gallery, with its three bow windows affording three of the finest prospects in the world, and Adam's own 'great room', the Library at Kenwood. Adam introduced it thus: "The great room, with its ante-room, was begun by Lord Mansfield's orders, in the year 1767, and was intended both for a library and a room for receiving company".[17] In the present century this room has been admired primarily for its ceiling, but an observation in Samual Curwen's diary of 1776 alerts us to the rival attraction. He wrote of a visit to Highgate:

> after dinner to Caen Wood, the seat of Lord Mansfield. The House elegant, not large... the library a beautiful room, (having a fine prospect of St. Paul's, distant about seven miles, through a wood, over a lawn, and ending in a fine piece of water) contains the largest mirrors I ever saw.[18]

The differences between the first designs and the finished room underline the emphasis placed on the view south. The original intention was to line the bays in the north wall with books, with a row of busts on top. Instead, a series of mirrors was installed in the bays, which according to Adam "reflecting the objects that are seen from windows, have a most singular and beautiful effect".[19] The windows are larger than any in the original building, with the exception of the Orangery. In this way the view north to Hampstead Lane was firmly blocked out, as it had been since guests first stepped into the forecourt. On the opposite wall between the windows vast pier glasses repeat reflections of the view south when seen from an oblique angle and help to 'dissolve' the wall to the terrace. Settees within the mirrored bays enabled guests to enjoy the view direct, interrupted only by other guests seated on scroll sofas in the window recesses. Mansfield himself, his portrait above the mantel, faces south towards the carefully landscaped ponds, the 'dummy bridge' providing a point for the eye to rest on before passing on to the City skyline. Like the Great Room at Marble Hill, the only view out is south towards the Thames. If Chesterfield's gallery at Ranger's House afforded three fine prospects, none is as commanding as the one Robert Adam made integral to his conception of 'the great room' at Kenwood.

Immediate access to the grounds was possible through the Venetian door in the ante-room; the two other doors on the south front were probably used more frequently by the family. Guests then found themselves on a terrace below the elaborate stucco decoration of the south front, the shallow relief of which, in contrast to the imposing architecture of the main entrance, was in keeping with the library decoration and provided a fitting backdrop to the parade of fashionable society as they admired the prospect. The summer house shown in Adam's own engraving (cat. 83) would have closed the immediate view east, just as the house itself blocked any view north. In Adam's own words (which follow the passage quoted at the opening of this essay): "The decoration bestowed on this front of the house is suitable to such a scene".

References in private journals and publications of the period indicate that members of the public, and not only Lord Mansfield's invited guests, were admitted to

Kenwood. For example, the Hon. Mrs. Boscawen wrote to Mrs. Delany on 14 October 1776:

> Yesterday we went to see Kenwood, but seeing Ld Mansfield come home, and being told there was to be company at dinner, we thought it polite to refrain from walking out, and only take a glance of the very excellent library, & c., promising ourselves, as indeed the servants very civilly promised us, we shd see ye woods and gardens at full liberty another time.[20]

Had her visit not been so brief, she would doubtless have praised the prospect, as periodicals at this time did in articles on Kenwood which encouraged such visits. For example, *The Ambulator* wrote in 1782 how "The park is a very beautiful spot, commanding the most delightful views"[21] and *The Morning Herald and Daily Advertiser* pointed out to its readers the previous year that "as the ground is very unequal, there are breaks, through which views open to Hampstead Heath, over London, a great way down the river even to below Gravesend".[22]

In the following year, 1782, *The British Magazine and Review* published an engraving of Kenwood with a similar long description, pointing out how "The garden front commands a most delightful prospect over a tract of the richest meadow grounds, which fall in a gentle descent for near two miles from the house".[23] The text accompanying Birch's engraving, published in 1789, described "in a rich distance, the Metropolis and River in a most striking point of view" (cat. 93). In this way, Kenwood became a more exclusive position from which to enjoy the prospect south than the inns of Hampstead; Adam's refinements in the current neoclassical taste further established it on the itinerary of fashionable visitors to the resort.

Another major reason for the production of engravings of Kenwood at the end of the eighteenth century was its sheer physical prominence; before the expansion of the estate and growth of new trees, it was one of the most conspicuous private houses by the Heath. The earliest views are of the south front seen from two roads which no longer exist, but can be found on Rocque's map. From 1782, engravings show Adam's entrance portico on the north front as seen from the lane running from Hampstead to Highgate. These remind us that the seclusion enjoyed by the house today, at the end of two wooded serpentine driveways, dates only from 1793-96, when the North Wood was added to the estate and Hampstead Lane was diverted. The number of engravings indicates the interest of travellers on this lane, as does a passage in the diary of the artist Joseph Farington from 1793, in which he describes the pleasures of a ride in the country on a route leading from Fitzroy Square to Highgate, then along this lane past Kenwood to Hampstead.[24]

The third viewpoint is from within the estate, looking back to the house from beyond the ponds, a scene presumably reserved for visitors and guests such as Mrs. Delany, who sketched here in 1756 and 1757 (cat. 77,78), but one which also inspired engravings (cat. 98). Views along the terrace, such as Adam included in *The Works in Architecture of Robert and James Adam Esquires* (1774) are rare (cat. 83). A further distinct view is of the house as a distant white landmark beyond the Heath; this occurs in Greig's plate for *The Beauties of England and Wales* (1805) (cat. 106) and in an aquatint from the same period (cat. 105). This is the only impression Kenwood made on nineteenth century artists. The house rarely occurs at all, and is seen from the Heath as part of the natural landscape, the prospect of London having been reversed.

The sources of these prints vary greatly, from antiquarian county histories to periodicals devoted to the latest fashions and current exhibitions. This variety of contexts, with their accompanying descriptions, reveals the full range of public interest in the house, including the associations with its residents, particularly the 1st Earl of Mansfield, whose name frequently appears in the printed titles. Indeed, one explanation for the quantity of these engravings is probably the 'celebrity' or even 'cult' status Mansfield achieved, particularly in the minds of lawyers, and of merchants who benefited from his reforms. A parallel may be drawn between the production of views of Kenwood and the publication of Holliday's biography of Mansfield, four years after his death which, unusually for the time, included a list of thirteen known portraits of him.[25] In his day, admirers could watch Mansfield at the Court of King's Bench, where students of law were free to attend and study the proceedings. Jeremy Bentham, for example, is said to have fallen "at once under Lord Mansfield's spell" and "He kept, as a great treasure, a picture of him, and frequently went to Caen Wood, as a lover to the shrine of his mistress, in the hope that chance might throw him his way".[26]

Mansfield's fame also brought him enemies, and they too came to Kenwood. During the 'No-Popery' Gordon Riots of 1780 his carriage windows were smashed outside the Houses of Parliament, his town house was burnt down and he narrowly escaped with his life. Kenwood escaped a similar fate thanks to the presence of mind of his nephew and heir Lord Stormont, then Secretary of State for the Northern Department, who, as Cabinet Minister responsible for dealing with the riots, despatched a party of dragoons to defend Kenwood, while the landlord of the Spaniard's Inn rendered them insensible with free ale.

This identification of Kenwood with Mansfield can be found in publications of the day. For example, in the year after the riots *The Morning Herald and Daily Advertiser* carried an article entitled "A Peep into Lord Mansfield's villa Caen Wood" which pointed out that "Except the additions made by Mr. Adam to the house it is little memorable, but from the *merit of the man who owns it*". This is the period when most of the engravings were produced, and they were complemented by published accounts of the estate, for example in *The Ambulator* in 1780, *The British Magazine and Review* in 1782, the *European Magazine* in 1786, *The Copper Plate Magazine* in 1786 and in Henry Boswell's *Views of the Antiquities of England and Wales* of 1786. Birch's print of 1789 (cat. 93) was accompanied by a description which reminded readers of the importance of Kenwood's prominent resident: "The greatest ornament of the place is the noble possessor, to whom Britain is so much indebted for the protection and improvement of its laws, as well as for his munificent patronage of the arts".[27] A similar identification was made by the Reverend Stebbing Shaw in *A Tour to the West of England in 1788* (1789): "the noble seat of Earl Mansfield.... A sweeter spot could not be well contrived, for the retirement and indulgence of that body, and that mind fatigued with the drudgery and employments of the law".[28] The same connection is central to an account of 1795: "The venerable Chief Justice, the celebrity of whose character is such as to need no further mention here, made Kenwood for many years his principal summer residence".[29]

These accounts underline the original associations these views carried, in contrast to the engravings from Adam's *Works in Architecture* (1774) which are more familiar to us today and tend to be identified, like the house, more with the architect than the owner of Kenwood.

By the time Lord Mansfield's nephew Lord Stormont had succeeded to the title and Kenwood in 1793, he was anxious to enlarge and remodel the grounds. The result of his improvements was a more rural setting and a reorientation of the house to give a change of prospect. In the same year he commissioned a 'Red Book' of designs from the landscape gardener Humphry Repton, and soon after saw foundations laid for both a new service wing and the pale brick wings to either side of the portico. The second earl also diverted Hampstead Lane to its present route beyond the North Wood and closed the upper part of Millfield Lane to the public, thereby denying passers-by the views of the north and south fronts previously recorded by artists. Joseph Farington, writing in his diary on 21 November 1793 of "strange additions to the late Lord Mansfield's house at Caen Wood"[30] was one of the last to enjoy passing the house on a ride around the Heath. The 1st Earl of Mansfield had already expanded the estate considerably, adding nearly ninety acres stretching down to Parliament Hill, including Highgate Ponds and Millfield Farm, making a total of some 232 acres. Under the second earl, the public's view of the house was pushed even further back onto Hampstead Heath, while the residents' view of London from the terrace was rivalled by a new western prospect.

With the creation of the large service wing to the east of the house, the original service buildings previously concealed between the forecourt wall and the Orangery could be demolished to make way for the Music Room wing and a formal garden. The large windows facing west from the new wing looked out onto a secluded lawn, flower beds and rhododendrons, while nearby the original prospect south was emphasized by demolishing the wall and planting a tunnel of ivy at the end of the Orangery. The removal of the wall and creation of this arbour meant that direct access to the south terrace, and thus to the view south, was now possible without going through the house. By 1838 when the view through the arbour was illustrated in J.C. Loudon's *Suburban Gardener* (cat. 117) the prospect was closed by distant trees and thus confined to the estate alone. The south terrace was rivalled by the new veranda on the west, and the open lawns by the new flower garden, alongside. This Loudon described as:

> the only defective part of the place. It is naturally shaded and confined by a lofty lime tree avenue on the one hand, and by a rising hill of oak wood on the other; and the area of the garden contains by far too many small trees and shrubs among the flowers.... Most of the flower-beds, also, are too large.... Were it ours, we should clear the whole area, and lay out a new combination of figures.[31]

Judging from Loudon's plan, this is precisely what a later owner did. But the original scheme is of interest in revealing the turn away from the open prospect towards St. Paul's in the nineteenth century, in favour of a more intimate sense of seclusion from the metropolis.

Although the trees had grown to obscure the prospect from the terrace, views of London could still be found by taking a path south of the ponds. The sense of seclusion from London, rather than the opportunity to enjoy it from afar, now became a virtue of the more 'romantic' taste. As J. Norris Brewer wrote in 1816, in a text that accompanied Greig's engraving (cat. 106):

> At different points, vistas are contrived, which casually reveal lands really unconnected with the estate, except as to the aid they thus impart to picturesque effect.... A serpentine walk, nearly two miles in extent, conducts round the most

interesting parts of the premises, and through the large and venerable woods. In the course of this perambulation occur numberless pleasing views, varied between a comprehensive prospect of the metropolis and its immediate environs, and the more attractive points of home scenery.[32]

J.C. Loudon also recommended the winding path south of the ponds "on the outskirts of the park, from some points in which magnificent views of London are obtained".[33] The prospect of London was otherwise unknown from the grounds:

> This is, beyond all question, the finest country residence in the suburbs of London... all exterior objects are excluded; and a stranger walking around the park would never discover that he was between Hampstead and Highgate, or even suppose that he was so near London. It is, indeed, difficult to imagine a more retired or more romantic spot, and yet of such extent, so near a great metropolis.[34]

The exclusion of all exterior objects worked both ways, for Kenwood became more remote from the public in the nineteenth century, when the Mansfield family spent more of each year on their Scottish estate at Scone Palace. Loudon observed: "Kenwood being at no season of the year shown to strangers, we regret to think that so few of our readers will have an opportunity of studying there".[35] The same comment is made by later writers, and this absence of residents, combined with the earlier expansion of the estate, may help to explain the scarcity of paintings and engravings of the house in the nineteenth century. Dickens included a vivid account of Kenwood's narrow escape from destruction during the Gordon Riots in *Barnaby Rudge* (1841), which also includes a character modelled on Lord Chesterfield of Ranger's House. But otherwise popular interest in Kenwood and the 1st Earl of Mansfield was far more limited than, for example, the legends that still attracted onlookers to Lady Suffolk's villa at Marble Hill, which remained clearly visible from the river. The continued inclusion of Kenwood in tour books, county histories and periodicals, such as *London and Middlesex* by J. Norris Brewer (1816), *The Ambulator* (1820) and *Handbook to The Environs of London* by James Thorne (1876), long after its withdrawal from public view, invites us to consider what, if any, appeal the house and estate held for nineteenth century visitors to the Heath, and for artists at work there.

In the nineteenth century Hampstead Heath continued to attract some of this country's greatest landscape painters. Like Richmond, Twickenham and Blackheath, to artists working in the capital the Heath presented nature on an expansive scale as a place of retreat and study within easy reach of the nation's centre of patronage. The prospect of London still held some appeal; Constable, for example, wrote from his family's lodgings in Well Walk in 1827 how:

> our little drawing-room commands a view unsurpassed in Europe from Westminster Abbey to Gravesend. The dome of St. Paul's in the air seems to realize Michael Angelo's words on seeing the Pantheon: 'I will build such a thing in the sky[36]

However, the paintings he produced show a greater interest in the rugged immediate terrain, the rapid changes in weather to be found on the Heath, and the overwhelming presence of the sky, made prominent by the sharp fall of the land on either side of Hampstead, Highgate, and the linking ridge on which Kenwood stands. Constable and Turner are often compared, but when one realizes that the former is not known to have painted the prospect from Richmond Hill or Greenwich Hill,[37] whereas the latter painted both, but did not paint at Hampstead, the differences in

approach between the two greatest English landscape painters becomes more apparent. To Constable the Heath offered a 'simple' but extensive rural world akin to the land painted by the Flemish and Dutch masters in the seventeenth century. To Turner the more celebrated prospects south of the Thames must have seemed closer to the ideal landscapes of Claude, with the river slowly winding past fine buildings, a wealth of historical and literary associations, combined with the additional challenge set by the achievements of previous generations of poets and artists in recording the same view.

John Linnell had affinities with Constable in his preference for studies of natural light over broken and overgrown ground, often under changing weather conditions. Having sketched in oil direct from nature at Twickenham (cat. 50) Linnell first took lodgings at what is now known as Wyldes Farm by Hampstead Heath in 1822 (cat. 112). Here he attracted a circle of like-minded artists, including William Mulready, John Varley, George Richmond and William Collins. Less frequent visitors to Collins Farm, as it was then known, included William Blake and Samuel Palmer. A parallel can be drawn with Leigh Hunt's home in the Vale of Health, visited by Byron, Hazlitt, Lamb, Keats and Shelley. The lower cost of living in Hampstead at this time was a further reason for the area's appeal to landscape painters, who had less need for houses in the City or West End than had portrait painters. However, in Victorian England Hampstead rapidly took on the status of a fashionable suburb for artists' 'villas', even more so than Richmond and Twickenham had been in the previous century. Madox Brown took lodgings in Hampstead in 1852 opposite the home of the marine painter Clarkson Stanfield, and in *English Autumn Afternoon* (cat. 119) painted the masterpiece of Pre-Raphaelite landscape painting, a prospect towards Parliament Hill which combines the topographical accuracy of eighteenth century engravings with a scrutiny of changing colour in the shadows, reflections, and full flood of autumn sunlight. Other artists of the period who painted the Heath include John Martin, J.J. Chalon, John Ritchie and F.W. Watts. In this way, Hampstead Heath, like Twickenham and Blackheath, became one of the forcing grounds of naturalism in English landscape painting and, inevitably, the subject of fashionable derivatives.

Despite this wealth of talent at large on the Heath, no paintings of Kenwood can yet be identified with certainty, a fact which seems to underline the physical obscurity of the house at this time. The Mansfields' estate was far from forgotten, however, as the nineteenth century saw repeated attempts to develop the remainder of the Heath as residential estates, gravel pits and brick fields, making Kenwood seem unspoilt by comparison. The Heath at this time consisted of several private estates. Sir Thomas Maryon Wilson of Charlton House near Greenwich became Lord of the Manor of Hampstead in 1821, and sought to develop the Heath as he did at Blackheath by Charlton and Woolwich. But an entail on his inheritance prevented building, forcing him to place a series of private Estate Bills before Parliament, all of which were defeated after much public protest. Geoge Cruikshank's well-known engraving *London going out of town*, for example, was published in 1829, the year Maryon Wilson sought the power to grant building leases; Hampstead's trees are clearly marked as the vulnerable distant target of the 'March of Bricks and Mortar'. While pursuing such powers, Wilson enclosed parts of the Heath, laid out a main road, sold off thousands of tons of sand and gravel, and allowed brick fields to further scar the terrain. Artists were aware of this disruption and the threatened destruction of this stretch of unspoilt nature; they participated in at least one formal approach to the Prime Minister.[38]

The sight of horse-drawn carts in Constable's paintings becomes less a matter of picturesque staffage when we realize that they were steadily removing the Heath so it could be sold off as building materials. Likewise, it hardly seems a coincidence that Madox Brown's map-like view east from Hampstead village records part of the Heath which was then the subject of Maryon Wilson's 5th Estate Bill, the East Park estate, introduced into Parliament early in 1853. The picture's less familiar full title *English Autumn Afternoon, Hampstead-Scenery in 1853* reminds us of this fateful year. The previous year, 1852, the threat to the Heath had come from another direction when the Copyhold Enfranchisement Act enabled copyhold tenants on the Heath to purchase the freehold of their houses from the lord of the manor; in the event, their interests were bought up by developers and the Suburban Hotel Company entered the Vale of Health. Behind the artists' 'rural' views also lay an awareness of the expansion of the number of day trippers at this time. The arrival of the railway at South End Green in 1860 enabled attendance at fairs to double over the next twenty years to one hundred thousand, making "'Appy 'Ampstead" for the first time a mass pleasure-ground. Nineteenth century artists were not only pursuing an elusive 'truth to nature' that we know as naturalism, but were painting an endangered prospect, on the brink of encroachment from the capital.

Through the continued ownership of the Mansfield family, Kenwood remained intact and undeveloped, its unspoiled woods becoming a haven for wildlife and rare flora escaping from the destruction of the Heath. The 3rd Earl of Mansfield was an active opponent of Maryon Wilson's bills in the House of Lords, and in 1840 the fourth earl purchased part of Fitzroy Park to the east to prevent the building of terraces and villas there. In 1889 the Mansfields sold Parliament Hill Fields to the new London County Council, and in 1900 the fifth earl headed a committee opposed to the creation of tube stations on the Heath. In this situation, the secluded Kenwood estate became conspicuous, not only as the seat of the family who fought to preserve the Heath, but as an enviably private rural property, ripe for development. In this way, old engravings began to carry new associations. By 1912, when Thomas Barrett published *The Annals of Hampstead*, a sense of curiosity coloured his account of Kenwood, like someone noticing greener grass growing on the other side of the fence. He felt that:

> To the present generation it is something of a mystery, its glades and lake, and all its lovely wildflower haunts and mossy dells being left to the enjoyment of the birds and beasts that still find sanctuary in this beautiful retreat. The public are not allowed to see its many beauties.[39]

In 1914, however, the sixth earl decided to sell the estate to a building syndicate. Over the ensuing years, public appeals prevented the spread of villas to Kenwood. The efforts of the Kenwood Preservation Council saved several parcels of land, and finally the last piece of the jigsaw was completed when in 1925 Edward Cecil Guinness, Earl of Iveagh, purchased the house and remaining grounds, which he bequeathed to the nation on his death in 1927. The prospect, for so long the public's view of Kenwood from afar, was finally reversed, and today we enjoy the view south from the library, much as Adam described it, and as Lord Mansfield's guests and visitors discovered it.

1. Adam, p.8
2. Harris, 1979, p.25
3. Harris, 1979, p.68
4. Richardson, pp.34-37
5. John Macky, *A Journey Through England* (London, 1714) I, pp.42-43
6. Mrs Barbauld, quoted in Farmer, p.27
7. See: Christopher White, *English Landscape 1630-1850*, exhibition catalogue, Yale Center for British Art, 1977 (9).
8. See: Clare Crick, *The Camden Scene*, exhibition catalogue, Camden Arts Centre, 1979 (154)
9. I am grateful to Kim Sloan for drawing my attention to the studies in Cozens's sketchbook in the National Library of Wales
10. Col. M.H. Grant, *A Chronological History of the Old English Landscape Painters* (London, 1926) I, p.115
11. See: Crick, *op. cit.* (158)
12. See: Susan Morris, *Thomas Girtin*, exhibition catalogue, Yale Center for British Art, 1986 (4)
13. Bute MSS Collection, Mount Stuart, Isle of Bute. Quoted with the kind permission of The Marquess of Bute. Reference kindly provided by Catherine Armet.
14. See Bibliography, under Kenwood
15. The left-hand door leads into the Marble Hall, which was a withdrawing room and closet in Adam's day
16. Ware, *op. cit.* p.433-4
17. Adam, p.8
18. G.A. Ward, ed. *The Journal and Letters of the late Samuel Curwen* (London, 1842) p.53
19. Adam, p.9
20. Mrs. Boscawen to Mrs Delany, 14 October, 1776; quoted in Lady Llanover, ed. *The Autobiography and Correspondence of Mary Granville, Mrs. Delany*, 2nd series, II, (London, 1862) p.265
21. *The Ambulator; or, the stranger's companion in a tour around London*, second edition (London, 1782) p.51
22. *The Morning Herald and Daily Advertiser*, 21 September 1781
23. *The British Magazine and Review*, II, 1782
24. K. Garlick & A. Macintyre, ed. *The Diary of Joseph Farington*, I, (London and New Haven, 1978) p.97
25. See: John Jacob, *The True Resemblance of Lord Mansfield*, exhibition catalogue, Kenwood, 1971; introduction
26. *ibid* (27)
27. See cat. 93
28. Shaw, *op. cit.* p.23. Reference kindly provided by Dr. Terry Friedman
29. Daniel Lysons, *The Environs of London* (London, 1795) II, part I, p.4
30. Farington, *op. cit.* p.97
31. J.C. Loudon, *The Suburban Gardener and Villa Companion* (London, 1838) p.673
32. J. Norris Brewer, *The Beauties of England and Wales*, X, part IV, *London and Middlesex*, (London, 1816) p.178
33. Loudon, *op. cit.* p.665
34. *ibid* pp.661-2
35. *ibid* p.673
36. Quoted in C.R. Leslie, *Memoirs of the Life of John Constable* (London, 1951) p.162
37. For Constable's pencil sketch of the view from Richmond Hill, (c.1812) see: Leslie Parris *et al*, *Constable*, exhibition catalogue, Tate Gallery, 1976 (110)
38. See: Farmer, p.75. For a list of artists resident in the Hampstead area in the nineteenth century, see Baines, p.405
39. Barrett, *op. cit.* p.265

Fig. 26 Johann Zoffany, attrib. *Lady Elizabeth Murray and Dido Belle* c. 1780, showing the dummy bridge and St. Paul's as seen from the terrace at Kenwood. Mansfield Collection, Scone Palace.

Catalogue

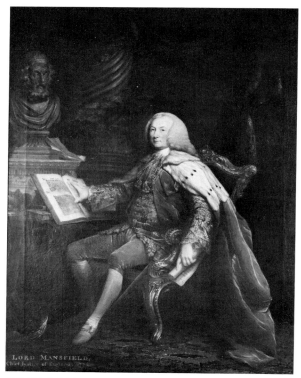

DAVID MARTIN 1737-98

71. *William Murray, 1st Earl of Mansfield*, 1775
Oil on canvas; 47¼×36½ in. (14·9×93 cm.)

INSCRIBED: *LORD MANSFIELD,/ Chief Justice of England 1775.*
PROVENANCE: Viscount Gage Collection; sold Christie's, 7 March 1952 (136), bt Sir Geoffrey Hutchinson; presented by Lady Ilford, 1975.
EXHIBITED: *The true resemblance of Lord Mansfield*, The Iveagh Bequest, Kenwood, 1971 (67)

Kenwood's most distinguished owner, William Murray (1705-96), Lord Chief Justice, later 1st Earl of Mansfield, is shown seated in baron's coronation robes pointing to a passage in Cicero. The background is dominated by a bust of Homer, believed at this time to be by Bernini, which Alexander Pope bequeathed to his friend and protégé. Between Homer and Mansfield spiral Solomonic columns (so called from their supposed use in King Solomon's temple) allude to the wisdom of Mansfield's judgements. The setting is imaginary, but the bust's pedestal, in the fashionable neoclassical style, reminds us of Mansfield's employment of Robert Adam to remodel Kenwood from 1764.

The original portrait, of which this is a replica, was painted for Mansfield's old college, Christ Church, Oxford. An almost identical, but much larger, portrait was painted by Martin after 1776 to hang in the library or 'Great Room' which Adam added to Kenwood. This now hangs at the Mansfield seat, Scone Palace in Perth. As an overmantel, set into a fixed frame, it formed the centrepiece of a decorative scheme of paintings, several of which allude to Mansfield's

abilities and pursuits. Adam originally intended to set a neoclassical painting or relief illustrating the administration of Roman Justice in this position, which, as a scene of judgement, would have been more obviously in keeping with the central ceiling painting, Zucchi's *Hercules between Glory and the Passions.*

David Martin trained under Allan Ramsay and became his drapery painter before returning to Scotland in 1775 as Principal Painter to the Prince of Wales for Scotland. He painted several portraits of Lord Mansfield, and engraved the prime version from which this replica is derived.

The Iveagh Bequest, Kenwood

ROBERT MORDEN fl. 1669-1703

72. *Middlesex*, 1695
Engraving, hand coloured; 14⅝×17 in. (37·2×43·2 cm.)

'Cane Wood' is clearly marked on this map, which appeared in 1695 in William Camden's *Britannia*, first published in 1637. The source of the Fleet River is shown on the Highgate side of the estate. Marble Hill and the present Ranger's House did not exist at this time, but their locations can be identified from the inclusion of 'The Observatory' below Greenwich in the south-east and 'Twickenham' in the south-west.

As a map seller and publisher, Morden published Wenceslaus Hollar's map of London in 1675 and, from 1681-7, *The Prospects of London, Westminster and Southwark*, comprising 35 plates, several of which were derived from Hollar.

The Iveagh Bequest, Kenwood

WILLIAM STUKELEY 1687-1765

73. *The 'tumulus' on Parliament Hill*, 1725
Pen and wash; 10¼×9½ in. (26×24·2 cm.)

INSCRIBED: *Immanuentii tumulus* and dated *1 May 1725*
LITERATURE: Farmer, pp.127-9

William Stukeley, one of the founders of the Society of Antiquaries and its Secretary, is well known for his interest

in recording the physical evidence of early British history, in particular Stonehenge and Avebury. He also encouraged the topographical draughtsman Samuel Buck to record the city prospects and antiquities of England and Wales, county by county, in sets of prints published from 1722. His notes to this drawing identify it as an ancient burial mound:

> This is a *tumulus* on an eminence by Caenwood, which I drew out on May day 1725, whether we always went a Simpling, in the years I lived in Town formerly. Dr. Wilmore now of Chelsea and Botanic professor in Apothecary's garden, commonly with me. It was the tumulus of some ancient Brittish king before Christianity: probably enough, of Immanuence monarch here just before Caesar's invasion.

Following a growth of speculation, the tumulus was excavated in 1894 and identfied as a Bronze Age barrow. It is now considered to be the site of a seventeenth century windmill, enlarged and planted with Scotch pines at the end of the eighteenth century to form a picturesque landmark. The tumulus can be found today, overgrown by trees and surrounded by an iron fence on a hill north of Parliament Hill itself. The view of London seen here is no longer visible owing to the growth of trees. Parliament Hill became separated from the mediaeval Caenwood estate in 1543, and was reunited with Kenwood by the 1st Earl of Mansfield in 1789. Stukeley's notes refer to 'Simpling', the collecting of medicinal herbs, which attracted apothecaries to Kenwood from mediaeval times.

Museum of London

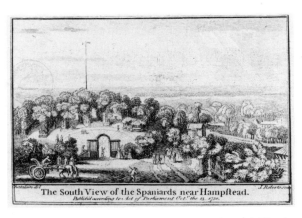

The South View of the Spaniards near Hampstead.
Published according to Act of Parliament Oct.r the 13, 1750.

obscura. Chatelain worked for Samuel and Nathaniel Buck, strengthening and embellishing their sketches of town prospects for engraving, and also for Vivares and for Boydell. His series of engravings entitled *Prospects of Hampstead and Highgate* first appeared in 1745, followed by further editions in 1750 and 1752. Among the first views of the Heath, they presented the area as a fashionable resort in which polite society could promenade, as if through paintings by Gaspar Poussin.

Guildhall Library, City of London

JAMES ROBERTS 1725-99
after JOHN BAPTISTE CLAUDE CHATELAIN c.1710-71

74. *The South View of the Spaniards near Hampstead*, 1750
Engraving; 2¾×4½ in (7×11·5 cm.)
in: JBC Chatelain, *Fifty Original Views* (London, 1750)

INSCRIBED: *Chatelain dell.J. Roberts scul/The South View of the Spaniards near Hampstead./Publish'd according to Act of Parliament Oct.r. the 13. 1750./32*

The Spaniards Inn still stands today on Hampstead Lane, north-west of Kenwood. The pleasure ground, shown here, no longer survives but probably stood on the south side on land later acquired by the 2nd Earl of Mansfield between 1793 and 1796. This is the site corresponding with the farmhouse and dairy cottages today. Besides an artificial mound from which to enjoy the surrounding prospect, the garden included mosaic tableaux showing the seven wonders of the world, ornamental walks, summer houses for tea and several mechanical surprises.

Chatelain included this engraving in his book of *Fifty small Original, and Elegant Views – Of The most Splendid Churches, Villages, Rural Prospects and Masterly Pieces of Architecture adjacent to London*, intended for "Such Gentlemen and Ladies as have a Taste for Drawing and Colouring, or are Delighted with the several Exhibitions of the Diagonal Mirror". The latter was possibly a form of camera

T. RAMSEY fl. 1755

75. *Heath House, Hampstead*, 1755
Oil on canvas; 31×44½ in. (78·8×113 cm.)

SIGNED (lower centre): *T. Ramsey 1755.*
PROVENANCE: Purchased by the 1st Earl of Iveagh from Leggatt Brothers, 18 March 1921; given to the 1st Lord Moyne, March 1927, thence by descent.
LITERATURE: Colonel M. H. Grant, *The Old English Landscape Painters* (London, 1926) I, p.114-5; Harris, 1979, p.213.

Heath House, 'the highest house in London', is virtually unchanged since Ramsey painted it. It stands on the summit of Hampstead Heath, 443 feet above sea level, at the top of the road from Hampstead village. The most obvious difference between this painting and the view today is the loss of the topiary screen which Ramsey records, and the addition of the war memorial. Whitestone Pond, where horses watered after the long haul up-hill, can be seen in the foreground, much as it survives. Kenwood is included in the distance through artistic licence, as it is not in fact visible from this point.

'The Heath', as the house Ramsey painted was originally known, was built about 1700, when John Sheffield, Duke of Buckingham, wrote to a friend after a recent visit:

> I'll add but one thing, before I carry you into the garden, and that is about walking too, but 'tis on the top of all the

detail COL. PLATE VII

1. Quoted in Baines, p. 56
2. Quoted in Barratt, II p. 179
3. Richardson p. 84; Alan Farmer, 'Colonel Fitzroy's Rustic Villa', *Camden History Review* 10 (1982) pp. 19-20
4. Reproduced *Country Life* CXXIII (1958) p. 1450
5. London Borough of Camden, Local History Library
6. Defoe, II, Letter III, p. 5.

Private Collection

house; which being covered with smooth mill'd lead, and defended by a parapet of ballusters from all apprehension as well as danger, entertains the eye with a far-distant prospect of hills and dales and a near one of parks and gardens.[1]

This view over five counties was enjoyed from the parapet, clearly visible above the right-hand wing of the house in this painting. As the home of the Quaker banker Samuel Hoare from 1790, 'The Heath' became a focus of literary and philanthropic activity in Hampstead. Guests included Wilberforce, Cowper, Crabbe, Mrs. Barbauld, Mrs. Siddons, Coleridge and Wordsworth. It may have been a visit to this parapet which prompted Wordsworth to write:

> Our haughty life is crowned with darkness,
> Like London with its own black wreath
> On which with thee, O Crabbe! forth looking
> I gazed from Hampstead's breezy heath[2]

John Constable painted Heath House in 1822 when it was the home of his legal adviser, Anthony Spedding. Later residents included Sir Algernon Borthwick Bt, M.P., from 1887, and Lord Iveagh from 1908 until 1919, when the house passed to his third son, Walter Edward Guinness, later Lord Moyne.

Although Kenwood cannot be seen from Whitestone Pond, the house features in nearly every eighteenth century account of Hampstead, Highgate and the Heath. Lord Southampton's villa, Fitzroy Farm, which stood to the east of Kenwood, is the only alternative identification for the white house in the painting. However, the villa was built later, sometime between 1760 and 1774.[3] A comparison with Mrs. Delany's sketch of Kenwood of 1756 (cat. 77) underlines the likelihood that this is the same house, seen as it appeared a decade before the remodelling by Robert Adam.

The liberties Ramsey takes as an artist, most noticeable in the disproportinate scale of the central group of figures, also makes it likely that Kenwood has been included through artistic licence. The artist himself is more difficult to identify and, but for one other painting from his hand, showing *Magdalen College, Oxford, and the River Cherwell*,[4] he remains a mystery. He may have been an amateur. A grey wash drawing after this painting was executed by E.J. Wheeler in 1770.[5]

The scene seems to have changed little since Daniel Defoe described this route for fashionable promenades, thirty years before Ramsey painted it:

> On the Top of the Hill, indeed, there is a very pleasant Plain, called the Heath, which on the very Summit is a Plain of about a Mile every way; and in good Weather 'tis pleasant Airing upon it[6]

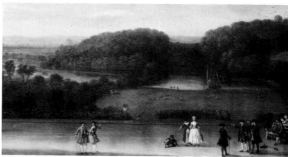

detail COL. PLATE VIII

JOHN WOOTTON 1682-1764

76. *A View from Caenwood House over London*, 1755
Oil on canvas; 32½×53 in. (82·6×134·6 cm.)

SIGNED: *J. Wootton/fecit/1755.*
INSCRIBED *(verso* on an old label): *View of London from Caen Wood Hampstead with Portraits of Ld. Mansfield & W. Hoskins father of the Duchess of Devonshire and John Wootton the Artist by Whom this picture was painted.*
PROVENANCE: Possibly painted for William Murray, 1st Earl of Mansfield; private collection.
EXHIBITED: *John Wootton*, The Iveagh Bequest, Kenwood, 1984 (32).
LITERATURE: Arline Meyer, *John Wootton*, exhibition catalogue, The Iveagh Bequest, Kenwood, 1984 (32)

This grand view of the prospect Kenwood commands, painted in the year after William Murray acquired the property, is in many ways quite fanciful. The artist's vantage point is impossible, given the immediate proximity of the house to the terrace; the fashionably dressed figures are reduced in scale; Highgate Hill on the far left is excessively steep, and the plain leading down to the City and the Thames is impossibly smooth. Comparison with two sketches by Mrs. Delany from the following years (cat. 77, 78) suggests that this may have been an artist's impression of William Murray's ambitions for his new estate, rather than an accurate record of changes achieved to date.

The statue of Flora and the trellis bridge are not otherwise recorded, and may be as much the product of artistic licence as is the grand model galleon shown on the pond. The 'Ancient Bridge' recorded by Mrs Delany two years later is not included. The gap in the trees beyond the pond, although enlarged, probably records one of the broad avenues visible in Rocque's map (fig. 24); these Mansfield subsequently turned into part of his 'circuit', a footpath that wound around the entire estate. The trees leading up from the ponds on the left obscure a public path, also visible in Rocque's map, and correspond with the line of a wall shown

in Robertson's drawing (cat. 86). Mansfield has yet to determine the outline of his 'Thousand Pound Pond' and build the 'dummy bridge' that masks its far bank, giving the illusion of a flowing river, such as Wootton has painted. Grazing sheep are not shown in any other view of the south lawn, but were present by 1838, when J.C. Loudon noticed the "wire fence, separating the mown ground from the sheep pasture"[1] running along the foot of the terrace.

Among the figures shown on the terrace (which appears to have been covered with sand at this time) Lord Mansfield can be seen on the right, pointing towards the City, while Wootton sits behind him sketching the prospect. A catalogue to the artist's studio sale of 1761 lists a 'small head' of Lord Mansfield, *A Moonlight and a View of Caen Wood*, and *A View from Canewood House over London*. The inclusion of the latter in the sale suggests that it might not have been commissioned by Mansfield himself, and the provenance of this painting remains a mystery.[2]

The portrait of *Lady Elizabeth Murray and Dido Belle* attributed to Zoffany (fig. 26) provides a close-up view from the terrace about twenty years later, with the dummy bridge and prospect of St. Paul's beyond.

1. J.C. Loudon, *The Suburban Gardener* (London, 1838) p.664
2. The Kenwood inventory of 1901 included *A Moonlight Subject.* Wootton and *A Woody landscape with figures.* Wootton.

Private Collection

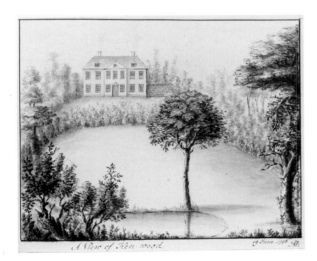

A View of Ken-wood

MRS DELANY (née MARY GRANVILLE) 1700-88

77. *A View of Ken-wood*, 1756
Pencil, ink and wash; 7¼×9 in. (18·4×22·8 cm.)
in an album of mounted drawings.

SIGNED with monogram: *MD.*
INSCRIBED: *A View of Ken-wood* and dated *19 June 1756*.
PROVENANCE: Purchased Sotheby's, Mr F. Wellesley Sale, 1920.
LITERATURE: National Gallery of Ireland, *Illustrated Summary Catalogue of Drawings, Watercolours and Miniatures* (Dublin, 1983) p.95

Mrs. Delany's sketch of the south front was executed two years after William Murray purchased Kenwood, and records the house as it appeared eight years before Adam

began to remodel it. Although the work of an amateur and not of a professional draughtsman, the basic accuracy of this drawing must be assumed in the absence of an alternative record from this period, even if Kenwood seems to resemble a doll's house. At this time the third storey was lit by dormer windows, the library and ante-room did not exist and the Orangery was detached. The wall on the right in this sketch connects the house to a bath house, which still stands.

The appearance of the grounds contrasts with Wootton's painting of the previous year; (cat. 76). The pond here is less imposing, the lawn is more confined, and there is no sign of a terrace. Furthermore, the arc of trees in this sketch is represented in the oil by a broken line of flower beds. Another drawing by Mrs Delany of the following year (cat. 78) records an 'Ancient Bridge' which cannot be seen in the oil painting. These differences suggest that Wootton's painting may be a projection of the appearance of the grounds, which Murray began to landscape soon after purchasing Kenwood in 1754, rather than an accurate record of his completed remodelling of the estate.

Mrs Delany, one of the original 'Blue Stocking Circle' which met in the second half of the eighteenth century, was a friend and correspondent of Swift, Pope, and Horace Walpole and a favourite of the royal family. Her *Autobiography and Correspondence* is an indispensable first-hand account of 'polite society' in eighteenth century England. Lord Mansfield, as Murray became in 1756, was sufficiently close a friend to provide Mrs Delany with one of the flowers she copied in 'paper mosaicks' for the herbal she compiled in her old age.[1] In 1776 the Hon. Mrs Boscawen wrote to her:

> Yesterday we went to see Ken wood, but seeing Ld Mansfield come home, and being told there was to be company at dinner, we thought it polite to refrain from walking out, and only just take a glance of the very excellent library, &c., promising ourselves, as indeed the servants very civilly promised us, we shd see ye woods and gardens at full liberty another time.[2]

During the Gordon Riots four years later Mrs Delany wrote to Mary Port, the day after Kenwood escaped destruction:

> Lord Bute (and Lady Bute) are gone out of town but I fear there will be as *little mercy* shown to *his* house as to *Lord Mansfield's* in Bloomsbury Square. Thank God *he* and his family are safe and well, but *his house* with everything in it is *burnt to the ground!* and Kenwood would have met the same fate had not the militia saved it yesterday.[3]

As the novelist Fanny Burney wrote of Mansfield after visiting Kenwood "to see the house and pictures" in 1792:

> He was particularly connected with my revered Mrs Delany, and I felt melancholy upon entering his house to recollect how often that beloved lady had planned carrying thither Miss P-- and myself, and how often we had been invited by Miss Murrays, my Lord's nieces.[4]

1. Ruth Hayden, *Mrs Delany: her life and her flowers* (London, 1980) p.143
2. Lady Llanover, ed., *The Autobiography and Correspondence of Mary Granville, Mrs Delany*, 2nd series, (London, 1862) II p.265
3. Hayden, *op.cit* p.532
4. Barratt, p.275

National Gallery of Ireland

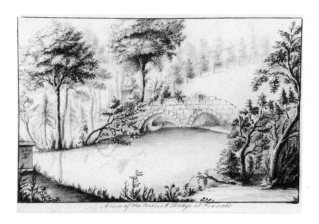

Arm of the Ancient Bridge at Kenwood

The Excursion to Cain Wood.

MRS DELANY (née MARY GRANVILLE) 1700-88

78. *A View of the Ancient Bridge at Kenwood,* 1757
Pen and wash; 9½×13½ in. (16×22 cm.)

SIGNED with monogram: *MD* and dated *25 June 1757.*
INSCRIBED: *A View of the Ancient Bridge at Kenwood.*

This is the only known record of the 'Ancient Bridge',
which was probably demolished soon after this sketch was
made, in the course of constructing Mansfield's so-called
'Thousand Pound Pond'. Rocque's map (fig. 22) shows four
small ponds that were later combined into two, to give the
illusion of a wide river at the foot of the south lawn. The pil-
lar on which Mrs Delany has inscribed her initials and the
date may be simply artistic licence, or possibly the earliest
evidence for the construction of the 'dummy' bridge. The
'Ancient Bridge' itself seems almost redundant; a lower
pond can be seen through the left arch and the right arch
appears dry. It may have been a modern sham; these were
not uncommon in landscaped gardens at this time. The arc
of trees confirms the planting visible in Mrs Delany's sketch
executed almost exactly a year before. The rowing boat
included in this view also appears in Corbould's engraving of
1786, and is more likely to be the subject of the annual pay-
ment for "lackering Boat £1-1" recorded in the house
accounts than the fanciful galleon shown in Wootton's paint-
ing (cat. 76).

The ruled border and inscription suggest that this sketch
may have belonged to the same album of mounted drawings
as *A View of Ken-wood* (cat. 77). This album covers the period
1739-73 and includes sketches by Mrs Delany that range
from Dublin to Gloucestershire and Derbyshire. Among the
other houses recorded are Kedleston Hall and Wroxton
Abbey; Kenwood is the only view near London.

Dudley Snelgrove Esq.

ANON.

79. *The Excursion to Cain Wood,* 1771.
Engraving; 4¾×7⅛ in. (12×18 cm.)
Various inscriptions

The subject of the earliest datable engraving related to Ken-
wood remains a mystery. One suggestion is that the figures
on a broomstick represent Lord Mansfield and Princess
Augusta of Wales flying from London to Kenwood to seek
the advice of the 3rd Earl of Bute.[1] If so, the print's inclusion
in the *Oxford Magazine* in October 1771 (volume VII, facing
page 128) must represent a reissue of an earlier engraving, as
Bute owned Kenwood from 1746 to 1754, before selling the
house to the future 1st Earl of Mansfield. This is an attrac-
tive explanation, as the subject of the satirical print is clearly
some current threat to liberty, represented by the City seen
ablaze from Parliament (or 'Traitors') Hill, while John
Wilkes and the Lord Mayor of London look on, recognizing
'These Birds of Ill Omen'.

Bute held a strong influence over Princess Augusta and
her son, George III, particularly through his belief in abso-
lute monarchy. Following the first Regency Act of 1751,
Augusta became Regent in George II's absence, and in
1760, on the accession of George III, Bute became the
King's chief minister. However, the text that accompanied
the engraving, a letter to the editor of the *Oxford Magazine*
signed 'A Dreamer of Dreams', clearly alludes to the topical-
ity of the engraving in the year of publication, 1771, while
giving nothing away. The artist was "presented with a vis-
ion, a few nights ago, that was so very remakable, that,
perhaps, some of your readers may be able to expound it".

1. Jacob, no. 41

The Iveagh Bequest, Kenwood

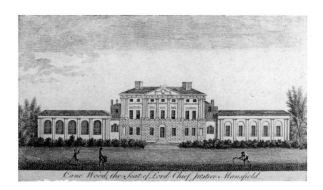

JAMES ROBERTS 1725-99 attrib.

80. *Cane Wood, the Seat of Lord Chief Justice Mansfield, 1773.*
Engraving; 4⅛×7½ in. (10·5×19 cm.)

INSCRIBED: *Vol. 2 P.73/Cane Wood, the Seat of Lord Chief Justice Mansfield.*

This is the earliest known print of Kenwood, and the first image of the house to show Adam's improvements, predating the plates in Adam's own *Works in Architecture* (cat 81-3). The engraving is an illustration to the second edition of *A New Display of the Beauties of England*. This popular book contained descriptions "of a greater number of Noblemen's and Gentlemen's Seats... than can be met with in any other publication.... And of these a very unusual number of engraved views are given". As the preface makes clear "this was our capital object.... this Work will be found an agreeable companion for those who may occasionally visit different parts of England, in order to take a view of the many fine palaces and seats with which this Kingdom abounds". It also contains views of Marble Hill (cat. 43) and Wricklemarsh (cat. 20), and of the prospects from Richmond Hill and One-Tree Hill in Greenwich Park. The view of Kenwood reappeared in subsequent editions dated 1776 and 1787. The rather crude portrayal of Kenwood and modest size of this print reflect the practical role of this early illustrated handbook to country house viewing in England.

The accompanying description indicates public interest in visiting the house and its fine prospect shortly after Adam made his improvements. The text is unusual in needing to identify Lord Mansfield, suggesting that he was not yet the celebrated figure he later became:

> On that side of Highgate which is next London, the fineness of the prospect over the city, as far as Shooter's-hill and below Greenwich, has occasioned several handsome edifices to be built.... At a small distance from Highgate is *Cane-wood*, where Lord Mansfield, the present Chief Justice of the King's Bench, has a fine seat, the situation of which is extremely rural.

The view was reemployed, enlarged, in several later publications, one of which, Henry Boswell's *Historical Descriptions of New and Elegant Picturesque Views of the Antiquities of England and Wales* (London, 1786) credits Roberts as the engraver. In this more lavish production, two plates are shown on each page, and Kenwood is paired with Syon, another house by Adam. The description of Kenwood

praises Adam's "many decorations; so that, in its present state, as represented in our Plate, this villa, for country retirement, exhibits the appearance of a sumptuous palace".

James Roberts executed engravings after J.B.C. Chatelain, Richard Wilson, George Barret the elder, James Seymour and others, but the artist responsible for the original drawing of the south front remains unknown.

The Iveagh Bequest, Kenwood

CHARLES WHITE 1751-85
after ROBERT ADAM 1728-92

81. *General Plan of Lord Mansfield's Villa at Kenwood, 1774.*
Engraving; 18×23¾ in. (45·7×60 cm.)

INSCRIBED: *Vol:1 No. II. Plate I./ General Plan of Lord Mansfield's Villa/at Kenwood./Plan general de la Villa du Lord Mansfield/a Kenwood./R. Adam Architect, 1767/Published as the Act directs 5ᵗʰ February 1774,/C. White Sculp*, with scale.

This plan reveals Kenwood as it stood after Robert Adam made his additions for the 1st Earl of Mansfield and before the modifications made by the second earl at the end of the eighteenth century. In the text, published to accompany this engraving, Adam identified his own work: "the portico to the north, the great room or library, and its anti-room, are the new additions".[1] The original house was built soon after 1616 and was substantially rebuilt some forty or fifty years before Adam commenced work here in 1764. The thickness of the walls can be taken as a guide to the original plan. The most significant differences to the house as it now stands are the absence of the Music Room and Dining Room (built by George Saunders in 1793-6) and the presence north of the Orangery of the Service Wing, which was demolished when the new service wing was constructed by Saunders. Other obvious differences include the limited access to the Orangery, which can only be entered from outside, the division of the parlour into two rooms, the southern alignment of doors between the south front rooms, and the direct access from the entrance hall into the parlour. The Marble Hall (created by Saunders) was merely a withdrawing room and closet at this time, separated from the library vestibule by a solid wall containing a niche for sculpture. The walls screening the 'Kitchen Court' and 'Kitchen Garden' from the 'Grand Court' on the north front were demolished when Saunders's wings were added. In the original design by Adam, now in Sir John Soane's Museum, the main stairwell is a major feature on the reception route, with the staircase set back at the east end beyond columns and lit from behind by a large venetian window.

This engraving is exhibited as it originally appeared, bound in the second of the five parts that together made up the first volume of *The Works in Architecture of Robert and James Adam Esquires*. Volume one appeared from 1773 to 1778, and fifty years passed before all three volumes were published.

The *Works* are best understood as a kind of *catalogue raisonnée*, a survey of the best commissions carried out by Robert Adam and his brother to date, presented in fine engravings with an accompanying text which clarifies their

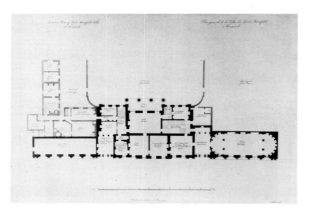

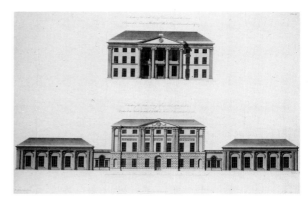

principles as architects. As a publication it follows the tradition of Colen Campbell's *Vitruvius Britannicus* (cat. 39) and William Adam's *Vitruvius Scoticus* (1720-40), with the latter of which, produced by their father, Robert Adam and his brother had assisted. Both Adam publications differ from Campbell's in omitting designs by architects other than themselves.

To Robert Adam's admirers the publication of the *Works*, when he was in mid-career, would have seemed a fitting sequel to his earlier folio representing the fruits of research and excavation: *Ruins of the Palace of the Emperor Diocletian at Spalatro in Dalmatia* (1764). The intended effect of the *Works* was probably to establish the prestige of the family firm, to advertise its best commissions and to attract further clients (who might also come from abroad as the text appeared in both English and French). To some extent the attempt failed, as the *Works* initially provided a convenient copy-book for other architects to plagiarise, before many patrons came to recognise the distinguishing qualities of the true 'Adam' style.

1. R. and J. Adam, *op.cit.* p.8

The Iveagh Bequest, Kenwood

JOHN MILLER fl. 1761-85
after ROBERT ADAM 1728-92

82. *Elevations of the North and South Fronts of Kenwood*, 1774.
Engraving; 24×35¾ in. (61×90.8 cm.)

INSCRIBED: *Plate III./Elevation of the North Front of Kenwood, towards the Court./Elevation de la Façade au Nord, de la Villa de Kenwood, donnant sur la Cour./Extends 90 Feet/Elevation of the South Front of Kenwood, towards the Gardens./Elevation de la Façade au midi, de la Villa de Kenwood, donnant sur les Jardins./Extends 240 Feet./R. Adam Architect 1748./Published as the Act directs, 5ᵗʰ February 1774./J. Miller Sculpᵗ*, with scale.

These two elevations from *The Works in Architecture of Robert and James Adam Esquires* represent Adam's remodelling of Kenwood almost exactly as built. The only differences between the engraved designs and the completed building are the omission of chimney stacks in the engraving and the proposed reduction in size of the Orangery windows to

balance those of Adam's library. George Saunders's additions of 1793-6 included two wings on the north side which are also visible from the south today, behind the low buildings beside the Orangery and Library. The original design for the South Front in Sir John Soane's Museum, dated 1764, reveals that Adam at first conceived a plainer and heavier effect in keeping with the Palladian style of neoclassical architecture. The grand portico was originally intended for the South Front, with no other decoration than a string course linking coupled pilasters at either end. At this stage the library windows were to be as large as those in the Orangery, and the addition of a third storey was not envisaged. A second design, dated 1768, records his intentions largely as built, the only difference from the engraving lying in the pediment of the South Front, which was to contain an allegorical sculpture group of twelve figures.

In his introduction to the text that accompanies this engraving, Adam indicated his main aims:

The noble proprietor, with his usual liberality of sentiment, gave full scope to my ideas: nor were these confined by any circumstances, but the necessity of preserving the proper exterior similitude between the new and the old parts of the building.[1]

Such continuity was established through the use of stucco. Adam employed this material to an extent that was unusual on a large house at this time, and anticipated the more frequent use of exterior plasterwork by James Wyatt and John Nash. The addition of rustication to the ground storey on the South Front enabled Adam to add a third row of windows without increasing the length of the pilasters and so disrupting the overall proportions. By removing the portico to the North Front and replacing it with shallow pilasters decorated in low relief, Adam distinguished between the main public entrance, with its debt to Roman civic architecture, and the more private garden facade, with its panels of ornament continuing the domestic scale of decoration from within. Kenwood is the finest example of this development in Adam's approach to architecture. In the introduction to the *Works* he criticised the earlier Palladian style for following the rules of proportion too closely, and praised the sense of 'movement' and 'picturesque' effect achieved by Baroque architects such as Vanbrugh a generation before. In this engraving we see the development of Adam's personal style between north and south elevations, his attempt "to seize, with some degree of success, the beautiful spirit of antiquity, and to transfuse it, with novelty and variety!"[2]

To some extent Adam's interests derived from his own abilities as an artist, which we see in this group of engravings after his designs. He trained under his father and, while in Rome, under the French landscape painter Charles Louis Clérisseau. The twenty-six engravers employed on the *Works* included noted artists such as Piranesi and Zucchi, and Adam seems to have encouraged specialization. Charles White (cat. 81) only engraved plans and Miller only elevations and a cross section. The best known view in the *Works* (cat. 83) required two engravers, Vitalba and Pastorini; after this collaboration Vitalba did not contribute again whereas Pastorini provided thirteen more plates over the next decade, more than any other engraver.

1. R. and J. Adam, *op.cit.*, I, part II (London 1774) p.8
2. *op.cit.*, part I, p.6

The Iveagh Bequest, Kenwood

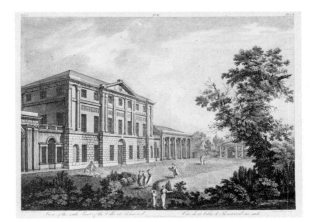

GIOVANNI VITALBA 1738-92 and BENEDETTO PASTORINI c.1746- after 1803 after ROBERT ADAM 1728-92

83. *View of the South Front of the Villa at Kenwood,* 1774.
Engraving; 17¼×23⅜ in. (44×59·4 cm.)

INSCRIBED: *Vol: I./N°. II/Plate II/R.Adam Architect 1768./Vitalba & Pastorini Sculp'./ View of the south Front of the Villa at Kenwood./Vue de la Villa de Kenwood au midi./Published as the Act directs 5ᵗʰ February 1774.*

The most familiar view of Kenwood, this engraving first appeared in 1774 in *The Works in Architecture of Robert and James Adam Esquires* (1773-1822). The actual viewpoint is imaginary, raised above the ground which in fact falls away sharply from the terrace, unlike the gentle slope shown in the engraving. This angle, however, enabled Adam to omit the Orangery on the left (which pre-dates his employment at Kenwood), place the celebrated library or 'Great Room' at the centre of the image, and emphasise the shallow relief decoration with a raking light. The pavilion terminating the terrace has long since disappeared and might be considered as unreal as the young maidens in classical dress who run

past the eighteenth century gentlemen and dog on the terrace, were it not for the survival of scaled drawings in Sir John Soane's Museum, dated 1771, and the discovery of a line of bricks at right angles to the house during the repair of a burst water main in 1974. If built, the pavilion would have helped to block the view to and from the public road, near the point where Robertson's sketch was made (cat. 86). Other differences are the omission of chimney stacks, (compare cat. 80), and the lack of a drainpipe on the side of the house (compare cat. 93). The balustrades along the tops of the rooms linking the wings to the main block no longer exist, nor does the string course, shown running along the side of the building.

In 1974 this engraving provided key evidence in the reconstruction of Adam's relief decoration on the South Front by the Greater London Council's Historic Buildings Division. The architect's text, published to accompany this engraving, points out how "The decoration bestowed on this front of the house is suitable to such a scene. The idea is new, and has been generally approved".[1] But by 1778 the original patent stucco employed had already begun to fail and, as Humphry Repton recalled in 1803:

> The great Lord Mansfield often declared, that had the front of Kenwood been originally covered with Parian marble, he should have found it less expensive than stucco.[2]

After nearly twelve years, fibreglass has fared considerably better. The chief purpose of Adam's accompanying text, however, is to describe the setting, not the architecture. His design for the South Front was conceived to harmonise with:

> a noble view let into the house and terrace, of the city of London, Greenwich Hospital, the River Thames, the ships passing up and down, with an extensive prospect, but clear and distinct, on both sides of the river.... The whole scene is amazingly gay, magnificent, beautiful and picturesque.[3]

1. R. and J. Adam, *op.cit.*, I part II, p.8
2. Humphry Repton, *Observations on The Theory and Practice of Landscape Gardening* (London, 1803) p.210
3. R. and J. Adam, *op.cit.*, p.8

The Iveagh Bequest, Kenwood

ROBERT CRONE c.1718-79 attrib.

84. *View of London from Highgate,* c.1777
Oil on canvas; 24×38½ in. (61×97·8 cm.)

PROVENANCE: Benjamin Booth; by descent to Captain Richard Ford, 1929; Ford Sale, Christie's 14 June 1929 (9); E.E. Cook, by whom bequeathed to the National Art-Collections Fund, 1955 and presented to Kenwood.
LITERATURE: D.H. Roberts, 'The Ford Collection of Works by Richard Wilson, R.A.', *The Connoisseur* LVII (1920) pp 33-4; Frank Rutter, *Wilson and Farington* (London, 1923) p.97; W.G. Constable *Richard Wilson* (London, 1953) pp.87, 180; The Iveagh Bequest, Kenwood *Catalogue of Paintings* (London, 1965) cat.72; Anne Crookshank and the Knight of Glin, *The Painters of Ireland c.1660-1920* (London, 1978) p.123.

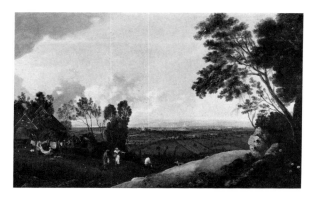

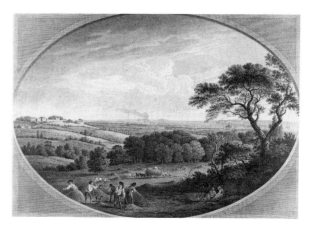

Eighteenth century paintings of the prospect of London from Hampstead Heath are surprisingly rare, compared to contemporary views from Greenwich Hill and Richmond Hill, although large engravings were produced towards the end of the century. One reason for this absence is probably the relative lack of fine villas adjoining this common land and thus of patrons who might commission a portrait of their home in its setting. The former title of this painting, *View of Oxford*, does, however, alert us to the fact that this lack of known landscapes may be partly accidental.

Long attributed to Richard Wilson (cat. 44-7), particularly on the strength of its provenance leading back to Wilson's early patron, Benjamin Booth, this painting has recently been tentatively attributed to Wilson's pupil, Robert Crone, by David Solkin. Few genuine paintings by Crone are known, but the handling is sufficiently close to Wilson to be the work of a pupil. Wilson is known to have taken his pupils sketching to Muswell Hill and he himself painted a similar panoramic view from Muswell Hill towards Southgate.[1] Crone's composition derives from the master's *Rome from the Villa Madama*.[2] He studied with Wilson in Rome, and painted on Hampstead Heath. In 1777 he exhibited at the Royal Academy a *View of Hampstead and Highgate*, which was presumably taken from the south.

Cottages such as the one shown here were not common on the Heath, but at the beginning of the eighteenth century several homes were established illegally north of Jack Straw's Castle at a commanding point now known as Heath Brow. J.T. Smith's engraving *Rustic Cottage near Jack Straw's Castle* (1797) records one of these cottages, which were later bought out by the gentry[3].

1. Solkin, pp.231-2.
2. Constable, *op. cit.*, pl.107b
3. Farmer, pp.30-1, pl.16

The Iveagh Bequest, Kenwood

DANIEL DE LERPINIERE d.1785
after GEORGE ROBERTSON 1749-88.

85. *A North View of the Cities of London and Westminster with part of Highgate, taken from Hampstead Heath near the Spaniards*, 1780.
Engraving; 18½×22½ in. (47×57·1 cm.)

INSCRIBED: *George Robertson Delineavit/Daniel Lerpiniere engr./John Boydell excudit 1780/A NORTH VIEW of the CITIES of LONDON and WESTMINSTER with part of HIGHGATE taken from/Hampstead Heath near the Spaniards.*

One of the earliest large 'fine art' engravings of Hampstead Heath, Robertson's panoramic view south-east stretches from Fitzroy Farm and Highgate to St. Paul's and Westminster. Looking across the Kenwood estate at harvest time, the artist evokes an idyllic world that contrasts with today's idea of the wild heath, as painted by John Constable and John Linnell (cat.110-112). The actual viewpoint is close to the Spaniards Inn, and may even have been the edge of its pleasure garden, as earlier recorded by Chatelain (cat.74), where customers enjoyed commanding views towards London. North Hill, now part of the North Wood that defends Kenwood from Hampstead Lane, has been identified as forming part of this garden in the eighteenth century; the part that survives behind a massive sandpit was then known as Prospect Hill.[1]

Like the same artist's view of Kenwood, published in the following year (cat.87), this engraving formed one of a set of landscapes published by Boydell. The group also included *A South View of London and Westminster*, also engraved by Lerpiniere, and two views of Windsor. The companion oval drawing by Robertson survives showing London from Blackheath.[2] The oval format anticipates Madox Brown's painting of the Heath from Hampstead High Street, in its effective omission of extraneous details in favour of the expansive horizon (cat.119). The inclusion of rustic reapers and elegant trees sets this work clearly in the picturesque world of Richard Wilson and George Stubbs, elevating it above contemporary topographical illustrations.

1. Farmer, pp.159-160
2. Cyril Fry, 'Artists in Greenwich and Lewisham', *Transactions of the Greenwich and Lewisham Antiquarian Society*, VIII, 6 (1972), reproduced facing p.283.

Keats House; London Borough of Camden

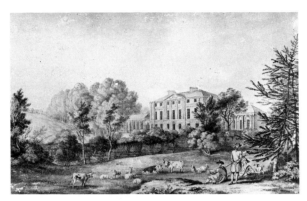

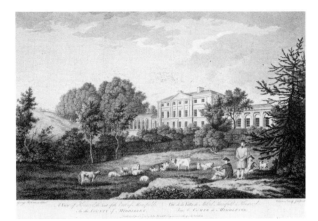

GEORGE ROBERTSON 1749-88

86. *A View of Kenwood*, 1780

Grey wash, pen and pencil outlines; 13¾×20⅝ in. (35×52·3 cm.)

PROVENANCE: Purchased Sotheby's, 30 November 1978 (115)

Robertson's view of the South Front was sketched on the eastern edge of the estate near the public path that linked Hampstead Lane and Kentish Town, and divided Kenwood from Lord Southampton's Fitzroy Farm. This lane can be seen in Rocque's map (fig. 22). The irregular overgrown wall was demolished after 1794 when the 2nd Earl of Mansfield diverted Millfield Lane to join Highgate West Hill and used the old road (since renamed Nightingale Lane) as a private carriageway. Part of the former estate wall survives today alongside the route of the old road that passes the stable block tea garden. The lime avenue can be seen on the left, receding towards a cluster of buildings which is probably intended to include the Spaniards Inn.

The group of gentlemen are enjoying a view of Kenwood (and, in the opposite direction, the City) which was well known by 1780 owing to its inclusion in three editions of *A new Display of the Beauties of England* (cat. 80), and in Adam's own *Works in Architecture* (1774). The viewpoint, from the east (unlike Adam's own view of the South Front, cat. 83) may have been chosen to avoid duplication. Kenwood was well known in the year this view was sketched. It narrowly escaped destruction during the Gordon Riots of 1780, thanks to the arrival of a platoon of dragoons up the east road. The wall that obscures this sylvan retreat reminds us of the privacy of the Kenwood estate, despite its prominence beside a public right of way.

The artist's large sketching board, shown in the drawing, suggests the presence of Robertson himself, and that this view may not have been enlarged in the studio from sketchbook notes. The use of grisaille indicates that it was commissioned specifically for engraving. Robertson drew five similar large views which, with his view of Kenwood, were engraved and published by Boydell on 1 January 1781 (see cat. 87). These differ from the draughtsmen's views of houses published in tour books such as Roberts produced (cat. 80) and bear a closer resemblance to landscape paintings in their choice of viewpoint and inclusion of picturesque groups of figures and trees. Robertson also painted wide oval prospects of London from Blackheath and from Hampstead Heath, which were engraved in 1780 (cat. 85).

The Iveagh Bequest, Kenwood

WILSON LOWRY 1762-1824
after GEORGE ROBERTSON 1749-88

87. *A View of Kenwood, the Seat of the Earl of Mansfield*, 1781

Engraving; 15¾×21¼ in. (40×54 cm.)

INSCRIBED: *George Robertson delin'./Wilson Lowry Sculpsit./A View of Kenwood, the Seat of the Earl of Mansfield's/In the COUNTY of MIDDLESEX,/Vüe de la Villa de Milord Mansfield à Kenwood,/dans le COMTE de MIDDLESEX/Published Jan⁵. 1ˢᵗ. 1781, by John Boydell, Engraver in Cheapside, London.*

This is the first 'independent' engraving of Kenwood, in which the print is considered as a work of art. The house had previously been published as a small illustration in a popular guide to country house viewing (cat. 80) and in Adam's *Works in Architecture* (cat. 83). The engraving appeared in a set of *Six Views of Gentlemens' Seats near London* after Robertson, published by Boydell in 1781, which also includes views of *The Ranger's House in the Park at Greenwich* (then the Queen's House), *Sir Gregory Page Turner's Seat at Blackheath*, namely Wricklemarsh (see cat. 20), two views of Wanstead House and one of Lambeth Palace. The French inscription suggests that the publishers anticipated an overseas market for this set of views. It also implies the range of travellers who came to admire Kenwood, having seen such engravings. A long article on Kenwood, including an account of Lord Mansfield's collection of paintings and a detailed description of the grounds, appeared in the *Morning Herald* on 21 September 1781 and, as the first of its kind, further indicates the extent of public interest in Lord Mansfield and Kenwood in this year.

Wilson Lowry, the son of the provincial portrait painter Strickland Lowry, came to London in 1780 at the age of eighteen with a letter of introduction to the printseller and publisher Boydell, and engraved this view the same year. He also made engravings after Salvator Rosa and Gaspar Poussin, but he is best known as the inventor of the ruling machine. The machine's steel needle could place matching lines close together with mathematical precision, but at the price of looking mechanical. Lowry's preference for such consistent accuracy is particularly noticeable in the tight shading of the sky in this engraving, executed a decade before his invention.

The most significant difference between this engraving

and the original drawing (cat. 86) is the slight change in perspective of the library on the right, which appears to enlarge it. There are minor differences in the foliage, particularly in the tree in front of the house which serves to obscure the blank wall, more visible in Birch's engraving of 1789 (cat. 93).

The Iveagh Bequest, Kenwood

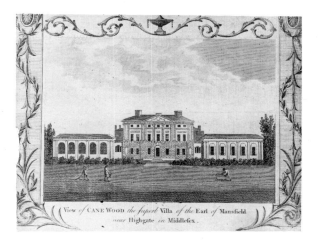

JAMES ROBERTS 1725-99 attrib.

88. *View of Cane Wood*, 1782
Engraving; 5⅛×7 in. (13×17·9 cm.)

INSCRIBED: *View of CANE WOOD the superb Villa of the Earl of Mansfield/near Highgate in Middlesex.*

This view of the south front is a re-issue of an earlier engraving (cat. 80), embellished at the sides with palms, husks, wreaths and studs, and above with a central urn flanked by scrolls. In this way it appeared on the same pages as a view of Syon House in William Thornton's *The New, Complete, and Universal History, Description and Survey of the Cities of London and Westminster* (1784) and in George Augustus Walpoole's *The New British Traveller: or a Complete Modern Universal Display of Great Britain and Ireland* of 1782, both published by Alexander Hogg in weekly numbers. Later stages of the latter omit the frame and credit Roberts under the image. The same plate is also included in Henry Boswell's *Historical Descriptions of New and Elegant Picturesque Views of the Antiquities of England and Wales* (1786), issued in one hundred numbers by Alexander Hogg. As a revised edition of Walpoole appeared in 1794, and Thornton was re-issued in 1796, the demand for luxury books including country house views must have been considerable at this time. According to Walpoole:

> At the North extremity of this village is a heath or common, which is adorned with many handsome buildings, and so elevated as to command one of the most extensive prospects in the kingdom. At the bottom of the heath, towards Highgate, is Caen-Wood, where there is a handsome seat belonging to the right honourable earl Mansfield.[1]

In his 'grand copper-Plate repository of Elegance, Taste and Entertainment containing.... Various Picturesque Views of the principal Seats of the Nobility and Gentry', Boswell praises 'the prospect from the garden front' of Kenwood. Thornton, Walpoole and Boswell were probably pseudonyms for a team of hacks employed by Hogg.

1. Walpoole, *op.cit.* p.286

The Iveagh Bequest, Kenwood

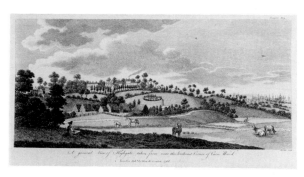

JOHN GOLDAR 1729-95

89. *A General View of Highgate*, 1786
Engraving; 5¾×12 in. (14·6×30·5 cm.)

INSCRIBED: *European Mag./Goldar sculp/A general View of Highgate taken from near the South-east Corner of Caen Wood/London Pub.ᵈ by J. Sewell. Cornhill. 1786.*

The artist shown with his board bottom left is recording the prospect south-east from the Kenwood estate, near the point where F.J. Sarjent drew his view towards London (cat. 103). The skyline of this 'foldout' engraving published in the *European Magazine* in December 1785 (despite its later date) stretches from Lord Southampton's Fitzroy Farm on the left to the dome of St. Pauls, with Highgate Ponds below.

The Iveagh Bequest, Kenwood

JOHN GOLDAR 1729-95

90. *A View of Lord Mansfield's House*, 1786
Engraving; 6⅜×8¾ in. (16·2×22·3 cm.)

INSCRIBED: *EUROPEAN MAGAZINE./A View of LORD MANSFIELD'S HOUSE taken from the side of his Park next to Hampstead./Publish'd by J. Sewell Cornhill, 1786.*

These gentlemen are standing on the old road that ran along the Manor and Parish boundary and marked the western perimeter of Lord Mansfield's estate. This is clearly marked on Rocque's map (fig. 22). From the favoured viewpoint they enjoy the fine prospect of Kenwood, Lord Southampton's Fitzroy Farm and Highgate beyond. The land behind them was only added to the Heath in 1889.

Kenwood itself has been enlarged by the artist, giving a view comparable to the one Ibbetson painted eleven years later (cat. 102). The *European Magazine*'s description of this prospect suggests the regular passing of fashionable sightseers:

> Agreeably to our promise in a former Number, and as a companion to the General View of Highgate inserted in our last Magazine; we now present our Readers with an Elegant Engraving from a Drawing furnished by the elegant Gentleman who favoured us with the former, of the Houses of Lord Mansfield and Southampton near Highgate.[1]

1. *European Magazine*, IX (January 1786) p.8

The Iveagh Bequest, Kenwood.

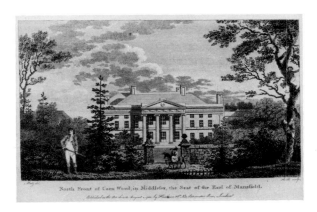

JAMES HEATH 1757-1834 attrib.
after CONRAD METZ 1755-1827

91. *North Front of Caen Wood*, 1788
Engraving; image size: 3¾×6⅜ in. (9·6×16·2 cm.)

INSCRIBED: *Metz del./Heath sculp/North Front of Caen Wood, in Middlesex, the seat of the Earl of Mansfield./ Published as the Act directs, August 1, 1788, by Harrison & Co. No. 18, Paternoster Row, London.*

Metz's view of the North Front was published as a 'sequel' to Corbould's original engraving of the garden front (cat. 98). As the accompanying text pointed out to readers:

This North Front is the regular approach from the road leading from Hampstead to Highgate..... In this charming villa, the Earl now enjoys that honourable and happy retirement from public business, which his great age rendered necessary, and to which his splendid talents and many virtues, have so frequently entitled him.

The engraving records the forecourt and entrance gates as seen from Hampstead Lane before the addition of the North Wood by the 2nd Earl of Mansfield from 1793-6.

An earlier impression appeared in *The British Magazine and Review* (volume I, July 1782, facing page 95), a monthly publication to which Metz regularly contributed country house views, including Wricklemarsh (cat. 20) in April 1783. As a book illustrator, Metz's work can be found in historical and theatrical publications, in addition to an illustrated edition of James Thomson's *The Seasons* (1793) which included the celebrated description of the prospect from Richmond Hill. James Heath, Historical Engraver to George III, engraved a variety of book illustrations and was the father of Charles Heath, the prominent publisher with whom J.M.W. Turner produced *Picturesque Views in England and Wales* (1826-37).

The Iveagh Bequest, Kenwood.

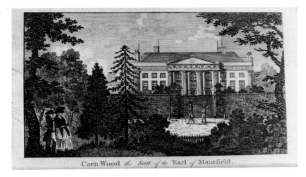

ANON.

92. *Caen-Wood*, c. 1788
Engraving; image size: 3¾×6½ in. (9·5×16·5 cm.)

INSCRIBED: *Caen-Wood the Seat of the Earl of Mansfield*, and indistinctly in ink, *For Dr. Lord (?) James Melvin.*

A view of the North Front from Hampstead Lane, possibly derived from Metz's view in *The British Magazine and Review* of 1782 (cat. 91), this engraving vividly illustrates the imposing impression Adam's portico originally made on passers-by before the North Wood was added to the estate from 1793-96. The original source and accompanying text have yet to be identified.

The Iveagh Bequest, Kenwood.

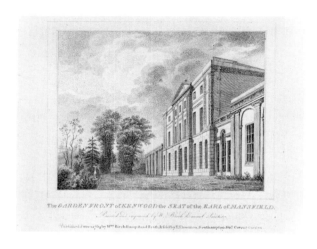

The GARDEN FRONT of KENWOOD the SEAT of the EARL of MANSFIELD.

WILLIAM BIRCH 1755-1834

93. *The Garden Front of Kenwood, the Seat of the Earl of Mansfield*, 1789

INSCRIBED: *The GARDEN FRONT of KENWOOD the SEAT of the EARL of MANSFIELD./Painted and engraved by W. Birch, Enamel Painter./Published June 1, 1789 by W^m. Birch, Hampstead Heath, & sold by T. Thornton, Southampton Str^t. Covent Garden.*

The steep perspective, dramatic sky and deserted terrace contrast with the earlier picturesque views of Kenwood to create an almost Romantic impression, with the Heath visible beyond the lime avenue. Although this engraving combines the two best known images of the house, the close-up viewpoint of Adam's *Works* (cat. 83) with the eastward view by Robertson (cat. 87), the effect is fresh and convincing; for the first time, we actually feel ourselves to be standing on the south terrace. The engraving is also of documentary value, particularly in that it shows Adam's relief decoration to the South Front still intact. The need for repairs to the new material used, Liardet's patent stucco, is documented from 1778. The inclusion of a sundial also seems to be accurate, as it can be seen in an illustration to J.C. Loudon's *Surburban Gardener* of 1838 (cat. 116). The high wall that originally concealed the service wing can be seen beyond the Orangery, where the arbour stands today.

William Birch is best known for his portraits and landscape paintings in enamels, which he exhibited at the Royal Academy from 1781 to 1794. The enamel painter's eye for detail can be seen in this engraving after his own painting (currently unlocated), while the extensive use of stipple in the sky to achieve atmospheric effect suggests an awareness of the rival medium of aquatint, then becoming increasingly popular. Birch lived near Kenwood on the Heath and, so he records in his unpublished autobiography, was a frequent visitor. His enamel copy after Reynolds's portrait of Lord Mansfield is in the Kenwood collection.

This engraving was included in a set of thirty-six published by Birch in 1791 as *Délices de la Grande Brétagne*. Most were executed after works by distinguished living English artists. The subscribers included Reynolds, Adam, Fuseli, Lord Mansfield and the 5th Earl of Chesterfield. Other engravings included the view from Mrs. Cosway's Breakfast

Room in Pall Mall, after William Hodges; the view from Richmond Hill, after Reynolds; Kew Gardens, after Richard Wilson; and Strawberry Hill, after J.C. Barlow. The short text that accompanies this engravings differs from earlier accounts in describing the setting but not the house and its contents. The prospect which the terrace afforded, together with Lord Mansfield himself; are for Birch the most distinguishing qualities of Kenwood:

> The verdant hills about it are broken by the full-grown woods, through which appear various domestic scenes, and, in a rich distance, the Metropolis and River in a most striking point of view.... but still the greatest ornament of the place is the noble possessor, to whom Britain is so much indebted for the protection and improvement of its laws, as well as for his munificent patronage of the arts.[1]

1. William Birch, *Délices de la Grande Brétagne* (London, 1791) facing pl.15.

The Iveagh Bequest, Kenwood.

ROBERT MARRIS 1750-1827 attrib.

94. *Caen Wood, Hampstead,* c.1790
Watercolour; 12¼×17¼ in. (31×43·7 cm.)

INSCRIBED *(verso): Caen Wood the Seat of Ld Mansfield – Hampstead.*
PROVENANCE: Purchased Christie's, 19 July 1983 (38).

Corbould's engraving of 1786 (cat. 98) is probably the basis of this view of the South Front. The line of shrubbery along the south terrace has been enlarged and deer have been added, although Lord Mansfield is not known to have kept them. The North Wood, visible beyond the house, cannot be seen in Corbould's engraving and may be an exaggeration, rather than an accurate record of the trees as later shown in Stockdale's aquatint of 1825 (cat. 114). The labourer carrying hay with a pitchfork also seems out of place, as in Corbould's engraving the south bank is a smooth lawn. The omission of figures from the lawn below the house, and addition of a fir tree (which appears in no comparable view) suggests the limitations of a copyist, as does the simple profile of the sailing boat and of the deer. The labourer, however, is a convincing figure and may have been copied from another engraving or added by another artist. The traditional attribution of this drawing to Marris, a professional landscape painter and son-in-law of Arthur Devis, thus seems unlikely. However, the drawing is of interest as an example of the appeal these engraved views of Kenwood held, in this instance as a subject amateurs and young landscape painters might copy in the course of their training.

The Iveagh Bequest, Kenwood.

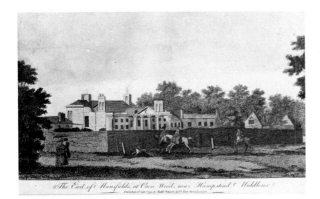

The Earl of Mansfields, at Caen Wood, near Hampstead, Middlesex.

ANON.

95. *The Earl of Mansfield's at Caen Wood*, 1792
Engraving; 6⅝×10⅝ in. (16·9×27 cm.)

INSCRIBED: *The Earl of Mansfields, at Caen Wood, near Hampstead, Middlesex./Published 12th Sept. 1792, by Robt. Sayer, &Co. Fleet Street, London.*

The North Front of Kenwood is here seen from Hampstead Lane in an engraving that probably lost a measure of topographical accuracy in the process of defining a loose sketch. Comparison with the view after Conrad Metz of 1788 (cat. 91) and a map in the British Museum of 1793 (cat. 96) reveals that the original viewpoint was from the north east, outside the wall that marked the original forecourt of the house, before the North Wood was added to the estate between 1793 and 1796. The original service buildings and stables, which stood on the northern side of the Orangery are probably the buildings seen on the right, with the lime avenue beyond. The avenue can be seen more clearly in Birch's engraving of 1789 (cat. 93). The menagerie is on the left. What appears to be a large extension left of the entrance should probably be read as the eastern end of the south range with it separate roof. This is also included in Metz's view and in Ibbetson's print of about 1795 (cat. 100). None of the three entrance gates in the wall bordering Hampstead Lane have been included. The general impression is of a conspicuous yet very private house, Adam's grand portico adding an imposing focus to the group of older buildings set behind a high wall. A later derivative of this engraving is even less accurate (cat. 120).

Greater London Record Office (Maps and Prints)

PRITCHARD

96. *Plan of the Grounds about Kenwood House*, 1793
Pen and ink; 28⅝×50¼ in. (72·6×127 cm.)

INSCRIBED: *Plan of the Grounds about Kenwood house/taken in 1793 – by Pritchard.*
LITERATURE: J.G. Crace, *A Catalogue of Maps...* (London, 1878) p.672; Simon, p.8

In 1793 David Murray, 6th Viscount Stormont, succeeded to the title of 2nd Earl of Mansfield and inherited the

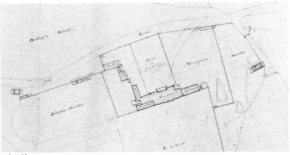

detail

Kenwood estate. This plan was possibly drawn up for the landscape gardener, Humphry Repton, following a commission from the second earl to remodel the Kenwood estate. It clearly shows the most significant change envisaged, the diversion of Hampstead Lane away from the house to its present position beyond 'Bishop's Wood', then part of the estate of the Bishop of London. The plan is of greater significance, however, as a record of the house and its various outbuildings as Adam left it, before major alterations were made. Of further interest are Nightingale Lane and Millfield Lane which, marked as 'Private Road' and 'To London', lead directly into Hampstead Lane, without entering the estate. From 1796 the northern part of this lane was absorbed into the estate as one of the entrance drives.

The Trustees of The British Museum (Crace Collection)

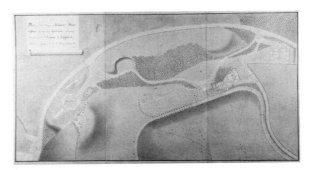

PRITCHARD attrib.

97. *Plan of Kenwood House, Offices & adjoining Grounds*, 1797
Pen and wash; 25×46 in. (63·5×116·8 cm.)

INSCRIBED: *Plan of lower Story of Kenwood House/Offices & adjoining Grounds Showing/the principal Drains & Cisspools/which are represented by the black lines &c./1797*
LITERATURE: See cat. 96

The 3rd Earl of Mansfield inherited the Kenwood estate in 1796 when he was nineteen and commissioned this estate plan shortly afterwards. Besides showing 'the principal Drains & Cisspools' it records the remarkable achievement of the second earl over the previous three years. Architectural changes included the addition of wings on the north front, the demolition of the old service buildings behind the Orangery, the construction of the service wing and

119

stable block to the east, and the building of the dairy cottages and octagonal farm to the west.

The two most obvious differences made to the grounds since the plan of 1793 was drawn up (cat. 96) are the creation of the pleasure grounds on the site of the old kitchen garden to the west of the house and the linking of the south terrace with the North Front via a path around the side of the house. The only significant changes made since 1797 are the demolition of a large part of this octagonal farm, the reduction in the number of crescent-shaped flower beds on the west lawn, and the removal of further beds from the south terrace.

The Trustees of The British Museum (Crace Collection)

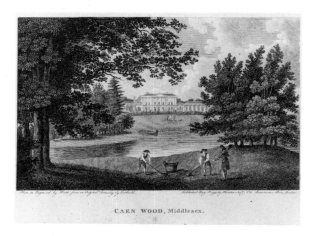

CAEN WOOD, Middlesex.

**JAMES HEATH 1757-1834 attrib.
after RICHARD CORBOULD 1757-1831**

98. *Caen Wood, Middlesex*, 1793
Engraving; 5⅞×7⅝ in. (15×19 cm.)
in: The Copper Plate Magazine (London, 1793)

INSCRIBED: *Plate 32. Engraved by Heath, from an Original Drawing by Corbould/Published May 1ˢᵗ. 1793 by Harrison & Cᵒ. Nᵒ. 18 Paternoster Row, London/CAEN WOOD, Middlesex.*

The text accompanying this view of the South Front, seen from below the present Lily Pond, points out how:

The garden front commands a most delightful prospect over a tract of the richest meadow grounds, which fall in a gentle descent for near two miles from the house, and are refreshed and beautified by many fine pieces of water.

The reader's attention is also drawn to the library added by Adam which, as "The new room.... has been pronounced at least equal, if not superior, to any thing of the kind in England". The Orangery "contains a fine collection of the most curious exoticks". A major feature lost today is "The lodge at the entrance of the pleasure-grounds, near the road leading from Kentish Town to Highgate". This could perhaps be the garden pavilion shown in Adam's engraving of the South Front (cat. 83), as a public road ran along this side of the estate before the 2nd Earl of Mansfield made major improvements from 1793-96. The 'lodge' was

presumably demolished at this time. The description of "The rustick arcade, cloathed with vines" may refer to the ivy arbour beside the Orangery, which is normally associated with Humphry Repton's remodelling of the grounds for the second earl from 1793-96. If so, the arbour could date to even earlier as the text has been plagiarised from *The British Magazine and Review* for July 1782, where it accompanied Metz's view of the North Front (cat. 91).

Harrison first published this engraving in 1786. *The Copper Plate Magazine*, a "Monthly Cabinet of Picturesque Prints, consisting of Sublime and Interesting Views of Great Britain and Ireland" appeared from February 1792, each number consisting of two engravings and two pages of accompanying text. Number sixteen, for example, included a distant prospect of Woolwich after Thomas Girtin, besides this view of Kenwood.

The Iveagh Bequest, Kenwood

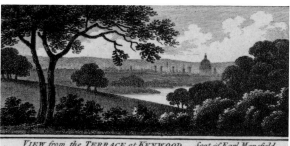

VIEW from the TERRACE at KENWOOD — Seat of Earl Mansfield.

**JAMES PELTRO 1760-1808
after HUMPHRY REPTON 1752-1818**

99. *View from the Terrace, Kenwood*, 1795
Engraving; 1×2½ in. (2·5×6·4 cm.)
in: The Polite Repository (London, 1795)

INSCRIBED: *VIEW from the TERRACE at KENWOOD – Seat of Earl Mansfield.*

In the absence of Humphry Repton's lost 'Red Book' of designs for remodelling the Kenwood estate, this engraving is the only visual evidence from his hand of the landscape gardener's employment by the 2nd Earl of Mansfield from 1793-96.[1] In the 'Address' to this pocket calendar, Repton is credited with having supplied "this work with designs of those places where any alterations are made under his direction – by which The Polite Repository becomes a pleasing record of the most recent ornaments and improvements to the country". The engraving of Kenwood illustrates the page for March 1795. This coincides with Repton's work for Lord Mansfield, which is documented from their correspondence.

Repton also worked for Mansfield's two neighbours, Lord Southampton at Fitzroy Farm in 1790, and from 1792 Thomas Erskine, later Lord Chancellor, who lived at Evergreen Hill beside the Spaniards Inn. The view through the tunnel under Hampstead Lane linking Erskine's house to his garden on the Kenwood side was engraved for *The Polite Repository* in 1808. According to Erskine's son, when his father conducted Edmund Burke through this tunnel:

All the beauty of Ken Wood, Lord Mansfield's, and the distant prospect burst upon him. 'Oh', said Burke, 'this is just the place for a reformer. All the beauties are beyond your reach; you cannot destroy them.[2]

Repton supplied Walter Peacock, publisher of the almanack, with watercolour views from 1790-1809. The volume for 1812 includes an engraving of Kenwood from the south for March, while the page for October carries a view of Marble Hill Cottage (see cat. 55).

1. Simon, pp.4-9
2. Caroline A. White, *Sweet Hampstead and its Associations* (London, 1900) pp. 133-34.

The Bodleian Library, Oxford, (MS Eng. misc. g. 68)

The entrance to LORD CHANCELLOR ERSKINE's Garden at Hampstead.

Fig. 31 J. Peltro after Humphry Repton *The entrance to Lord Chancellor Erskine's Garden at Hampstead* 1808, Victoria and Albert Museum

JAMES SARGEANT STORER 1771-1853
after JULIUS CAESAR IBBETSON 1759-1817

100. *Mastiff & Lion Dog, 1794-96*
Engraving; 12×9½ in. (30·5×24 cm.)
in: John Church, *A Cabinet of Quadrupeds* (London, 1805)

INSCRIBED: *Ibbetson dell J. Storer Sc London. Published by W. Darton. J Harvey & W. Belch, December 1ˢᵗ 1796 MASTIFF & LION-DOG.*

The eighty-four illustrations of animals in this book, all engravings after Ibbetson, are dated from 1793 to 1800, a period which covers his work on the new Music Room at Kenwood (see cat. 101). One of these, *Mastiff & Lion-Dog*, clearly shows the South Front of the house from the southeast, and is of considerable documentary interest as it records the appearance of the east end of the north range of the house, before the addition of the wing containing the Dining Room. The chimney stacks are clearly visible today, behind the stairwell block adjoining the wing and a high screen wall. Although the engraving was published in 1796, Ibbetson's original sketch must have been made some time before, as the wing was built by George Saunders for the 2nd Earl of Mansfield from 1794-96.

Other illustrations for the *Cabinet* appear to have been sketched at Kenwood. In the section devoted to 'The Bull', the author points out:

> The engraving which accompanies this account, is from a portrait of a Bull of the Warwickshire breed, which is now in the possession of the Earl of Mansfield, and is allowed,

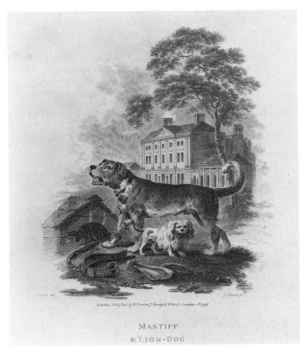

MASTIFF
& LION-DOG.

by the best judges, to be a most complete specimen of that particular variety.[1]

The illustrations for 'The Black Horse' and 'Fox' may include Kenwood's former outbuildings in the background. The book was initially published in fifty numbers. This was followed in 1805 by the complete edition in two volumes, bound in red morocco with gold-leaf tooling, shown here, which Ibbetson himself descibed as a "literary luxury in every respect".[2]

1. Church, *op. cit.* I, unpaginated.
2. Quoted in Rotha Mary Clay, *Julius Caesar Ibbetson* (London, 1948) p.60.

The Iveagh Bequest, Kenwood.

JULIUS CAESAR IBBETSON 1759-1817

101. *Lord Mansfield's Pedigree Cattle, 1797*
Oil on canvas; 10¾×15¼ in. (27·2×38·7 cm.)

SIGNED: *Ibbetson pinx 1797*
PROVENANCE: Bequeathed by J.A.D. Shipley to Shipley Art Gallery, 1909.
EXHIBITED: *Julius Caesar Ibbetson*, Kenwood, 1957 (23); *The true resemblance of Lord Mansfield*, Kenwood, 1971 (80).
LITERATURE: Rotha Mary Clay, *Julius Caesar Ibbetson* (London, 1948) p.58

Cattle from the Warwickshire long-horned herd belonging to David Murray, 2nd Earl of Mansfield, are here seen on the Kenwood estate. The picture may have been commissioned by Louisa, Countess of Mansfield as Joseph Farington noted the previous year that William Birch the enamel painter "has lately had two commissions of 10 guineas each, one for Lady Mansfield, a seal of a favourite

Cow".[1] Ibbetson was probably introduced to the 2nd Earl of Mansfield by Lady Mansfield; her brother, Colonel Charles Cathcart, led the first British Mission to the Imperial Court of Pekin in 1788, on which Ibbetson served as draughtsman. Lady Mansfield also knew the painter through her cousin, Robert Fulke Greville, who had travelled with Ibbetson on his second tour of Wales in 1792. Following the death of Lord Mansfield in September 1796, Greville became her second husband.

Ibbetson executed a set of decorative paintings for the newly built Music Room at Kenwood (1793-96); this opened onto the new flower garden created for the west front, on the site of the former service buildings. His first decorative scheme, it consisted of large painted borders with oval medallions representing, according to a visitor in 1816, "various operations of agriculture, fancifully represented by unattired children. Interspersed are views in North-Wales, delicately executed. Over the organ the artist has introduced cherubs, performing in concert on many instruments".[2] The scheme may have been conceived as a light-hearted 'balance' to Zucchi's decoration of Adam's library. However, the central panels were left blank as patronage ceased, either when Lord Mansfield died in 1796, or when Lady Mansfield remarried and left Kenwood in 1797. In 1799 Farington recorded that "Ibbetson was employed to decorate a room at Caenwood, but gave his employers a great deal of trouble – there was no depending on him".[3]

During this time at Kenwood, Ibbetson made at least one sketch in the grounds, later published in *A Cabinet of Quadrupeds* (cat. 100). A watercolour in the Victoria and Albert Museum showing *Cattle on Rocky Ground* (signed and inscribed *ad. Nat. del.¹ Kenwood 1796*) is closely related to groups published in 1816 by Ibbetson as *Six Etchings of Cattle, from Nature*. The Countess of Mansfield's daughter, Lady Caroline Murray, subscribed to this publication.

1. K. Garlick and A. Macintyre ed., *The Diary of Joseph Farington* (New Haven and London, 1978) II, p. 598.
2. J. Norris Brewer, *The Beauties of England and Wales* (London, 1816) X pt.4 pp.176-7.
3. Farington, *op. cit.*, IV, p.1297

The Shipley Art Gallery, Gateshead
(Tyne and Wear Museums Service)

JULIUS CAESAR IBBETSON 1759-1817

102. *Two cows*, 1797
Oil on canvas; 10½×15 in. (26·7×38·1 cm.)

SIGNED: *J. Ibbetson pinx. 1797*
INSCRIBED (verso): *Julius Ibbetson, Painted for Louisa, Countess of Mansfield at Caen Wood.*
PROVENANCE: Messrs. Bernard.
EXHIBITED: Julius Caesar Ibbetson, Kenwood, 1957 (24); *The true resemblance of Lord Mansfield*, Kenwood, 1971 (79)
LITERATURE: Rotha Mary Clay, *Julius Caesar Ibbetson* (London, 1948) p.58

The only surviving oil painting to show Robert Adam's improvements to Kenwood (with the exception of modern views) is this unusual 'conversation piece' of cattle. Two cows from the Mansfields' Warwickshire herd stand southwest of Kenwood, which can be seen in the background. Ibbetson painted other members of this herd in the same

year, during his time as 'artist in residence' at Kenwood (see cat. 101).

Under the 1st Earl of Mansfield (who died in 1793) the dairy was run as a model farm. It was not an essential source of income, as the maintenance of the estate depended primarily on Mansfield's earnings as Lord Chief Justice. A certain amount of play-acting took place. The first earl's adopted daughter, the black Dido Belle, was described by a visitor as "a sort of Superintendent over the dairy, poultry yard & c".[1] A neighbour in Hampstead wrote of rivalry with the adjacent Fitzroy Farm: "Lady Mansfield and Lady Southampton, I am told, are both admirable dairy-women, and so jealous of each other's fame that they had many heart-burnings, and have once or twice been very near a serious falling out on the dispute which of them could make the greatest quantity of butter from such a number of cows".[2] Marie Antoinette's dairy in the *jardin anglais* of the Château de Rambouillet (built in 1785) is an obvious comparison. Lord Mansfield himself, acting out an ideal of rural retirement made fashionable by the pastoral poetry of Virgil and Horace, did not get his hands quite so dirty. As J.T. Smith recorded:

> Mr. Nollekens was standing with the late Earl Mansfield, in his Lordship's farm-yard at Ken-wood, when a little girl came up to him and presented her mother's compliments to Farmer Mansfield, and she would be obliged to him for a jug of milk. "Who is your mother my little dear?" asked his Lordship. "She's just come to live in that small house close by the road." His Lordship, with his usual smile called to one of the helpers, and desired him to fill the child's mug, and if he found the family deserving, never to refuse them milk.[3]

At this time, the farmyard lay north-west of the house, just south of today's car park by the West Lodge. The second earl built a new farm, west of the car park, on land added with the North Wood when Hampstead Lane was diverted away from the house. The octagonal farmhouse was designed by the agriculturalist William Marshall, and the dairy buildings (appropriately in Swiss chalet style), still stand nearby. As J. Norris Brewer recorded in 1816:

> The Earl of Mansfield retains an adjoining farm of about two hundred acres, which is in a very high state of cultivation. The dairy is situated within the pleasure grounds, and is a tasteful building, paved with marble.[4]

Nine years later, the author of an article on Kenwood in *Ackerman's Repository* (cat. 114) noted that the farm "enables its present noble proprietor to employ many poor labourers who otherwise would become a burthen upon the parish".[5] By the 1880s the farm was managed by the Express Dairy, which subsequently acquired Fitzroy Farm.

1. P.O. Hutchinson, ed., *The Diaries and letters of... Thomas Hutchinson* (London, 1883-6) II, p.276
2. Mrs. Barbauld, quoted in 'Colonel Fitzroy's Rustic Villa', *Camden History Review*, 10 (1982) p.20
3. J.T. Smith, *Nollekens and His Times* (London, 1829) I, p. 384
4. J. Norris Brewer, *The Beauties of England and Wales* (London, 1816) X pt. 4p.179
5. 'Caen Wood', *Ackermann's Repository*, V (1825) p. 312

The Wernher Collection, Luton Hoo, Bedfordshire

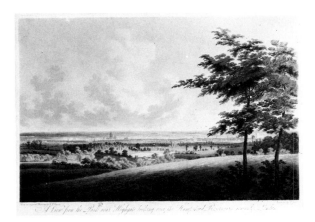

FRANCIS JUKES 1746-1812
after FRANCIS JOHN SARJENT c.1780-1812

103. *A view from the Park near Highgate, looking over the Hampstead Reservoirs towards London,* 1804
Aquatint; 17⁵⁄₁₆×22⁷⁄₈ in. (44×58 cm.)

INSCRIBED: *From an Original Drawing by F.J. Sarjent/ Engraved by F. Jukes/A View from the Park near Highgate looking over the Hampstead Reservoirs towardss London/ F. Jukes, No. 10 Howland Street, Novr 30th 1804.*

'The Park near Highgate' must be the Kenwood estate, to judge from the topography and an earlier engraving taken from an adjacent viewpoint (cat. 89). Fitzroy Farm can be seen on the left; in the centre lie Highgate Ponds, here called 'Hampstead Reservoirs', as they became known at the end of the seventeenth century when they were leased to the Hampstead Water Company. The difference in names persisted in the eighteenth century; they are clearly marked as 'Hampstead Ponds' on Rocque's map (fig. 22). As part of Millfield Farm the ponds were separated from the mediaeval Caenwood estate in 1543, but were reunited with Kenwood by Lord Mansfield in 1789 in order to prevent the development of suburban villas.

Guildhall Library, City of London

FRANCIS JUKES 1746-1812
after FRANCIS JOHN SARJENT c. 1780-1812

104. *A view on Hampstead Heath, looking towards London,* 1804
Aquatint; 16¹⁵⁄₁₆×22⅝ in. (43×57·5 cm.)

INSCRIBED: *From an Original Drawing by F.J. Sarjent/Engraved by F. Jukes/A View on Hampstead Heath, looking towards London/Published Nov'. 30ᵗʰ. 1804 by F. Jukes, No. 10 Howland Street*

The Vale of Health is a former swamp near Hampstead Village, known as 'Hatches Bottom' before it was drained to create a pond in 1777. The essayist Leigh Hunt lived here from 1815-18 and in 1821; his guests included Shelley, Keats, Lamb and Hazlitt. The earliest print to show cottages in the vale, this view records the area's appearance before the construction of a grand hotel from 1863; this provided assembly rooms, tea gardens, grottoes and boating on the lake. By 1890 the hotel was joined by fifty-three houses. The prospect of London is similar to the view enjoyed by the figures in Ramsey's painting of Whitestone Pond (cat. 75).

Guildhall Library, City of London

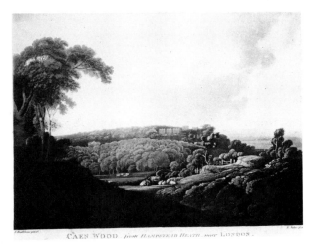

CAEN WOOD *from HAMPSTEAD HEATH near LONDON.*

FRANCIS JUKES 1746-1812
after JOHN RATHBONE 1750-1807

105. *Caen Wood from Hampstead Heath,* c. 1804
Aquatint; 9⅝×11¾ in. (24·6×30 cm.)

INSCRIBED: *J. Rathbone pinxᵗ./F. Jukes fecit/ CAEN WOOD – from HAMPSTEAD HEATH – near LONDON.*

Kenwood can be seen above the crest of trees on the left, in a view which is far more picturesque than topographically correct. The setting suggests that the original sketch was made from the south, near Parliament Hill before the trees grew and obscured this view, but for Highgate to appear beside Kenwood the artist must have sketched the estate from the east, closer to Hampstead. More significant than this preference for effect over topographical accuracy is the

popular interest in Kenwood and Hampstead Heath at this time which justified the publication of this large independent aquatint. This is the only view of the house of its kind, the closest comparison being Greig's engraving of 1805, which also shows the house from afar (cat. 106).

The Iveagh Bequest, Kenwood

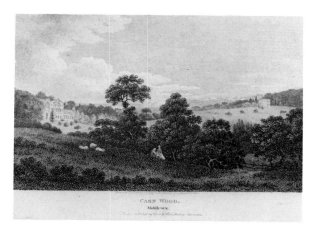

CAEN WOOD.
Middlesex.

JOHN GREIG fl. 1803-24

106. *Caen Wood. Middlesex*, 1805
Engraving; image size: 4×6⅛ in. (10·2×15·5 cm.)

INSCRIBED: *Drawn and Engrav'd by J. Greig for the Beauties of England & Wales/CAEN WOOD./Middlesex./London Published by Vernor & Hood Poultry Dec. 1. 1805.*

This distant view of Kenwood from the west, facing towards Highgate, also includes the neighbouring villa Fitzroy Farm, built for Lord Southampton c.1765 and demolished by 1826. The viewpoint is similar to that in the *European Magazine* engraving of 1786 (cat. 90) only now, in place of fashionable gentlemen admiring the view across a spiked fence, we see a young couple with their dog and grazing sheep, apparently on the edge of open heath. The general effect gives a more relaxed, rural impression, but the distant viewpoint reminds us that Kenwood in the nineteenth century was far less accessible to visitors, as the Earls of Mansfield preferred to live at the family's Scottish seat, Scone Palace. A deliberate contrast may be intended between the rough heath in the foreground, and the park of Fitzroy Farm, landscaped by Capability Brown and later by Humphry Repton, in the distance.

A landscape painter, draughtsman and engraver, Greig contributed to several topographical publications devoted to London and its environs. This engraving after Greig's own drawing is taken from *The Beauties of England and Wales, or, Delineations Topographical Historical and Descriptive of each County* by E.W. Brayley and J. Britton, volume X part IV (1816), facing page 178; the volume also includes J.P. Neale's view of Marble Hill (cat. 52). The lengthy account of the house and grounds by Norris Brewer makes only passing reference to the architecture of Robert Adam, favouring instead the collection of paintings and sculpture and the

rural setting. Indeed, Ibbetson's decoration of the Music Room (see cat. 101) receives as much attention as does Adam's Library, suggesting a decline in interest in the neoclassical style in favour of the picturesque. Norris Brewer's observations are fully in character with Greig's impression:

that deep mass of woodland which imparts a name to the domain, is an adjunct of the picturesque rarely found in the close vicinage of the metropolis ... vistas are contrived which casually reveal lands really unconnected with the estate, except as to the aid they thus impart to picturesque effect. The edges of rich oak woodland are finely broken and unequal ... [giving] numberless pleasing views, varied between a comprehensive prospect of the metropolis and its immediate environs, and the more attractive points of home scenery.

Kenwood may have been secluded at this time owing to Mansfield's absence, but as Norris Brewer observes of Fitzroy Farm: "The Earl of Buckinghamshire is now resident here, and the spot has acquired some fashionable notoriety from the public breakfasts given by his Lordship".

The Iveagh Bequest, Kenwood

JOHN CLAUDE NATTES c. 1765-1822

107. *Kentish Town; Caen Wood, Highgate*, 1810
Pencil; 7×9⅞ in. (17·7×25 cm.)

INSCRIBED: *Kentish Town/Caen Wood Highgate* and dated (*verso*) 1810.
PROVENANCE: Godfrey Groves, Little Park, Enfield
EXHIBITED: *Hampstead Heath 1810-15*, Burgh House, Hampstead, 1981 (20)

These two drawings belong to a large group of London sketches by the same hand, now dispersed, a large number of which are in the Guildhall Library and Burgh House, Hampstead. Kenwood can be seen in the lower drawing among trees, beyond South Meadow. The subject of the upper drawing has not been identified, but as a house with three or four outbuildings bordering on the heath it may be Millfield Farm, which adjoined Parliament Hill by Highgate Ponds.

The artist's control of a panoramic landscape with firm, clear line is typical of a professional topographical draughtsman. Nattes worked as a drawing master and pro-

duced a series of engraved views of Scotland, Ireland, Paris, Bath and Bristol but was expelled from the Old Water-Colour Society in 1807 for exhibiting his pupils' work as his own.

The Iveagh Bequest, Kenwood

108. Lord Mansfield's – Kenwood, c.1812
Pencil; 13×18¾ in. (33×47.6 cm.)

INSCRIBED: *Lord Mansfields's-Kenwood*
PROVENANCE: Godfrey Groves, Little Park, Enfield

Kenwood is seen through foliage on the left beyond a fence that probably marked the division between the park and farm, rather than the perimeter of the Kenwood estate as a whole. The viewpoint is slightly closer to the house than in J.C. Ibbetson's painting of cattle (cat. 102) in which the same tree can be seen before the South Front. The obscuring foliage is unusual in views of Kenwood and presents a more secluded and 'Romantic' image of the house in contrast to the topographical tradition. The more tonal sketching technique is appropriate to this approach and differs from other drawings from this group. Kenwood was little used at this time as the 3rd Earl of Mansfield preferred to reside at his Scottish seat, Scone Palace.

The Iveagh Bequest, Kenwood

109. Caen Wood, 1814
Pencil; 4¾×9⅞ in. (12×25 cm.)

INSCRIBED: *Caen Wood* and verso: *Hampstead Ponds 1814*
PROVENANCE: Godfrey Groves, Little Park, Enfield
EXHIBITED: *Hampstead Heath 1810-1815*, Burgh House, Hampstead, 1981 (21)

The Iveagh Bequest, Kenwood

JOHN CONSTABLE 1776-1837

110. Branch Hill Pond, Hampstead, 1819
Oil on canvas; 10×11⅞ in. (25.4×30 cm.)

INSCRIBED: (along the original stretcher): *End of Octr. 1819*, and in pencil: *Isey*
PROVENANCE: Presented by Isabel Constable, 1888
LITERATURE: Graham Reynolds, *The Later Paintings and Drawings of John Constable* (New Haven and London, 1984) cat. 19.32

This is Constable's earliest dated oil sketch of Hampstead Heath. His choice of viewpoint for this, and many similar sketches of the same area, is not some undiscovered corner of the Heath but a traditional prospect, enjoyed since at least the beginning of the eighteenth century. Looking towards Harrow, Constable's back is turned to Judges' Walk; this avenue of trees on the north edge of Hampstead Village, west of Whitestone Pond (cat. 75), was known in the eighteenth century as Prospect Walk. This former village 'mall' or promenade is visible on Rocque's map of London (fig. 22), as is Branch Hill Pond, which has since dried up. Where Constable's other locations can be iden-

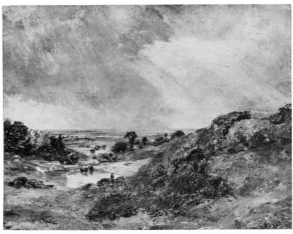
COL. PLATE IX

tified, they rarely reach beyond the village environs and include other traditional prospects. For example, the Vale of Health lies directly east on the opposite side of Whitestone Pond, and the prospect of London could be seen from Constable's house in Well Walk. As he wrote in 1827, "our little drawing room commands a view unsurpassed in Europe, from Westminster Abbey to Gravesend".[1]

Constable probably first visited Hampstead Heath in 1812. At the end of August 1819 he rented Albion Cottage, Upper Heath Street, with his wife and two children for the summer months. In the same year he exhibited the first of his ambitious series of six foot wide paintings representing scenes on the River Stour, which he executed in his central London studio in the winter months. Besides the traditionally popular prospect over the Heath, Branch Hill Pond doubtless held the artist's interest because of its similarities to 'Constable Country'. There is a similar expanse of open sky, grass and soil, such as Dedham Vale presented. In the absence of the Stour, the pond, like the one in the Vale of Health, provided a focus for reflected light, while the horses and carts used to excavate gravel from the area offered a counterpart to the Suffolk figures. There were, however, significant differences between Hampstead Heath and Dedham Vale which ensured that Constable's Heath sketches had a formative influence on his major works. These included the lack of obvious topographical features such as farmhouses, windmills, fences and fields of corn, and the presence of a more rugged terrain which combined clay, gravel and sand, as in this sketch. Furthermore, the height of this ridge along the Thames Valley provided a natural platform from which to study the changing sky.

This little oil sketch was never intended for exhibition, but Constable was encouraged to show his finished Heath paintings at the Royal Academy from 1821 until the year before his death; a view of the Heath accompanied *The Hay-Wain* to the Paris Salon in 1824. In painting such works, including at least five finished versions of *Branch Hill Pond*, Constable did more than any other artist to establish the popular idea of Hampstead Heath.

1. R.B. Beckett, ed., *John Constable's Correspondence* (London, 1968) VI, p.228

The Trustees of the Victoria and Albert Museum

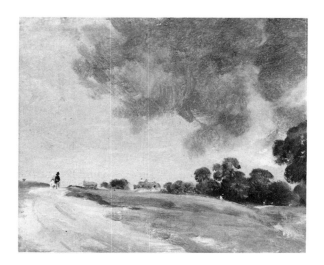

JOHN CONSTABLE 1776-1837

111. *A View at Hampstead, looking due east*, 1823
Oil on paper; 9¾×12 in. (24·8×30.5 cm.)

INSCRIBED (*verso*): *Hampstead. August 6th 1823 Eveng. looking due East* (? *ward* or *wind* deleted) *Eveg – 6th Augt 1823*, various scribbles, *JC*
PROVENANCE: Presented by Isabel Constable, 1888
LITERATURE: Graham Reynolds, *The Later Paintings and Drawings of John Constable* (New Haven and London, 1984) cat. 23.14

With the help of Constable's inscription, this oil sketch can be identified as showing Hampstead Lane facing towards the Spaniards Inn, the artist having walked nearly half a mile east towards Highgate from Whitestone Pond. This view is in striking contrast to Constable's first oil sketch of Hampstead Heath (cat. 110) and reveals his development over four years. The composition is so simple that it makes the choice of viewpoint in the earlier work, *Branch Hill Pond*, appear deliberately contrived in its presentation of foreground, middle distance and background. In this sketch the artist devotes over half his picture to the sky, the only concession to conventional composition lying in the curving path and the inclusion of two figures to define scale. In the years that separate the two sketches, Constable made innumerable cloud studies on the Heath and, around 1823, he copied engravings of clouds by Alexander Cozens, who himself had sketched on the Heath over fifty years before. Such aerial topography sprang both from the artist's response to the developing science of meteorology and from an attempt to analyse the source of transient effects of light in landscape, interests essential to the pursuit of naturalism.

The Trustees of the Victoria and Albert Museum

JOHN LINNELL 1792-1882

112. *Pathway on Hampstead Heath*, 1826
Pencil; 4¼×12½ in. (10·8×31.7 cm.)

INSCRIBED: *Hampstead /26 J. Linnell*
PROVENANCE: Mrs J.P. Linnell
EXHIBITED: *The Camden Scene*, Camden Arts Centre, 1979 (172)

After Constable, who first stayed at Hampstead in 1819, Linnell is the greatest painter associated with Hampstead Heath. Like Constable, he was an early exponent of oil sketching out of doors in this country, producing several views around Twickenham from 1805 which invite comparison with Constable's own studies of the effects of natural light (cat. 50). In 1822 Linnell stayed at North End, a group of houses north-west of Hampstead Village on the road from Heath House to Golders Green. He returned the following year to stay at Wyldes Farm (then known as Collins Farm), and from 1824 he remained there for about five years. During this time his visitors included John Varley, George Richmond, William Collins, William Mulready and William Blake. Constable and Linnell knew one another, but they kept apart, as from 1821 Linnell believed that Constable was thwarting his attempts to be elected a member of the Royal Academy.

This pencil sketch is closely related to Linnell's oil painting of a similar corner of Hampstead Heath, dated 1838[1], a version of which is in Manchester City Art Gallery (fig. 33). The drawing is similar to Constable's contemporary sketchbook studies of the Heath[2], but for the crisper use of line, and extended width, which sets Linnell's work more in the topographical tradition. Such fine draughtsmanship can also be found in Linnell's well known drawing of William Blake on Hampstead Heath (Fitzwilliam Museum) and reminds us of the artist's work as a miniaturist. According to Linnell's journal, he visited Kenwood; his account books confirm that in 1820 he copied a miniature of Lady Frederica Stanhope and in 1823 a similar portrait of Lady Elizabeth Stanhope, both daughters of the 3rd Earl of Mansfield[3].

1. Sold Christie's, 25 July 1986 (206)
2. See Leslie Parris, *et al*, *Constable*, exhibition catalogue, Tate Gallery, 1976 (199)
3. Alfred T. Story., *The Life of John Linnell* (London, 1892) pp.254-5

London Borough of Camden, Local History Library

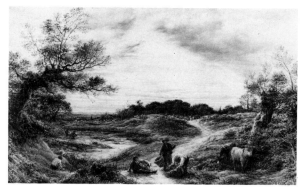

Fig. 33 John Linnell *Hampstead Heath*, 1855, Manchester City Art Gallery

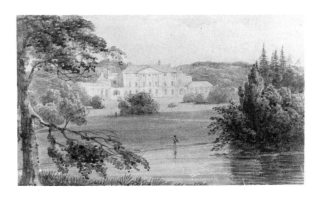

FREDERICK WILTON LITCHFIELD STOCKDALE
fl. 1803-48 attrib.

113. *Caen Wood*, 1825
Watercolour; 4½×7⅜ in. (11·5×18.8 cm.)

PROVENANCE: Sir Edmund Coates, Bt; John Edmund Gardner; Sotheby's, 26 February-2 March 1923, *The Gardner Collection of London Topography* (57)
LITERATURE: Farmer, p.91

Previously attributed to George Shepherd, this watercolour is probably the study for the aquatint published in *Ackermann's Repository*, 1 June 1825 (cat. 114), where Stockdale is credited with both the plate and details included in the accompanying text.

London Borough of Camden, Local History Library

after FREDERICK WILTON LITCHFIELD
STOCKDALE fl. 1803-48

114. *Caen Wood, The Seat of Earl Mansfield*, 1825
Aquatint; 4¾×8 in. (12×20.2 cm.)

INSCRIBED: *Pl. 30. vol.V./F.W. Stockdale del.l/CAEN WOOD./THE SEAT OF EARL MANSFIELD/Nº. 30. of R. ACKERMANN's REPOSITORY of ARTS & c. Pub. June 1. 1825.*

The South Front, seen from beyond the pond, is the classic view of Kenwood. It is also the oldest, dating back to Mrs Delany's sketch of the pre-Adam house of 1756 (cat. 77), and to Heath's engraving after Corbould, originally published in 1786 (cat. 98). In the forty years that separate Stockdale's view from the latter the grounds had been landscaped by the 2nd Earl of Mansfield and his heirs, following the advice of Humphry Repton. The effect is evident in the lack of shrubs along the outer edge of the terrace; in the planting of trees which breaks up the open expanse of lawn leading down to the water's edge; and in the North Wood (visible beyond the house) which the second earl added from 1793-6 in order to divert Hampstead Lane northwards.

Two of these changes would have met with the approval of J.C. Loudon, who illustrated a similar view in his discussion of Kenwood in *The Suburban Gardener and Villa Companion* (1838) (cat. 117). The terrace shrubs can be seen close to in the engravings by Birch (cat. 93) and Roberts (cat. 88).

They were probably removed because, according to Loudon: "wherever the view from the lawn front has a decidedly marked expression that is agreeable, whether by its grandeur, its picturesque beauty, or its peaceful rusticity, flowers in the foreground ought to be avoided".[1] Trees were probably planted on this lawn to overcome a "want of harmony between the foreground and the distant scenery ... we sometimes find an extensive lawn in front of the house, which is continued in the same style of smoothness and high keeping till it terminates abruptly on ... an extensive wood, or some other uniform surface".[2] At Kenwood, this uniform surface was provided by the 'Lily Pond', which Stockdale treats rather more as a fast flowing river. Together with the omission of gardeners and the three figures strolling past the South Front seen in Corbould's engraving, these changes give the impression of a more rural setting.

This illustration first appeared as the frontispiece to *The Repository of Arts, Literature, Commerce, Manufactures, Fashions and Politics*, Third Series, vol.V no. XXX, published by Rudolph Ackermann on June 1, 1825. *Ackermann's Repository* was a monthly periodical launched in 1809 and intended for a wider and more fashion seeking audience than the *Gentleman's Magazine* and *European Magazine* had catered for since the eighteenth century. Each issue contained two colour prints of houses in the series 'Views of Country Seats', together with two colour fashion plates, a colour plate showing 'Fashionable Furniture' and a muslin pattern. Clearly this impression of Kenwood was not intended for the antiquarian traveller or fine print collector that its predecessors appealed to, but reflects a wider interest in house-viewing. The accompanying description of Kenwood echoes its traditional appeal as: "a very elegant Structure ... erected by the late Earl of Mansfield ... the Southern Front, which is exhibited in the annexed Engraving, commands a fine prospect of the metropolis and surrounding country".[3]

1. Loudon, *op. cit.* p.669
2. *ibid.*, p.735
3. *The Repository of Arts, op. cit.* p.312

The Iveagh Bequest, Kenwood

EDWARD BUCKTON LAMB 1806-69

115. *View from The Terrace, Lord Mansfield's*, 1837
Pencil; 4¼×7 in. (10·9×17·9 cm.)

INSCRIBED: *View from The Terrace. Lord Mansfields, Oct 19. 1837* and annotated with instructions to the engraver.
PROVENANCE: See cat. 113.

This study of the grounds at Kenwood, seen from the terrace on the South Front, is the original sketch for plate 286 in J.C. Loudon's *The Suburban Gardener* (London 1838), engraved as *View at Kenwood, from the Terrace Walk near the House*. The only significant difference between the sketch and the published engraving is the substitution of a young lady and child for the strolling couple; this, combined with the effect of wind in the trees, contributes a greater sense of movement to the engraving. The inscriptions distinguishing between *grass* and *gravel* are instructions to the engraver. In the accompanying text Loudon discusses the grounds at Kenwood as they appeared after the remodelling of the

estate by the 2nd Earl of Mansfield, who consulted Humphry Repton (see cat. 99). The terrace is identified as part of a continuous circuit, whereas at the time of the 1st Earl of Mansfield it was blocked at the east end by a wall, and possibly by a pavilion built by Robert Adam (cat. 83). As Loudon wrote:

> This terrace walk is one of the finest artificial features of Kenwood. It is 20ft. wide in front of the house; and this width is continued both to the right and left, as far as the walk remains in a straight line; it then becomes imperceptibly narrower, till, in the lowest parts of the grounds, where it passes the ponds of water, it is no more than 8ft. wide; and it is continued at this breadth through the wood …. If it were desired completely to spoil the characteristic beauty of Kenwood, as far as could be done without removing any of the trees, the way would be to place beds of flowers along the terrace walk…. wherever the view from the lawn front has a decidedly marked expression … flowers in the foreground ought to be avoided.[1]

Comparison with earlier engravings of the South Front reveals that such flower beds had been removed by 1837, trees had been planted to break up the lawn and others had grown to obscure the prospect of London. The sundial also appears in Birch's engraving of 1789 (cat. 93).

1. Loudon, *op. cit.* pp. 667-9

London Borough of Camden, Local History Library

EDWARD BUCKTON LAMB 1805-69

116. *Lord Mansfield's looking west,* 1837
Pencil; 4¼×7 in. (10·9×17·9 cm.)

INSCRIBED: *Lord Mansfields looking west. Oct 19.–1837/To be done a Vignette the whole size of Page;* annotated with further instructions to the engraver.
PROVENANCE: See cat 113

From the inscription and general composition this drawing can be identified as the original sketch for the engraving entitled *View at Kenwood, from the Terrace Walk near the House,* published as plate 287 in J.C. Loudon's *The Suburban Gardener* (cat. 117). No other early record of the view to the south-west is known, as artists and writers preferred to look

south-east, across the ponds towards London and Greenwich. By the time this sketch was drawn, however, the estate was enclosed by trees, as Loudon described it: "The park may be said to consist of an amphitheatre of hills; the house being situated on one side, backed by natural oak woods rising behind it, and looking across a valley, in which there is a piece of water, to other natural woods, also chiefly of oak, which clothe the opposite hills".[1] The overall effect was a "powerful impression made by scenery so decidedly simple, rural, and sylvan, in the immediate neighbourhood of London. The contrast is powerfully felt, not only between this place and a crowded city, but between it and the extreme artificialness of most other suburban residences".[2]

Loudon reassured his readers that his illustrations "are faithful copies from nature" and his devotion of two full pages to the terrace prospect reflects his opinion that "the simple and sylvan grandeur of the scene, can only be represented by landscapes on a tolerably large scale; or best of all by a panoramic view".[3] Loudon was an accomplished draughtsman who illustrated his early books himself; the views he exhibited at the Royal Academy from 1804 to 1817 included *A scene on Lord Mansfield's estate, Perthshire* (1804). However, in 1825 his right arm was amputated following an accident and thereafter he dictated his books and supervised their illustration. Nevertheless, as his widow recorded: "though he had only the use of the third and little finger of his left hand, he would frequently take a pen or a pencil and make sketches with astonishing vigour, so as fully to explain to his draughtsman what he wished to be done".[4] The attribution of this drawing to E.B. Lamb is confirmed by a passing reference elsewhere in *The Suburban Gardener*.[5] Lamb is best known as a Gothic Revival architect and designer, but he also worked as principal illustrator for several of Loudon's publications.

1. Loudon, *op. cit.*, p.661
2. *ibid.*, pp.673-4
3. *ibid.*, p.663
4. Jane Loudon, "An account of the Life and Writings of John Claudius Loudon", reprinted in *John Claudius Loudon and the Early Nineteenth Century in Great Britain* (Dumbarton Oaks, 1980) p.26.
5. Loudon, 1838, *op. cit.*, p.735

London Borough of Camden, Local History Library

JOHN CLAUDIUS LOUDON 1783-1843

117. *The Suburban Gardener, and Villa Companion* (London, 1838)

The Suburban Gardener, "intended for the instruction of those who know little of gardening and rural affairs, and more particularly for the use of ladies",[1] contains the longest account of the Kenwood grounds published in the nineteenth century, and is illustrated with twelve original views. Kenwood is presented as "beyond all question the finest country residence in the suburbs of London".[2] By 1838 the growth of trees had obscured the prospect of the City from the terrace, but Loudon considered this to be a virtue for "a stranger walking round the park would never discover that he was between Hampstead and Highgate, or even suppose that he was so near London. It is, indeed, difficult to imagine a more retired or more romantic spot, and yet of such extent, so near a great metropolis".[3] The prospect could now be enjoyed only by taking "A broad terrace walk of turf, or rather moss, overhung by immense trees, on the outskirts of the park", south of the ponds, "from some points in which magnificent views of London are obtained".[4] Although the panoramic view from the terrace that Loudon illustrates in two engravings (cat. 115, 116) now embraced the estate alone, it was sufficiently open to prompt the author to remark: "we scarcely ever knew a place where, from the existence of so high a terrace, there was so slight an appearance of fencing or confinement".[5]

As a landscape gardener, Loudon is distinguished from his predecessors, 'Capability' Brown and Humphry Repton, by being more of a popularizer than an original theorist. As a designer, who had grown up in Edinburgh, his patrons included the 3rd Earl of Mansfield, for whom he provided plans for improving the gardens of the family's Scottish seat, Scone Palace. However, his greatest energies were devoted to writing thirty-four books; launching and editing four monthly periodicals; and revising his *Encyclopaedia of Gardening* (1822), which went through nine editions in his own lifetime. *The Suburban Gardener* appeared in monthly numbers from 1836. Loudon was an admirer of Repton (who had provided a 'Red Book' of designs for the Kenwood grounds in 1794, now unlocated),[6] and produced a new edition of Repton's *Landscape Gardening* (1840). His admiration for Repton's contribution to the Kenwood estate is evident from reading *The Suburban Gardener*. Like eighteenth century authors of texts that accompanied engravings of Kenwood, Loudon filled his readers with hopes of seeing the house and estate. However, these were false, as he concluded "Kenwood, being at no season of the year shown to strangers, we regret to think that so few of our readers will have an opportunity of studying there ... Gardeners, however, can always visit gardeners, and they may profit from perusing these remarks".[7]

1. Loudon, *op. cit.*, title page
2. *ibid.*, p.660
3. *ibid.*, pp. 661-2
4. *ibid.*, p. 665
6. Simon, pp.4-9
7. Loudon, *op. cit.*, pp. 673-4

The Worshipful Company of Gardeners

DAVID COX 1783-1859

118. *Landscape with a view of Kenwood House, c. 1840*
Pencil; 7½×10¾ in. (19×27·5 cm.)

PROVENANCE: Harriet Cox; Walker Galleries, 1904; Sir Rober Witt; Witt Bequest, 1952
EXHIBITED: *The Camden Scene*, Camden Arts Centre, 1979 (178)

The topographical differences between this drawing and the actual view of Kenwood from the south-west, particularly in the architecture, make the accepted identification of this view unlikely. Cox came to London in 1804 and, like John Linnell (cat. 50, 112), studied under John Varley. After living in Hereford from 1815-27 he settled in London again until 1841; this sketch might have been drawn during this period. However, at this time Kenwood was little used, the crowds in this picture being more reminiscent of a Sunday afternoon after 1928, when the house and grounds opened to the public, than the first half of the nineteenth century. The only exceptions were the royal visits by William IV in 1835 and by Prince Albert in 1843, of which no visual record has yet been located.

Courtauld Institute Galleries (Witt Collection no. 1433)

FORD MADOX BROWN 1821-93

119. *English Autumn Afternoon, Hampstead – scenery in 1853.*
Oil on canvas, oval: 28¼×53 in. (71·7×134·6 cm.)

SIGNED (bottom left) *F. Madox Brown*
PROVENANCE: Sold at auction 1854, bt. R. Dickinson, who sold it to Charles Seddon; bt. back by the artist and sold to George Rae, 1861; acquired from his estate by Birmingham, 1916.
EXHIBITED: British Institution 1855 (79) and, most recently, *The Pre-Raphaelites*, Tate Gallery, 1984 (51)
LITERATURE: Allen Staley, *The Pre-Raphaelite Landscape* (Oxford, 1973) pp. 35-8; Mary Bennett in *The Pre-Raphaelites*, exhibition catalogue, Tate Gallery, 1984 (51)

One of the masterpieces of the Pre-Raphaelite movement, this panoramic view eastward from Hampstead is perhaps the finest and most important British landscape painting of

detail

COL. PLATE X

the second half of the nineteenth century. It is also a vivid example of the continuing appeal of viewing and painting prospects. The artist's viewpoint corresponds with the back bedroom window of the present No. 17 or 18 High Street, Hampstead. Madox Brown had lodgings here at this time, directly across the street from a mount crowned by a fine Georgian house, then occupied by the artist Clarkson Stanfield. Before High Street was developed in the nineteenth century, this same prospect would have been enjoyed from the opposite side of the road.

The outbuildings in the centre of the picture still stand, although much altered, but much of the view has been built over. The distant horizon is pierced by the spire of St. Anne's in Highgate West Hill, with East Heath to the left, and Parliament Hill Fields, Gospel Oak and London to the right; Parliament Hill itself is obscured by tall trees. The white building to the left is thought to represent Kenwood, but if this is, as Brown claimed, "a literal transcript"[1] of "the view from the back window",[2] then the distance from St. Anne's has been compressed, Highgate has been omitted and tall chimneys have been added to the house. Brown did, however, employ artistic licence, for the foreground is not a view from an upstairs window, but clearly a viewing point transposed from the Heath, complete with steps and handrail, painted white bench and a picturesque young couple resting with their dog. The gentleman gestures towards London with his cane in the time-honoured convention of foreground figures in such paintings.

Brown's own account of this painting is not concerned with local topography, but reveals him to be closer to Constable in his determination to capture the most transient effects of natural light:

> The time is 3PM, when late in October the shadows already lie long, and the sun's rays (coming from behind us in this work) are preternaturally glowing, as in rivalry of the foliage.[3]

Like Constable, who worked on the Heath a generation

before, Brown sees in full colour. The strength of green and gold is not softened by tonal contrasts, only relieved by specific observed highlights, such as the blue sky reflected in the man's hat, and the radiance of a white wall hit by sunlight. Closer to Pre-Raphaelitism, however, is Brown's attention to more than light, to the known physical world, captured with laborious detail on a single canvas painted entirely from nature over two successive autumns, taking a total of six months. The high horizon and high viewpoint concentrate our attention on the ground rather than the sky, giving an effect that recalls the Netherlandish topographical prospect tradition of Siberechts (fig. 4) and Danckerts (cat. 3). However, the bizarre perspective which suddenly drops from the foreground as if over a ridge, then leads into an unclear and crowded sea of autumnal foliage, seems deliberately naive. In this Brown follows the Pre-Raphaelite principle of resisting artistic convention, such as single vanishing point perspective, in favour of the 'primitive' effects of mediaeval painting. Nothing directs our gaze through the scene as in more conventional landscape compositions, such as Wootton's prospect from Kenwood (cat. 76). Bold diagonals lead the eye from right to left but only into a barrier of trees, just as the young man's cane takes us into the thicket, while his own glance is sideways away from the prospect. The oval format may be intended to compensate for this lack of directives as it serves to focus attention on the distant horizon by trimming the foreground and sky, a device probably inherited from eighteenth century prospect engravings (cat. 85). Seen in this way, it becomes obvious that Brown needed the white highlight, previously identified as Kenwood, at this particular point on the horizon to draw the eye and to give a sense of scale, and hence recession, to an otherwise claustrophobic scene, lacking both mathematical and aerial perspective.

Brown has brought the seventeenth and eighteenth century traditions of prospect painting to a scene apparently without subject and focus, combining it with the closer scrutiny of light associated with nineteenth century naturalism. But, painting from 1852-4, he cannot have been unaware that the landscape he recorded in such detail was an endangered prospect. The Copyhold Enfranchisement Act of 1852 enabled copyhold tenants of the Lord of the Manor of Hampstead to purchase the freehold of their homes, which brought developers onto the Heath. In 1853, the year included in the painting's full title, an estate bill seeking the right to build 'East Park' (to the left in this picture), consisting of twenty-eight villas, entered Parliament. Contemporary plans reveal that the sand track cut across the Heath in Brown's painting was to be the central avenue of the new estate. Opposition from local residents backed an alternative scheme by C.R. Cockerell for creating 'Hampstead New Park' for the public on the same land. In 1853, according to evidence later presented to a Select Committee, this was proposed to the Prime Minister:

> A deputation of the inhabitants of Hampstead, accompanied by ... some of the artists of London, who took a great interest in the preservation of the Heath, went to Lord Aberdeen.[4]

Even the church spire was a new addition to the landscape, as St. Anne's was consecrated in this same year, 1853. Brown was no 'ivory tower' artist. His best known picture, *Work*, painted in Hampstead from 1852, became a visual

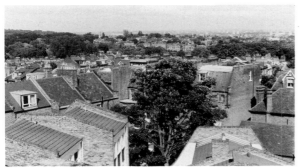

Fig. 33 The same view towards St. Anne's, Highgate, today

essay on the relationship between the variety of human labours. The scene is set in full summer sunlight which Brown considered "peculiarly fitted to display *work* in all its severity".[5] The fading glories of autumn in 1853 seem equally appropriate to this endangered prospect. As Brown later observed of another north London landscape, the River Brent at Hendon, painted in 1854:

> Views near London so often become 'dissolving views' now-a-days, that I can hardly affirm that this romantic little river is not now neatly arched over for 'sanitary purposes', but ten years ago, it presented this appearance, and once embowered in the wooded hollows of its banks the visitor might imagine himself a hundred miles away.[6]

But for the creation of the Metropolitan Board of Works in 1855, which later purchased most of the Heath for public use, Brown's 'literal transcript of nature' would have become another dissolved view. Only his foreground fell to the march of bricks, mortar, and tarmac; it is now a private car park.

1. *The Exhibition of Work, and other Paintings, by Ford Madox Brown* (London, 1865) pp. 7-8
2. Virginia Surtees, ed., *The Diary of Ford Madox Brown* (New Haven and London, 1981) p.80
3. *ibid.*
4. Quoted in Farmer, p.75
5. Quoted in Bennett, *op. cit.*, (88)
6. *op. cit.* in note 1, p.10

Birmingham Museum & Art Gallery

J.G.

120. Caen Wood, Lord Mansfield's House, in 1785 1878.
Engraving; image size: 5¾×8¼ in. (14·5×21 cm.)
in: Edward Walford, *Old and New London*, V (London, 1878)

This illustration is clearly derived from the same source as the similar view published by Robert Sayer in 1792 (cat. 95). The innumerable topographical inaccuracies are inherited from the earlier engraving, and remind us that this view of the North Front was in fact unknown to passers-by from around 1794, when the North Wood was added to the Kenwood estate and Hampstead Lane was diverted to its present course. The only real difference between the two engravings is the replacement of the figures in eighteenth century dress by donkeys; these recur in nineteenth century

sketches of the area (cat. 112) and were a common feature at this time owing to the popularity of rides around the Heath.

The Iveagh Bequest, Kenwood

'POY' (PERCY FEARON)

121. Save Kenwood, 1921
Poster; 40×25 in. (101·6×63·5 cm.)

The 6th Earl of Mansfield first negotiated the sale of Kenwood and its immediate grounds with a syndicate of developers in 1914, but was delayed by a committee of local residents and the outbreak of war. In the year this poster appeared, the Kenwood Preservation Council launched an appeal to raise £340,000 to purchase the estate of 220 acres from Lord Mansfield. In the event, contributions amounted to only £85,000 but, thanks to several private donations, 100 acres were acquired in December 1922, and 32 acres were added later. A fountain near the concert pond commemorates Henry E. Goodison, Treasurer of the Council.

London Transport Museum

C.B. KING & W.J. KING

122. Kenwood Estate, c.1923
Pen, ink and wash; 22¼×18½ in. (56·5×47 cm.)

INSCRIBED: *KENWOOD ESTATE/MR. C.B. KING. HAMPSTEAD/AGENT TO:-/THE RT. HON. THE EARL OF MANSFIELD/W.J. KING. SURVEYOR/40, GREAT JAMES ST./BEDFORD ROW, W.C.*
LITERATURE: Farmer, p.141

Following the failure of the Kenwood Preservation Council to purchase the entire estate in 1922, Lord Mansfield had this plan drawn up to develop Kenwood as an exclusive estate of 33 villas, set with the house in a total area estimated at 101 acres. Land recently acquired for public use, popularly known as 'Kenwood' (cat. 124) is clearly marked, as is the proposed 'Kenwood Drive'. Messrs. King of Hampstead held the auction of the contents of Kenwood from 6-9

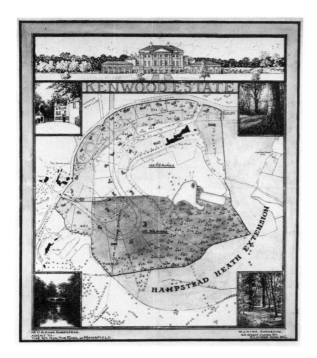

November 1922, when Robert Adam's original furniture for the house, and the rest of the contents, were dispersed.

The Iveagh Bequest, Kenwood

WALTER ERNEST SPRADBERY 1889-1970

123. *Kenwood, London's New Park,* 1925
Poster; 40×25 in. (101·6×63·5 cm.)

On 18 July 1925, King George V opened 132 acres of the Kenwood estate to the public; the area stretched from the north end of the boating pond in Parliament Hill Fields to the south ponds below Kenwood House, and north-east to Hampstead Lane. Parliament Hill itself and the three Highgate Ponds had already been acquired from Lord Mansfield and opened to the public in 1889. The so-called Lily Pond, at the foot of the lawns below Kenwood, is the subject of this underground poster. The underground railway line from Charing Cross to Golders Green opened in 1907. But for opposition from a committee headed by Lord Mansfield, an intermediary station between Hampstead and Golders Green would have been built at Jack Straw's Castle.

London Transport Museum

GEORGE SHERINGHAM 1884-1937

124. *Kenwood, The Crest of London,* 1926
Poster; 40×25 in. (101·6×63·5 cm.)

At the time this poster appeared, Kenwood House and 74 acres of surrounding land were the property of Edward Cecil

Guinness, 1st Earl of Iveagh. Having purchased the estate the previous year from Lord Mansfield, Iveagh was now installing his collection of paintings and furnishing the house with the intention of leaving it to trustees after ten years. In the event, he only survived another two, and the house and immediate estate opened to the public in 1928. The 'Kenwood' advertised by this poster in 1926 thus refers to land which would now generally be regarded as part of Hampstead Heath.

London Transport Museum

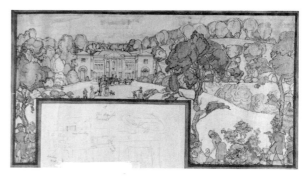

ROGER R. BLAND b.1904

125. *Mural Design for Kenwood Tea Room,* 1928
Watercolour; 15⅞×29½ in. (40·4×75 cm.)

SIGNED with initials; various inscriptions
LITERATURE: G.C. Rothery, 'Mural Painting. Decoration of the Kenwood Tea Room', *The Decorator*, 22 June, 1929, pp.17-20

Bland's imaginary view of the North Front is a design for the decoration of the fireplace wall in the tea room at Kenwood, unveiled in June 1929, the year after The Iveagh Bequest first opened to the public. Owing to the deterioration in their condition, the murals were painted out prior to Kenwood's reopening in 1950, but originally they extended around three of the four walls of the Old Laundry, a room thirty foot square which adjoins the Brew House. Together they form the present cafeteria. The murals represented the local panorama, extending from Hampstead to Highgate, with Kenwood in the middle on the chimneybreast with the arms of the Mansfield family above. Bland's annotations indicate that this design was originally intended for the wall dividing the Old Laundry from the Brew House, but early photographs reveal its final destination.

The final medium was line and wash applied direct onto the plaster, cobalt blue being used over a cream ground to give a monochrome effect similar to willow pattern. Although the scheme complemented the blue and cream crockery, table linen and waitresses' uniforms of the day, it was not the artist's original intention, as he noted in one of the inscriptions to this design: "This coloured idea was never used – would have taken too long & cost too much". The obvious comparison with Rex Whistler's decoration of the Tate Gallery restaurant showing 'The Hunt after Rare Foods' was made at the time. The decoration of the Kenwood Tea Room was the first independent commission

undertaken by Roger Bland, then aged twenty-five. He was the son of Christopher Bland, one of the trustees of Lord Iveagh's estate named in the Kenwood Act of May 1929. Bland had formerly worked as an assistant to Frank Brangwyn and with George Sheringham (cat. 124). Ibbetson's painted decoration of the Music Room (cat. 101) may have influenced his scheme, as Lord Iveagh gave the twenty-seven oils by Ibbetson to Roger Bland after their removal in the 1920s; they remained in Bland's possession until 1952 when they were purchased by The Iveagh Bequest.

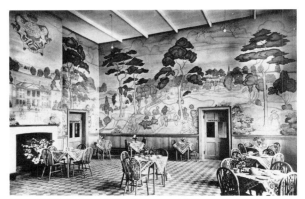

Fig. 34 *The Kenwood Tea Room*, c. 1930.

In addition to sketching a plan of the room to indicate the design's destination, the artist noted on the same sheet: "done at Sherborne in Dorset while working with George Sheringham on Leweston Manor. When I did this I had no drawings of Kenwood nor had I seen it much. Had to use imagination & one bad photo". The boy climbing a tree on the right suggests that Bland also had the engraving of the North Front after Metz (cat. 91) to hand, to which he has added the distant prospect of London. Bland's statement is counter-signed with the initials of George Sheringham and dated 1928.

The Iveagh Bequest, Kenwood

R. & B. STUDIOS

126. *Ken Wood and Highgate Ponds*, c. 1928
Poster; 27⅜×14¼ in. (69·5×32·2 cm.)

In this tramway poster the gentlemen's bathing pond in Parliament Hill Fields is shown as if in a Swiss alpine resort; the distant hills of Kenwood and Highgate have been considerably exaggerated to convey the appeal of this healthy 'beauty spot', and attract customers into trams to escape the London smog. In fact, the shallow waters would have made such high dives dangerous, and there is only one fixed board, and not three, today.

Greater London Record Office (Maps and Prints)

R. & B. STUDIOS

127. *Ken Wood and Hampstead Heath*, 1928
Poster; 27⅜×14¼ in. (69·5×32·2 cm.)

Greater London Record Office (Maps and Prints)

J. LYON

128. *Ken Wood House*, c. 1930
Lino cut; 6⅜×7⅞ in. (16·3×20 cm.)

SIGNED with monogram and inscribed *KEN WOOD HOUSE*; signed in pencil on plate mark.

The Iveagh Bequest, Kenwood

129. *Ken Wood*, c. 1930
Lino cut; 7⅞×8½ in. (20×21·6 cm.)

SIGNED and inscribed in pencil *KEN WOOD*

The Iveagh Bequest, Kenwood

ENID MARX b.1902

130. *Kenwood*, 1932
Wood engraving; 6⅞×8¾ in. (17·5×22·2 cm.)

SIGNED in pencil and numbered *30/60*

The Iveagh Bequest, Kenwood

A. MURRAY

131. *Hampstead Heath, Ken Wood and Parliament Hill*, **1931**
Poster paint; 29⅞×21¼ in. (76×54 cm.)

SIGNED: *A. Murray 1931*

Greater London Record Office (L.C.C. TWYS 115)

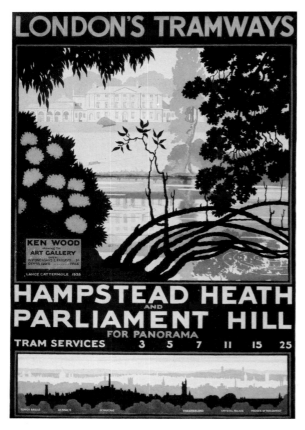

LANCE CATTERMOLE b.1898

132. *Hampstead Heath and Parliament Hill*, **1933**
Poster paint; 29⅞×21¼ in. (76×54 cm.)

SIGNED: *LANCE CATTERMOLE 1933*

This design for a hoarding poster, issued by London Tramways, shows Kenwood from below the concert pond and advertises the view south from Parliament Hill with a printed panorama running from Tower Bridge to the Houses of Parliament. As the advertisement for the 'Art Gallery' makes clear, admission to Kenwood was initially charged on two week days, an arrangement which was dropped by the time the house reopened after the war. Trams terminated at Parliament Hill Fields, partly to avoid the steep gradient of Highgate West Hill; the terminus survives as a bus stop.

Greater London Record Office (L.C.C. TWYS 147)

MARGARET CALKIN JAMES fl. 1935-39

133. *Kenwood*, **1935**
Poster; 40×25 in. (101·6×63.5 cm.)

London Transport Museum

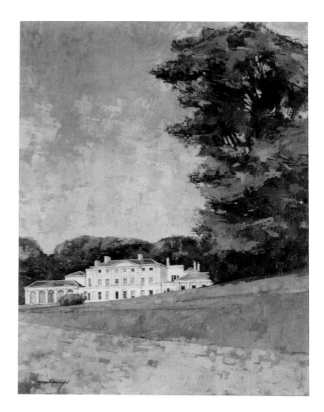

R.F. MICKLEWRIGHT

134. *Kenwood House*, **1974**
Oil on canvas; 32¾×25 in. (83·2×63.5 cm.)

SIGNED: *r.f. micklewright*

An image of Kenwood known to thousands through its reproduction as an underground poster from 1975.

London Transport Museum

ADRIAN BERG b.1929

135. *Hampstead Heath, 18 September* **1982**
Watercolour; 5¼×60 in. (13·3×152·4cm).

EXHIBITED: *Adrian Berg*, Serpentine Gallery, 1984

This panoramic view south-east from the Kenwood estate includes Caenwood Towers and Witanhurst on the horizon.

Private Collection

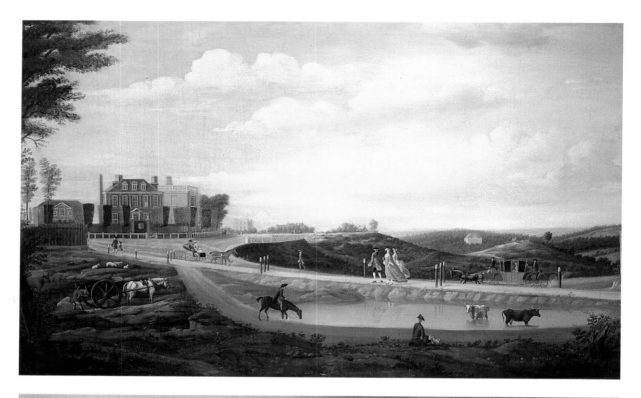

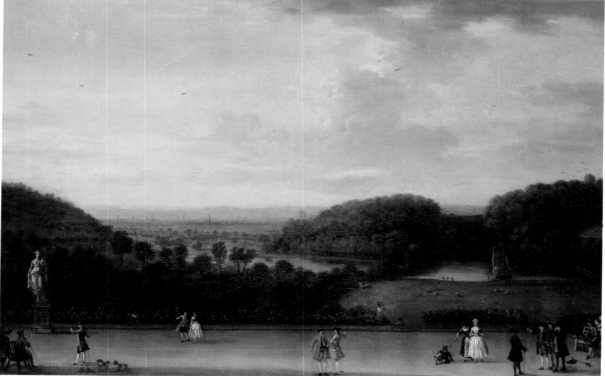

VII T. Ramsey *Heath House, Hampstead*, 1755 (cat. 75)

VIII John Wootton *A View from Caenwood House over London*, 1755 (cat. 76)

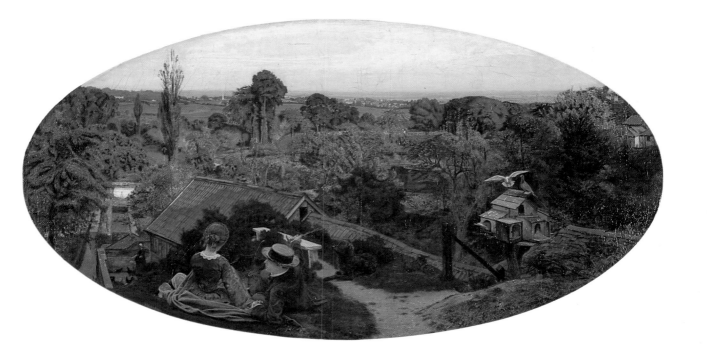

IX (above)
Ford Madox Brown
English Autumn Afternoon, Hampstead – scenery in 1853, 1852-4 (cat. 119)

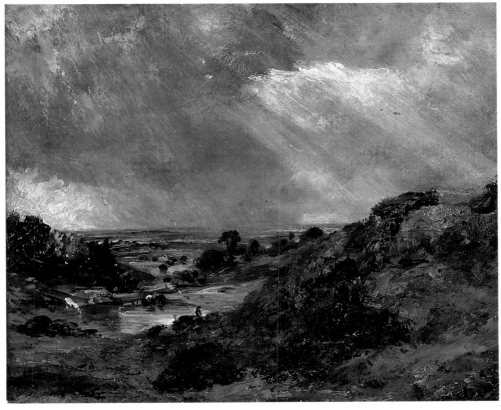

X John Constable
Branch Hill Pond, 1819 (cat. 110)

Select Bibliography

General

Bernard Adams, *London Illustrated 1604-1851* (London, 1983)

John Barrell, *The dark side of the landscape* (Cambridge, 1980)

Daniel Defoe, *A Tour Thro' the whole Island of Great Britain* (London, 1724-7)

John Gage, *A Decade of English Naturalism 1810-1820*, exhibition catalogue, Norwich Castle Museum, 1969

John Harris, 'English Country House Guides, 1740-1840' in *Concerning Architecture: Essays presented to Nikolaus Pevsner*, John Summerson, ed. (London, 1968)

John Harris, *The Artist and the Country House* (London, 1979)

Ralph Hyde, *Gilded Scenes and Shining Prospects. Panoramic Views of British Towns 1575-1900*, exhibition catalogue, Yale Center for British Art, 1985

Daniel Lysons, *The Environs of London*, III, *Middlesex* (London, 1795)

John Macky, *A Journey through England* (London, 1722)

Elizabeth Wheeler Manwaring, *Italian Landscape in Eighteenth Century England* (London, 1925)

Esther Aline Lowndes Moir, *The Discovery of Britain. The English Tourists 1540 to 1840* (London, 1964)

Christopher Morris, ed., *The Journeys of Celia Fiennes* (London, 1949)

Henry V.S. Ogden & Margaret S. Ogden, *English Taste in Landscape in the Seventeenth Century* (Ann Arbor, 1955)

David H. Solkin, *Richard Wilson. The Landscape of Reaction*, exhibition catalogue, Tate Gallery, 1982

Lindsay Stainton, *British Landscape Watercolours 1600-1860*, exhibition catalogue, British Museum, 1985

Paget Toynbee, ed., 'Horace Walpole's Journals of Visits to Country Seats', *The Walpole Society*, XVI (1927-8) pp. 9-80

Ranger's House

Bonamy Dobrée, *The Letters of Philip Dormer Stanhope, 4th Earl of Chesterfield* (London & New York, 1932)

Alan Glencross, *The Buildings of Greenwich* (Greenwich, 1974)

Greenwich and Lewisham Antiquarian Society, *Transactions*, VII, 6 (1978)

Derek Howse, *Francis Place and the Early History of the Greenwich Observatory* (London, 1975)

John Jacob & Jacob Simon, *The Suffolk Collection. Ranger's House, Blackheath* (London, 1975)

Beryl Platts, *A History of Greenwich* (Newton Abbot, 1973)

Neil Rhind, *Blackheath Centenary 1871-1971* (London, 1971)

Marble Hill

Patricia Astley Cooper & Diana Howard, ed., *'Blest Retreats'. A History of Private Gardens in Richmond upon Thames* (Richmond upon Thames, 1984)

Borough of Twickenham Local History Society, *Twickenham 1600-1900 – People and Places* (Twickenham, 1981)

Julius Bryant, *Marble Hill: The Design and Use of a Palladian Estate* (Twickenham, 1986)

Alister Campbell, *The Countess of Suffolk and her Friends*, exhibition catalogue, Marble Hill, 1966

R.S. Cobbett, *Memorials of Twickenham* (London, 1872)

J.W. Croker, ed., *Letters to and from Henrietta Countess of Suffolk* (London, 1824)

Marie P.G. Draper & W. A. Eden, *Marble Hill House and its Owners* (London, 1970)

Bamber Gascoigne & Jonathan Ditchburn, *Images of Twickenham* (Richmond upon Thames, 1981)

Greater London Council, *Marble Hill House, Twickenham. A Short Account of its History and Architecture*, second edition (London, 1982)

John Hervey, *Memoirs of the Reign of George the Second*, J.W. Croker, ed. (London, 1848)

Lewis Melville, *Lady Suffolk and her Circle* (London, 1924)

Kenwood

Robert & James Adam, *The Works in Architecture of Robert and James Adam*, I, number II (London, 1774)

F.E. Baines, ed., *Records of the Manor, Parish, and Borough of Hampstead* (London, 1890)

Thomas J. Barratt, *The Annals of Hampstead* (London, 1912)

Arthur T. Bolton, *The Architecture of Robert & James Adam* (London, 1922)

Alan Farmer, *Hampstead Heath* (New Barnet, 1984)

C.W. Ikin, *Hampstead Heath – How the Heath was saved for the Public* (London, 1971)

John Jacob, *The true resemblance of Lord Mansfield*, exhibition catalogue, The Iveagh Bequest, Kenwood, 1971

Simon Jenkins & Jonathan Ditchburn, *Images of Hampstead* (Richmond upon Thames, 1982)

London County Council, *Survey of London*, XVII, *The Village of Highgate* (London, 1936)

J.C. Loudon, *The Suburban Gardener and Villa Companion* (London, 1838)

John Richardson, *Highgate – its History since the Fifteenth Century* (New Barnet, 1983)

Jacob Simon, 'Humphry Repton at Kenwood: A Missing Red Book', *Camden History Review*, 11 (1984) pp. 4-9

John Summerson, *The Iveagh Bequest, Kenwood. A Short Account of its History and Architecture* (London, 1967)

Visitors' Information

Address all enquiries to The Curator, The Iveagh Bequest, Kenwood, Hampstead Lane, London NW3 7JR
Telephone: 01-348 1286/7
Admission to all three historic houses is free.

	Ranger's House	Marble Hill House	The Iveagh Bequest, Kenwood
Address	Chesterfield Walk, Blackheath, London SE10 8QX	Richmond Road, Twickenham, TW1 2NL	Hampstead Lane, London NW3 7JR
Car Park	Limited free car parking space is available in Chesterfield Walk on either side of the entrance to the House. Coaches are not allowed to park in front of the House.	Free car park at the Richmond end of Marble Hill park. The entrance is not suitable for coaches and these must be left outside the park. No parking of any vehicle is permitted in front of the House	Free car parking space is available at the West Lodge and some space is also available opposite the front of the House. Coaches are not allowed to park in front of the House and should be left outside.
Facilities for Disabled	Lift. W.C.	No steps. W.C.	No steps. W.C.
Open	Daily February to October 10am-5pm. November to January 10am-4pm. Closed on Good Friday, Christmas Eve and Christmas Day.	Daily (excluding Fridays) February to October 10am-5pm. November to January 10am-4pm. Closed on Christmas Eve and Christmas Day.	Daily April to September 10am-7pm. February, March and October 10am-5pm. November to January 10am-4pm. Closed on Good Friday, Christmas Eve and Christmas Day.
Publications	'The Suffolk Collection' Catalogue of Paintings.	Marble Hill House Guidebook.	Kenwood History and Architecture by John Summerson.
Recitals	Music recitals in the Gallery on Sunday evenings during the spring, summer and autumn.	Richmond Shakespeare Society perform plays on Terrace in summer. Brass bands and occasional concerts.	Music and poetry recitals are held on Sunday evenings in the Orangery during the spring and autumn: Symphony Concerts are held by the Lake in summer.
Refreshments	Refreshments are not available at Ranger's House. There is a cafe in Greenwich Park and the Dolphin Restaurant (closed Sundays and Mondays) is in the National Maritime Museum (Telephone 01 858 4422). There are also various restaurants in Blackheath and Greenwich.	Light refreshments are available in the Clockhouse Restaurant. All enquiries to the Manager (Telephone 01 891 2900)	Food and light refreshments are available in the Old Kitchen and Coach House. All enquiries should be addressed to the Manager, Iveagh Bequest Restaurant (Telephone 01 348 4286)
Telephone	01 853 0035	01 892 5115	01 348 1286/7
The Park	The 272 acres of Blackheath, in front of the house, include facilities for bowls, cricket, football and tennis. Fairs are held on Bank Holidays. At the rear of the house lies Greenwich Park with a magnificent rose garden.	The grounds have facilities for cricket, football, putting and tennis. There is a One O'clock Club and a playpark for children.	The flower gardens, woodland and sloping green lawns of Kenwood make an ideal setting for the House. With Hampstead Heath there are over 800 acres of scenery to explore.
Transport	British Rail to Blackheath and Greenwich; Underground New Cross (Metropolitan Line). Bus 53, 54 and 75. River Launches to Greenwich from Westminster Pier (Telephone 01 930 4097) and Charing Cross Pier (Telephone 01 839 5393) then 15 minutes walk.	British Rail to St. Margaret's from Waterloo also BR (North London Link) or Underground (District Line) to Richmond. Buses 33, 37, 90B, 202, 270 and 290. River launches pass Marble Hill in the summer. Enquire at Westminster Pier (Telephone 01 930 4097) or Richmond Bridge Pier (Telephone 01 520 2090). Ferry to and from Ham House.	Bus 210. Green Line 734. Underground (Northern Line) to Archway or Golders Green, then Bus 210.

Lenders to the Exhibition

Birmingham Museum & Art Gallery, 119
The Bodleian Library, Oxford, 99
The Trustees of the British Museum, 5, 61, 96, 97
British Rail Pension Funds, 36
Courtauld Institute Galleries, 21, 118
Greater London Record Office, 6, 42, 63, 95, 126, 127, 131, 132
Greenwich Local History Library, 7, 8, 14-18, 22, 23, 26, 27, 29, 30, 32, 34
Guildhall Library, City of London, 9, 10, 19, 74, 103, 104
Harris Museum and Art Gallery, Preston, 25
The Hon. Ian Hope-Morley, 35
Leeds City Art Galleries, 1
London Borough of Camden, Local History Library, 85, 112, 113, 115, 116
London Borough of Richmond upon Thames, 41, 43, 53, 54, 69, 70
London Transport Museum, 121, 123, 124, 133, 134
Manchester City Art Galleries, 67
Lt. Col. Sir Arscott Molesworth-St. Aubyn, Bt., 45

Museum of London 2, 31, 73
National Gallery of Ireland, 77
National Maritime Museum, 3, 4
Norfolk Museums Service (Norwich Castle Museum), 46
Orleans House Gallery (Ionides Bequest), 48, 60, 62, 64, 68
Leslie R. Paton, 49
The Rt. Hon. the Earl of Pembroke, 38
Private Collections, 58, 75, 76
Public Record Office, 11, 12, 13
The Shipley Art Gallery, Gateshead (Tyne and Wear Museums Service), 101
Dudley Snelgrove Esq., 78
Spink & Son Limited, 65
The Trustees of the Tate Gallery, 47, 50, 51, 66
The Trustees of the Victoria and Albert Museum, 59, 110, 111
The Wernher Collection, Luton Hoo, Bedfordshire, 102
The Worshipful Company of Gardeners, 117

Photographic Acknowledgements

Birmingham Museum & Art Gallery, 119
The Bodleian Library, Oxford, 99
The Trustees of the British Museum, 5, 61, 96, 97, fig. 3
British Rail Pension Funds, 36
Sir Frank Cooper, Bt., fig. 8
The Courtauld Institute of Art, 21, 45, 118
Government Art Collection, fig. 20
Greater London Record Office, 6, 42, 63, 95, 126, 127, 131, 132
Greenwich Local History Library, 7, 8, 15-17, 22, 26, 27, 29, 32, 34, fig. 10, 27, 28
Guildhall Library, City of London, 9, 10, 19, 74, 103, fig. 13
John Harris, fig. 4, 29
Harris Museum and Art Gallery, Preston, 25
Lord Hesketh, fig. 19
The Hon. Ian Hope-Morley, 35
The Keeper of the Records of Scotland, 37
Leeds City Art Galleries, 1
London Borough of Camden, 85, 112, 113, 115, 116
London Borough of Richmond upon Thames, 41, 43, 53
London Regional Transport, 121, 123, 124, 133, 134
Manchester City Art Galleries, 67, fig. 32

Mansfield Collection, Scone Palace, Perth, fig. 26
Lt. Col. Sir Arscott Molesworth-St. Aubyn, Bt., 45
Museum of London, 2, 31, 73, fig. 2, 30
National Galleries of Scotland, fig. 26
National Gallery, London fig. 1
National Gallery of Ireland, 77
National Maritime Museum, 3, 4
National Portrait Gallery, 35
Orleans House Gallery, 48, 60, 62, 64, 68
The Rt. Hon. the Earl of Pembroke, 38
Paul Mellon Centre for Studies in British Art, 78
Public Record Office, 11, 12, 13
The Shipley Art Gallery, Gateshead (Tyne & Wear Museums Service), 101
Dudley Snelgrove Esq., 78
Spink & Son Limited, 65
The Trustees of the Tate Gallery, 50, 66, fig. 6, 7, 21
The Trustees of the Victoria and Albert Museum, 59, 110, 111, fig. 31
The Wernher Collection, Luton Hoo, Bedfordshire, 102
The Worshipful Company of Gardeners, 117
The Yale Center for British Art, fig. 5, 14

Index of Artists